ADVENTURES IN
CLOSEUP
PHOTOGRAPHY

ADVENTURES IN
CLOSEUP
PHOTOGRAPHY

by Lief Ericksenn and Els Sincebaugh

AMPHOTO

American Photographic Book Publishing
an imprint of Watson-Guptill Publications/New York

TECHNICAL NOTE:
As this book was in preparation, the method of designating film speeds
was in transition from the familiar ASA system to the new ISO system.
The ISO rating combines the old ASA and DIN systems. For example, a
film rated at ASA 400 (27 DIN), will be expressed ISO 400/27, or simply
ISO 400. In this book, the new ISO rating system is used.

Paperback Edition 1985

First published 1983 in New York by AMPHOTO, American
Photographic Book Publishing: an imprint of Watson-Guptill
Publications; a division of Billboard Publications, Inc.,
1515 Broadway, New York, New York 10036.

Library of Congress Catalog Card Number: 83–3873

ISBN 0–8174–3501–8

ISBN 0–8174–3502–6 pbk.

Distributed in the United Kingdom by Phaidon Press Ltd.,
Littlegate House, St. Ebbe's St., Oxford

Manufactured in Japan

1 2 3 4 5 6 7/90 89 88 87 86 85

CONTENTS

INTRODUCTION TO CLOSEUP PHOTOGRAPHY

Through closeup photography we can see how a drop of water splashes or the fantastic structures of veins in a leaf. Closeups give a magnified and intensified view of our world. We experience a kind of magic when we see a spectacular closeup photograph of something shown in far greater detail than our eyes would have noticed. When the camera moves in to give it more impact, we see the subject of that image in a new way.

Taking closeup photographs is even more exciting than viewing them. The photographer who begins to isolate details through closeup photography learns a whole new way of "seeing." He learns to study the details and parts of what we habitually see as total objects. He learns to look about him with eyes sharpened to the possibilities of imagery in a magnified world.

Taking closeups today can be as simple as finding a subject, bringing a macro lens into sharp focus, and pressing the shutter release. Specialized equipment is available, but not always necessary. Many of the simpler cameras on the market offer close focusing, though not to the extremes possible with more sophisticated equipment, of course. Very few people are aware of how close they can actually focus with their cameras. In actuality, even instant and fixed-lens cameras often will move in to approximately a foot or two and give a large image size that is a "closeup" in terms of this equipment.

Before you decide to invest in special equipment, look at the camera you've got, and try to bring it to its point of closest focus. Your results could be just what you had hoped for. There is plenty of room in photography for you to determine what is a closeup in terms of your equipment.

Whatever your equipment choice, you can easily produce stunning closeups in the environment around you. Once you've gotten your choice of closeup equipment, it is just a matter of learning to "see" closeups in a photographic way.

This book presents 26 environments available to almost everyone and gives you ideas about how to look for and photograph exciting details in those environments. Each environment is presented as an illustrated adventure, or project, composed of the following:

A general introduction to the closeup opportunities in the environment and an "establishing shot" of a typical overall scene.

A list of equipment and accessories needed for the environment.

A discussion of technical and creative approaches to taking closeups in that environment.

Examples of closeups taken in that environment.

Specific problems that may occur during the project and solutions to those problems.

Throughout the projects there are self-contained mini lessons in closeup photography. By the time you have tried most of the "adventures" in this book, you will have encountered nearly every closeup situation that could arise, and you will have learned all the basics of closeup photography. Following the 26 projects, there are suggestions on how you can use your closeup pictures for everything from decorating your home or apartment in a unique way to making money through sales to a stock photo company.

BASIC CONCEPTS OF CLOSEUP PHOTOGRAPHY

Taking closeup photographs is easy, but before you start there are some basic concepts that will help you take successful pictures.

Point of Closest Focus

Any lens has a *range* of distance at which it can register a subject in sharp focus. This is usually engraved on the lens barrel. The shortest camera-to-subject distance that will render the subject sharp is the *point of closest focus for that particular lens.*

Lens-to-Film Plane Distances

If you move a lens further from the film plane with the use of an accessory such as an extension tube, you will produce a *larger image of the subject on the film.*

Magnification

Lenses can, at their point of closest focus, render a subject on film from about 1/10 lifesize (standard 55mm lens) to 1/2 lifesize (55mm macro lens) to lifesize (55mm macro lens with an extension tube). The difference, then, between standard lenses and macro lenses is the ratio in which they represent the actual size of a subject on film.

If you have been thinking that closeup photography is confined to special lenses

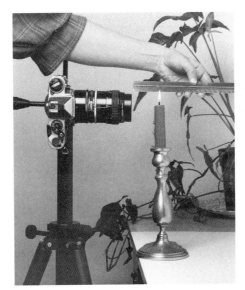

A 55mm macro lens with extension tube produces this image at its point of closest focus.

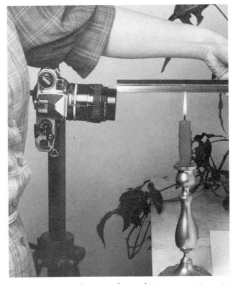

A 55mm macro lens produces this image at its point of closest focus.

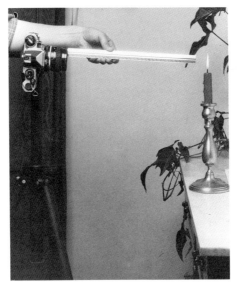
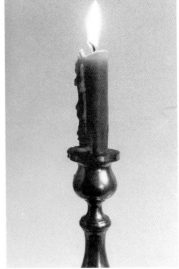

A 55mm lens produces this image at its point of closest focus.

7

and accessories, you might consider this: When you are using an interchangeable lens camera, such as a 35mm SLR, it is fairly safe to assume that any lens you own can be used—with a little help—in a way that will produce larger images on the film than it is primarily designed to do.

Definition of Closeup

Though the word "closeup" is generally used in a rather open-ended fashion, there are more precise guidelines for the serious photographer. For the purpose of this book, closeup is defined as the range of $1/10$ up to $1/2$ lifesize, or image ratios of 1:10–1:2. A closeup made at the closest focusing point of a standard lens or with a macro lens can fall in this category. At times in this text you will find the term "medium closeup" used to refer to a subject falling midway in this range.

Extreme closeup. The subject is recorded on the film from half to full lifesize. The majority of images shown in this book are one-half to full life-size pictures of the subjects, which means that their image ratios fall between 1:2 (half lifesize) and 1:1 (lifesize).

Macro. Technically, this means rendering an image on film at lifesize (1:1) or larger than the actual subject. However, most macro lenses achieve an image of at most half to full lifesize, which means their product falls in the previous category.

Photomacrography. A specialized area of closeup work that means making images that are larger than the actual subject on film, from more than lifesize up to about 35 times lifesize.

Photomicrography. Closeup work using a microscope, with very large magnifications of the actual subject on film.

This book encompasses 26 projects to teach you how to take closeups and extreme closeups. The equipment discussion that follows in the next chapter will help you decide what you can achieve with the equipment you have, or whether you want to invest in some accessories or macro lenses to get even "closer." The highly specialized realms of photomacrography or photomicrography are not discussed.

Closeup, in general terms, implies that you literally work close to your subject. The lens may be only inches or feet from your subject.

DEPTH OF FIELD IN CLOSEUP PHOTOGRAPHY

Depth of field, or the zone of sharp focus in the photograph, is minimal for the closeup photographer. For example, if you took a picture of a flower garden with a 55mm lens and you were about 10 feet (305 cm) away from the flowers, all the plants falling into a zone about 3 feet (91 cm) deep would be in sharp focus. But, if you added an extension tube to the same lens and moved in to take a lifesize picture of just one flower in the garden, at a distance of about 2 inches (5 cm) from the flower, the depth of field would be a zone only about $1/16$ inch (.16 cm) deep even at $f/16$; it could be only about $1/64$ inch (.04 cm) at $f/4$. This means that understanding and working with limited depth of field is one of the greatest challenges in closeup photography.

COMPOSITION FOR CLOSEUP PHOTOGRAPHY

Composition is a matter of organizing visual elements inside the image area of your negative or slide so that they have the most pleasing visual effect. Though the subject areas of the real world isolated for closeup photography may be very small, composition is just as much a part of closeup picture-taking as in taking any other kind of photograph. For this reason, a few brief lessons on composition are included in this book to make you aware of how your photographic eye can help make the most of your closeup subjects.

These concepts, which photographers should employ when taking any kind of picture, are: *balance, positive and negative space, horizon and the rule of thirds, motion and countermotion,* and *lines of strength.* Each of these concepts is explained in separate demonstrations placed throughout the 26 adventures.

FOCUSING TECHNIQUE IN CLOSEUP PHOTOGRAPHY

You should bear in mind that using a lens attached to an extension tube or bellows generally precludes normal focusing proce-

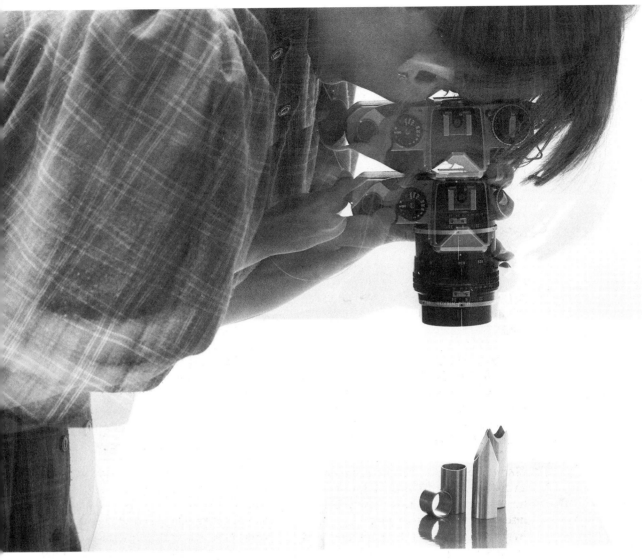

dures. You will need to *physically move the camera toward or away from the subject* to achieve focus. This can be awkward when the camera is on a tripod, since you also have to move the tripod. You can either move camera and tripod together or buy a tripod that offers a special focusing rail, which moves the camera and lens assembly toward or away from the subject without actually having to move the tripod itself.

When a bellows system is used, the same problem arises and the same procedure of physically moving the assembly should be followed. There is an accessory you can buy that attaches to the extension track of the more elaborate bellows. This too is a focusing rail and the bellows sits on top of it. Turning a knob moves the entire camera and bellows assembly in and out and allows for ease of continuous focusing.

When using an extension tube, the photographer must physically move the camera toward or away from the subject to achieve focus, as shown in the photograph above.

EQUIPMENT FOR CLOSEUP PHOTOGRAPHY

The term closeup in the context of this book refers to the product of any number of cameras, be they fixed-lens or interchangeable-lens types. Naturally closeups depend upon the closest point any lens is capable of focusing. Thus, if you have a 35mm fixed-lens camera, which has a closest focusing distance of, say, 3.5 feet (107 cm), it will render the size of a subject on film at most approximately 1/10 lifesize (an image ratio of 1:10). This, then, is the closeup capability of that particular camera. With this in mind you should also remember that pictures shot at this focusing distance may differ from camera to camera and lens to lens.

If your camera is a 35mm SLR, then the same would apply to the so-called standard 50mm lens. However, since you are able to change the lenses on 35mm SLR cameras, you can remedy this by changing to a lens whose point of closest focus suits your concept of closeup. Where the camera is capable of using interchangeable lenses, then the close focusing ability of the camera is governed by the lens in use. Because of the opportunity to use macro lenses, a camera capable of taking different lenses is, without doubt, *best* for large magnification in closeup images, but you should not rule out using simpler equipment for pictures that are closer than those ordinarily take.

When the close-focusing ability of any lens, fixed or interchangeable, is changed by the addition of a series of closeup lenses, such as a set of diopters on a fixed lens or any of the following options: diopters, a reversing ring, an extension tube, or bellows for interchangeable lenses, then the situation is drastically changed. These accessories provide much larger image size and therefore make any given lens focus "closer."

This chapter will give you a basic understanding of all the possible ways there are to take closeups and leave the specific choice of equipment and technique up to you.

CLOSEUPS WITH 35mm INTERCHANGEABLE-LENS CAMERAS

Most people do not realize what a wonderfully versatile and simple camera a single lens reflex is until they want to take pictures other than snapshots.

The 35mm single-lens-reflex camera has

been called "the king of cameras" because of its incredible versatility and the number of different focal-length lenses available for it. Even the least expensive 35mm SLR has at its command lenses ranging from, say, super-wide-angle to wide-angle lenses, up through the standard 50mm optics to telephoto and super-telephoto lenses. Roughly, the range would be from about 7.5mm to 2000mm—quite an arsenal at the disposal of the 35mm SLR photographer.

Closeup work with almost any SLR is *easy*. The use of a macro lens, an extension tube, a bellows outfit, or diopters presents no problems with framing the image since on an SLR, unlike a rangefinder, what you see in the focusing screen *is* what you get in the final shot. Also, most 35mm systems offer automatic exposure calculation, which makes closeup photography extremely simple with meter-coupled lenses.

Because the 35mm SLR camera is so versatile a picture-taking tool, many equipment options have been devised for taking closeups with this kind of camera. The basic options are: the macro lens, extension tube, bellows unit, reversing ring, and diopters.

The choice of how you arrive at your closeup picture is entirely up to you. You will hear arguments from some photographers that one method or system is better than another, but each of these options works and one will suit you best. Read on and decide which suits you and your photographic goals.

Macro Lens

Simply stated, a macro lens is a lens specifically designed to focus closer than most lenses without special adapters such as diopters, extension tubes, reversing rings, or a bellows unit. The macro lens is constructed so that the lens barrel is capable of much longer extensions than a more conventional lens. If a normal 50mm lens will focus, from, say, 3 feet (91cm) to infinity, a 50mm *macro* lens will focus from several *inches* to infinity. Macro lenses are, by their nature and design, highly corrected for closeup photography and, naturally, cost a little more.

A true macro lens has an image ratio of 1:1. That is, a subject is reproduced on the film at lifesize. Many so-called macro lens features such as those often found on zoom lenses are not true macro. They are usually very close-focus settings: 1:4, 1:3, 1:2, etc.

A macro lens has its own extension tube built in; the lens barrel will allow you to focus down to a few inches and thus produce a correspondingly larger image on the film. Exactly how much larger? That depends upon the lens and the way the manufacturer designed it. Certainly most macro lenses will produce images of at least a 1:2 ratio, that is, about ½ lifesize. Some will produce an image that is 1:1, which is lifesize. For example, the butterfly you photograph at 1:1 will fill the frame on the film.

Macro lenses come in a number of focal lengths, generally 50mm, 100mm, and 200mm. The 50mm and 100mm macro lenses are the ones most commonly used. There are some special macro lenses that are designed solely to work on a bellows unit.

Why so many focal lengths? Because some photographers like to use a longer focal length lens to be able to "stand off" farther from a subject. The longer focal lengths permit you to get a bigger image than shorter focal length macro lenses. This is useful if the subject is shy or hostile, or if you need to use a supplemental lighting source such as flash.

As stated, some macro lenses will focus close enough to allow you a full 1:1 image ratio, that is, lifesize. Some require a short extension tube to achieve 1:1. If the latter is the case, you will probably find that the macro lens you buy comes as a two-part kit: a lens and its extension tube. This is no ordinary extension tube. It is designed to couple to the lens and totally maintain any and all automatic features of the lens it is intended for. The extension tube may also be used with your other lenses, so you get a bonus when you buy a macro lens that comes as a set. However, not all macro lenses require an extension tube. It depends upon who makes the lens and the camera it is designed for. You may also use your macro lens with almost any extension tube and even on a bellows.

The Advantages and Disadvantages of Macro Lenses. If you can use most of your conventional lenses to take closeups, why would you need a special macro lens? You don't, unless you are intent on getting even closer and achieving the very best definition

One or more extension tubes can be fitted between the camera and lens.

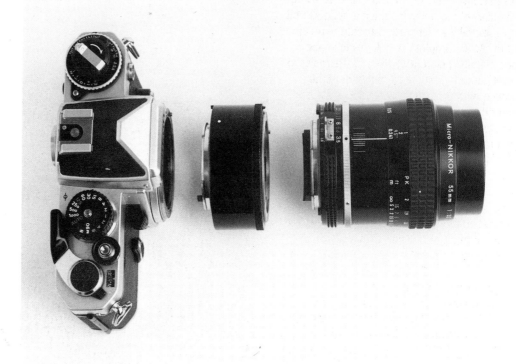

and image resolution from a lens.

Lenses other than macro lenses, although excellent, are not specifically designed for the work you may be putting them to. A macro lens is designed around the capability of shooting to image ratios of 1:1 and even greater without any compromise either in use or quality.

If a macro lens has any disadvantage it is that, compared with many lenses in the, say, 50mm to 100mm range, it is slow. Generally, a macro lens will have a maximum aperture of around $f/3.5$. Does this really matter? Not really—modern, state-of-the-art films are both fast and good, and using the faster film offsets the lack of speed in a macro lens. Consider this too: How often will you be shooting very closeup and macro pictures at $f/3.5$? You will most likely be stopping your lens down as far as you can to obtain the best possible depth of field.

A macro lens may also be used as a general purpose optic as well as for closeups since it is quite capable of focusing at infinity. It is not advisable to use a 100mm macro lens for portraits, however, unless you are very sure of the flawlessness of your model's complexion. Macro lenses are very unforgiving as far as what they record,

and wrinkles and bumps can be recorded on the film with ferocious accuracy.

The reason behind macro lenses lies in the fact that they are much more highly corrected for very close photography whereas a standard lens may well not be.

The Extension Tube

An extension tube is a tube, or set of tubes, made of metal with a mount at one end to take the lens and a mount at the other end to fit onto the camera.

An extension tube increases the image size by physically moving the lens away from the camera, extending the distance between the lens and the film plane. The extension tube will decrease the amount of light reaching the film plane, causing the transmission to fall off and will also change the way the lens focuses. This should be considered when working with extension tubes.

Extension tubes may be bought singly or as a set and may be obtained in various lengths to allow you a choice of image size. Generally, they are designed to maintain the mechanical link-ups between the lens and the camera so that full automation is maintained.

Bellows Unit

All that has been said of extension tubes applies largely to bellows, since a bellows unit is essentially an infinitely variable extension tube. At its simplest, a bellows is an inexpensive and pocketable item; at its most sophisticated it becomes a highly versatile device with other features such as swings and tilts, special focusing rails, automatic couplings, and so on. You can use your conventional lenses on a bellows, or you can buy special lenses designed exclusively for work on a bellows unit. These special lenses are highly corrected and do have the advantage of allowing the camera to maintain a normal infinity that is generally not possible when working with, say, a 50mm standard lens on the bellows.

Reversing Ring

Yet another closeup option is a "reversing ring." It is one of the simplest devices for closeup photography. The reversing ring does just what it says. It is screwed into the filter ring of the lens and allows the lens to be mounted *backwards* on the camera. This changes the way the lens works and allows the lens to behave as though it were really a macro lens.

Why use a reversing ring? Because usually nonmacro lenses are not at their best in extreme closeup situations. Turning the lens backwards changes the optical corrections in the lens and makes for better definition in closeup pictures.

Remember that when you turn a lens around with a reversing ring, you lose all the automatic functions of the lens, so you have to manually open up and close down the lens aperture. The final image size obtained will vary from lens to lens.

The reversing ring may be used with most zooms; however not all lenses will work with a reversing ring. Check with your camera dealer.

Diopters

A diopter, or closeup lens, is a fairly simple animal as far as lenses go. It is a weak lens that is screwed over the front of the camera lens to allow the latter to move in closer and make the resultant image larger on the film. The closer you get to the subject, the bigger the image will appear on the film. However, it's not the same as putting a telephoto lens on the camera because a diopter will

A bellows units, such as the one shown in the photograph above, fits between the camera and lens in much the same manner as an extension tube.

not allow the lens to focus at its original infinity. In fact, in many ways it makes the lens on the camera somewhat shortsighted!

Diopters come in a variety of powers (or diopters, from which the lens takes its name). The most widely used are +1, +2, +3, and sometimes +4. The higher the number, the more powerful the closeup lens.

Diopters are relatively inexpensive, they are light and easy to carry, they work well, and they do not slow the lens down as do extension tubes and bellows units. For the most part they are highly corrected optically and do not change the image-making characteristics of the lens they are screwed in front of, except that they make it see a bigger, more magnified image.

TAKING CLOSEUPS WITH NON-MACRO INTERCHANGEABLE LENSES

It has been stated that closeup photographs can be taken simply by bringing the lens on your camera to its point of closest focus. The following will explain how to take closeups with any of the standard interchangeable lenses for a 35mm SLR.

Close Focus with Normal Lenses

The so-called normal lens for the 35mm SLR camera is usually around 50mm in focal length. This focal length is considered to roughly approximate the way our eyes perceive a scene. A 50mm lens will, depending upon its design and the manufacturer's specifications, usually focus as close as 2½ or 3½ feet (76–107cm). At 3½ feet (107cm), for example, your closeup of a person would be a fairly tight head-and-shoulders picture. It is difficult to specify exactly how close any lens will focus because, as stated, every manufacturer has different ideas of how close a lens should focus.

Close Focus with Wide-Angle Lenses

Many photographers use a wide-angle lens incorrectly. They buy the lens to "get everything in the picture," and of course, this is what a wide- or super-wide-angle lens will most certainly do. Pointing a wide-angle lens at a landscape will include everything

the lens can see as determined by its angle of view horizontally and vertically. Of course, a wide-angle lens does this by *reducing the image size* of any and all objects in its field of view just as a telephoto and super-telephoto lens sees a narrower angle because it *magnifies* whatever it sees.

A second common misconception about a wide-angle lens is that it has greater depth of field for a given lens aperture than a longer or telephoto lens. Actually depth of field is a constant of any aperture irrespective of the focal length. $F/8$, for example, provides the same depth of field whether the lens is a 28mm wide-angle or a 300mm telephoto lens. If the focal length is short enough, everything appears pin sharp from about 3 feet (91cm) through to infinity because the wide-angle lens reduces the scale of the subject on the film.

Consider a fish-eye lens (that peculiar, extremely wide-angle lens that produces a circular image on the film). It does not usually have a focusing ring. It is generally a true fixed-focus optic. Yet if you use a small enough aperture, you can almost place an object on its mushroom-shaped front element and have it and the rest of the scene quite sharp. It makes for some strange pictures, but it is still closeup photography— and often, both funny and effective. Take a closeup portrait of a friend this way and you will see what we mean!

Of course the fish-eye, be it the circular-frame type or the full-frame fish-eye, is an extremely wide-angle lens that does not correct the bending of the lines of a subject at the edges of the frame. If you use the super-wide 17mm, it produces a well-corrected image of a nonfish-eye type, but you can move it in very close and come away with some spectacular pictures. Choose a fairly small lens aperture and focus the lens as close as its barrel will allow. Now frame a flower, for example, in the foreground and maybe toward the bottom of the focusing screen, and you will find that the sharpness will sweep right back from, say, a few inches to infinity. The effect is striking and gives the picture high visual impact.

You can play this game with almost any wide-angle lens but as the focal length increases the effect decreases and so it is only really spectacular with very wide-angle optics. Much longer than about 24mm and the apparent depth of field simply will not

stretch that far. It is not really a good idea to try sticking a wide-angle lens on an extension tube. There is just no point to it.

Close Focus with Telephoto Lenses

We have mentioned the various methods for making a lens get in closer than it is designed to do, but so far we have stayed in the area of about 17mm to 50mm in focal length. What may surprise you is that a lot of telephoto and super-telephoto lenses are able to focus remarkably close even without extension tubes or other accessories. In fact, some of the super-telephotos like 500mm, 600mm, and 1000mm mirror (catoptric and catadioptric) lenses often have lens barrels that will extend tremendously and produce high magnifications of relatively small subjects at a range of several feet! Indeed, it is a fact that the telephoto and super-telephoto lenses are more amenable than lenses of shorter focal length to the use of a short extension tube between them and the camera. Why? Because having a narrow angle of view they tend not to vignette; that is, the tube does not cut off the corners of the picture.

Let's say you have a 200mm or 300mm telephoto lens and you add a short extension tube behind it. What happens? Everything that happens when you move any lens farther away from the film plane than it is designed to work at. It won't focus at its old infinity and it will lose speed. But what it will do is allow you to shoot huge images of a small subject from a distance of several feet. It's a useful thing to know if you are trying to photograph a rattlesnake that's fully awake, for example. And of course, the longer the focal length of the lens you are using, the farther away you can stand, which is also handy if the subject is small and inaccessible. What you have in fact created when using a long lens at a short working distance is a low-powered microscope that can reach in from a considerable distance.

Close Focus with Zoom Lenses

Zooms are no different from single focal length lenses in what you can do with them for closeup work. They are handy because you can zoom and frame and crop the subject from one position, which is, to say the least, convenient. Many zooms have a so-called "macro" mode, but few are truly

macro in the sense of producing images at a ratio of 1:1 (lifesize). So what you generally get in the so-called macro mode of a zoom lens is between a closeup and an extreme closeup.

Can you add an extension tube to a zoom lens? For the most part yes, although some zooms will perform poorly. You can even reverse some zooms with a reversing ring and of course you can use diopters over the front element as well. Again, this is a matter for experimentation because zoom lenses differ from type to type and from manufacturer to manufacturer.

CLOSEUPS WITH FIXED-LENS CAMERAS

It is not that easy to use fixed-lens, rangefinder-type cameras for any closeup work other than for the closest point that the lens built into the camera can focus at. (For the purposes of this book, anything other than an SLR—this classification includes true rangefinder focusing and zone-focusing cameras.) This varies, but is generally in the area of 2½ to 3½ feet (76–107cm).

You can, however, get some impressive closeup pictures with a fixed-lens camera and a set of diopters. You can make a fixed lens appear to focus a lot closer by adding a +1, +2, or even a +3 diopter in front of the working lens on the camera. Diopters are good options when you cannot change the lens on your camera.

If your camera is a fixed-lens type it is probably a rangefinder or zone-focusing type. The problem with rangefinders is that the viewfinder will not be seeing what the camera lens is seeing. By adding a diopter, you have changed the way the camera lens sees but not the way the viewfinder sees. The vertical displacement between the camera lens and the viewfinder with rangefinder cameras is called *parallax,* and you have to be aware of it or your picture will be framed correctly in the viewfinder but not in the actual lens or on the film.

There are some closeup kits made for this type of camera where a set of diopters comes with a special viewfinder attachment that corrects the problem. The simplest solution is to use a special device comprised of an arm with a frame on the end of it attached to the camera. The frame extends to the point where each lens should be focused

according to the power of the diopter supplied with the kit. You put the frame over the object and what lies within it is what you get on the film—simple and quite efficient. Check with your local photo supplier for these kits. A more elaborate device is a viewfinder correction device, which is like a pair of spectacles that, when fitted over the viewfinder, bends the light rays to the viewfinder to accommodate the now shortsighted camera lens.

FILM FOR CLOSEUP PHOTOGRAPHY

Which film is best for closeup photography? The short answer is that any film you use for any other type of photography may be used for closeup work. On the other hand, you may wish to resolve much finer detail in the subject especially if it is tiny and has fine detail. If so, the slower the film, the finer the grain, and the better the fine detail will be resolved. This philosophy applies to both black-and-white and color film.

The problem is that when you go to high image magnifications with slow, fine-grain film you encounter the problem of shutter speed limitation, so you must choose your film with the subject in mind. On bright sunny days or with flash, the problem is not critical and slower films offer the best advantage. Films with speeds from about ISO 12 to 64 offer excellent resolution characteristics and often the best color rendition. The latter, however, is a matter of personal choice. The faster films (ISO 100 and above) deliver the speed inherent both in themselves and in higher shutter speeds. They too may be used with daylight or flash.

What about films designed to work with tungsten light? You can shoot small subjects with tungsten light, such as a high-intensity desk lamp, photofloods, or even microscope lamps, but this type of lighting not only illuminates the subject but applies heat as well. It is all very well to chill an insect in the refrigerator to keep it still awhile, but the heat from the lamps will soon bring it back up to full mobility! It is better to photograph an insect by daylight or with flash.

The most important aspect of film choice for the closeup photographer is that film speed can help to control aperture width and shutter speeds. Remember that when you add an extension tube, bellows system, or

reversing ring you are decreasing the transmission of light through the lens. This may cause your meter to select a lens aperture that will deliver insufficient depth of field or even shutter speeds too slow for hand holding.

You can, of course, use a light-weight tripod and a cable release to compensate for slow shutter speed, but using a faster film is a simple solution to avoiding the extremely shallow depth of field caused by a larger aperture in closeup photography.

FLASH AND CLOSEUP PHOTOGRAPHY

The electronic flash unit is both portable and versatile, and it's easy to use for closeup work. Most flash units are automatic self-sensing types that figure out the exposure for themselves.

However, if the lens is extended beyond its normal working range, its light transmission falls off. If this happens, then will the flash exposure be incorrect? Yes, unless your camera offers true through-the-lens metering for flash. Then it will simply accommodate the extension and still correctly expose the shot by allowing the flash to pump in light until the meter says "enough."

How does the flash and its sensor eye know how much extension on the lens is in use? The answer is that it does not know, you have to tell it. On most macro lenses you will find a scale engraved on the lens barrel that will tell you quite simply how much exposure to add for compensation. If the flash has no provision for altering the data to accommodate the exposure change due to lens extension, there is a simple solution—"lie" to your flash unit!

Here is the simplest way to deceive an automatic flash unit. Imagine you are using an ISO 200 film and you know from the lens barrel of the macro lens or the ratio scale of the bellows that you need to add at least 1 stop of compensation to derive a correct exposure for the flash and the camera/lens system. Decreasing the *film speed setting* on the flash unit to ISO 100 will deceive the flash unit into pouring twice as much light (one stop's worth) than it normally would onto the subject. This will compensate for the light loss through lens extension. If you need a 2-stop compensation, turn the film speed setting down again on the flash unit,

in this case to ISO 50. Playing around like this takes a little practice and it's a good idea to bracket exposures in this manner until you become adept at this simple exposure compensation technique.

A specialized flash option for closeup work is a *ring flash,* which mounts on your lens and produces flash illumination from its circular, light-emitting element. There are specialized macro lenses that have a ring flash built in; these are generally used for medical and other areas of photography. For the most part, these are manual flash units.

The Advantages of Using Flash

The chief advantage of an electronic flash unit for closeup and macro work lies as much in the speed of the flash as it does in the simple portability of a modern flash unit. A self-sensing flash unit, be it externally sensed or metered through the lens, is quite capable of delivering flash illumination for durations as long as about $1/500$ sec. to as short as $1/30,000$ sec. These latter speeds generally occur at close range and their action-stopping capability is incredible. Imagine having a shutter speed of $1/30,000$ sec.; it is more than rapid enough to stop a high-velocity bullet in flight! You will appreciate then that it is a relatively simple matter to catch a raindrop falling from a twig or to stop a ladybug as it scurries across a leaf with flash.

Parallax and Flash in Closeup Photography

If you are using a self-sensing flash unit where the flash sensor is built *into the flash itself,* there is a small problem you should be aware of—parallax. If you mount the flash in the camera hot shoe, the flash and its sensing eye may not be looking at the same part of the scene as the camera lens. This is called "flash-to-lens parallax" and it is troublesome only at close and very close

ranges because the light from the flash has not had time to fan out and the acceptance angle of the sensor is not wide enough at short ranges to actually see what it's supposed to be reading. To understand the nature of this problem, draw an imaginary line through the axis of the lens and the axis of the flash sensor. If the lens is aimed at the subject, you will see that the sensor eye is actually aimed above the subject. Incorrect exposure may result. To correct this when you have set up the shot, hold your hand or a gray card above the subject and in line with the flash sensor and let the sensor eye read that. You will be surprised how well this simple solution works.

Vivitar offers a handy idea for use with their automatic flash units and closeup photography. It is called the MFS-1, an acronym for *Macro Flash Sensor.* Essentially it is a small lens attached by a clip to the lens shade of the lens you are using. A fiber optic "pipes" the light from the sensor lens to the flash sensor and thus eliminates flash to lens parallax.

CLOSEUPS MADE AFTER THE FACT

Almost everyone is aware that a photographer can isolate a portion of a slide or negative and create a closeup by blowing this portion of an image up to much larger size. Though this is, of course, possible, it is not preferable to taking closeups by recording larger image ratios on the film in the first place.

On the whole we would argue against this idea unless you are prepared to put up with an increase in the grain structure and the enlargement of focusing errors and the like. It's best to try to fill the frame with the subject to begin with to minimize the overall image enlargement in the darkroom.

EQUIPMENT GLOSSARY

A good photographer is a prepared photographer, and even though many of the 26 adventures contained in this book are conducted in or around your home, a list of recommended equipment is provided to tell you what you should have on hand before you start. Some suggestions are obvious (so obvious you just may forget them), others are optional recommendations and you may improvise with other equipment more suited to your needs.

Backgrounds. You may want to use colored paper or other simple backgrounds behind your closeup subject.

Black-and-white film. Although all but the last of the adventures presented here are shown in color, many of these projects can be photographed on black-and-white film. Follow the recommendations provided in the previous chapter to determine which black-and-white film is most appropriate to your subject.

Color film. Outdoors, use daylight-balanced film. Indoors, use tungsten type A or type B depending on whether your light source is photofloods or incandescent lights, respectively.

Camera. Of course your camera is the most important piece of equipment you will need for these adventures, but make sure that your camera is in proper working order with fresh batteries and set to the proper ISO rating for your film.

Closeup lens. This refers to your choice of the following: the closest focus of the lens on your camera, the addition of a diopter, a macro lens, extension tubes, bellows unit or a reversing ring.

Cooler. It is a good idea to bring a cooler with you to warmer climates to protect extra film and provide you with refreshments.

Copying stand. This may be improvised from a white cardboard box on which you can fasten any object that should remain absolutely flat to be photographed.

Dulling spray. This is helpful for cutting down on unwanted reflections from very shiny objects.

Exposure meter. If your camera does not feature through-the-lens metering, it's a good idea to bring along an exposure meter. Make sure it is set to the proper ISO rating before you take a reading.

Extra batteries. Even if you are sure that the batteries in your camera are fresh, bring

along an extra set of batteries for your flash, or any additional equipment you are using that may run down.

Flash. A self-sensing, portable flash is recommended for fill-in light for many outdoor situations as well as for use indoors.

FLD filter. This filter can be used to counteract the effects of fluorescent light when using daylight-balanced film.

Good boots. You should remember to protect yourself from the environment just as you would your camera. If you are planning to shoot at the beach or anywhere else near water, bring a pair of water-repellent boots. You may just have to wade into the water to get close enough to your subject. Similarly, if you are going out into strong sun you may want to bring along a wide-brimmed hat. And when photographing outdoors in cold weather, make sure that your gloves are flexible so that they won't impede your work.

Insect repellent. When working out of doors, keep a can of insect repellent handy to keep the insects off of you and any subject on which you don't want them to land.

Lens cleaning kit. Always keep a lens brush or canned air handy to keep pollen or dust off of your lens. You might also use it on subjects photographed out of doors.

Light box. Whether store-bought or improvised, a light box is needed for the transillumination of translucent subjects.

Photolamps. You should use 3400K reflector lamps when working indoors with tungsten (type A) film. For lower Kelvin ratings indoors, use tungsten (type B) film.

Plastic "camera raincoat" bag. When working outdoors, protect your camera from the environment as you would yourself. A plastic covering will protect your camera and lens casing from salt water, sand, rain, and snow.

Polarizing filter. Many photographers consider a polarizing filter standard equipment for excellent color saturation and haze reduction. It is also used to eliminate glare and reflection from water and glass.

Portable reflector panel. A portable reflective board can bounce additional light into a shadowy area. This works well for plants, but many animals are sensitive to light and instinctively run when the light level changes. Experiment with a white or aluminum foil-covered sheet of cardboard as an additional light source.

Small jar of honey or sugar water. Use this to attract insects and some small animals to the desired location.

Spray bottle of water. This is used to simulate dew on plants, to refresh plant foliage, and sometimes to wash dust off subjects. Many photographers use a solution of glycerin and water to simulate dew more realistically, as it beads on a surface in a manner almost indistinguishable from nature.

Tabletop set. You can construct a "ministudio" for indoor or outdoor use with a pair of white cardboard walls intersecting at 90 degrees to serve as a reflective environment. A piece of white paper curved vertically inside these walls will serve as a seamless background.

Terrarium, pie plate, or translucent plastic container with a wide opening. Sometimes the only way to photograph a small creature is to catch it and put it into some kind of container. If you use a real terrarium, you can design a realistic environment at the same time, so that you have the liberty to compose your shot without worrying that the subject may dart away. Or you can use a white plastic milk bottle with the upper portion cut off so that you can get your lens in close enough. Though some photographers may find it necessary to spray insects with insecticide to still them, skillful photographic work can be done just by containing the creature. Afterward, you can return the insect or animal to its natural environment.

Tripod. Some locations are ideal for a photographic blind into which living creatures come, but there will also be times when it is impossible to use a tripod, as in the case of pursuing a fast-moving dragonfly. Learning to use a tripod and to hand-hold your camera for closeup work will give you a full repertoire of techniques. A smaller tripod may often come in handy; make sure it has a good ball and socket head.

UV filter. Ultraviolet, Haze, 1A, or Skylight filters all work in a very similar manner, and many photographers consider one of these filters to be part of their standard equipment. While any of these filters will eliminate a certain amount of haze from the atmosphere and will reduce glare and reflections, their most beneficial use is to protect the coated surface of your lens from the harmful effects of water and dust.

IN YOUR BACK YARD

EQUIPMENT RECOMMENDATIONS

Camera

Closeup lens

Daylight-balanced film

Exposure meter

Lens cleaning kit

Portable reflector panel

Small jar of honey or sugar water

Spray bottle of water

Terrarium

Tripod

Your back yard may appear to be an expanse of grass, perhaps with a fence, some trees, shrubbery, and flowers. Now select a 10-foot (305-cm) square area of it. What activities go on there? What lives there? Think about the minute lifestyles of plants, insects, and small animals who, by the thousands, construct living spaces, find food, protect themselves from predators, and generate young at all times of year. In fact, spend some time in your back yard, with the idea that it is a universe in itself, inhabited by thousands of beings.

Exercise your visualization of scale during this project. Think of a clump of clover as an enormous area of shelter or a dewdrop as a watering pond for a small creature. Try to understand these lifestyles, imagine their cycle and place in relation to the larger world. This is one of many ways to learn to "see" close up.

Returning to an environment over a period of time to take pictures can offer a broad range of photographic opportunities. If you enjoy working with natural subjects, you might consider repeating this project in all seasons. Your pictures could encompass the first greenery in spring, the abundance of insects and small animals in summer, leaves in autumn, and ice formations in winter. Practicing your photography throughout the natural cycle of seasons can be a very refreshing experience, especially if the rest of your life's activities have drawn you far from the direct experience of nature. Part of the aim of this book, beyond teaching you the basics of closeup photography, is to stimulate your creativity by showing you how to rediscover the environments of your daily life and use your surroundings as a source of exciting imagery.

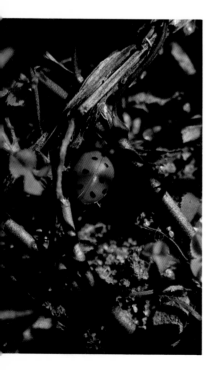

This minute landscape shows a ladybug moving among the twigs and plant life. A twig casts a shadow that falls on the ladybug's form. It is a problem to keep the photographer's shadow off the subject area when working at very close distances.

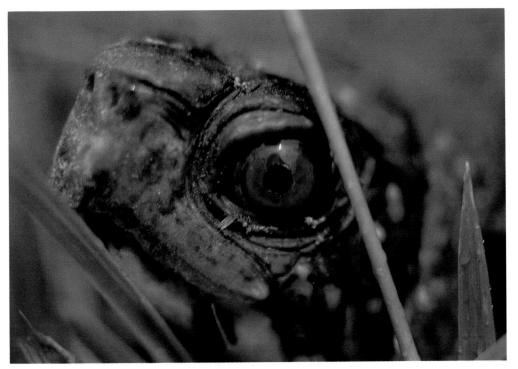

An eastern box turtle lumbers through the grass. In the scale of this back yard and its inhabitants, this turtle is an enormous beast, slow-moving and implacable. The photographer had to lay in the grass and hand-hold the camera at the turtle's eye level. Notice how the zone of sharpness is only a fraction of an inch in depth.

The shell of the turtle was moistened with water from the photographer's spray bottle to bring out the texture and color of the creature and to rinse off the dust it was covered with. This image is an example of one of nature's most intriguing survival efforts: protective coloring.

APPROACHING THE SUBJECT

The basic technique of closeup photography when subjects are fast-moving or spontaneous is to preset your exposure and then *move yourself and your camera and lens back and forth* to achieve sharp focus, rather than trying to turn the focusing ring. This may take some getting used to, but it is an essential technique. Practice a while before you actually shoot until you develop a sense of the decisive moment when the image is sharp. Brace yourself whenever possible to help guarantee sharpness, and try not to shoot at a shutter speed slower than $1/60$ sec.

Keep in mind that the extremely limited depth of field in closeup work requires you to stop down as much as possible. In your back yard on a sunny day, you ought to be able to shoot at $1/60$ sec. with apertures from $f/5.6$ to $f/11$, but remember, the smaller the lens aperture, the better the depth of field.

Use your depth-of-field preview button (if your camera has one) before each shot. It will show you where you have placed the area of sharp focus. Make sure to make effective use of sharp focus, and note that the background is also satisfactory before you shoot.

Try thinking of your pictures as *portraits*. Do they express the nature of the insect or animal? Look at the portrait of a turtle shown in this chapter, with a red eye staring at you half-hidden by blades of grass. Its sense of life and character can be likened to portraiture. Compose your pictures to show something about what your subject is like.

You could take the attitude that you are a photojournalist. Take an "establishing shot" that shows the overall environment, shots that set up a story or event, and shots that show details of the overall story.

A ladybug in the "passing lane" makes its way across a leaf. Guessing where flying insects will alight next is not easy, and it may take some swift maneuvering to catch such an insect at rest, but it can be done. After the ladybug landed on the plant, the photographer waited, composed the picture, and clicked the shutter when the insect emerged into the sun.

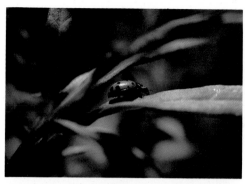

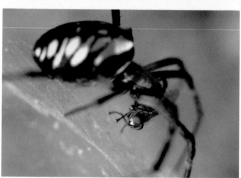

A spider eating a fly was one of the most dramatic incidents that occurred in an afternoon of close-up shooting. The spider, poised head down on its web, awaiting the tremors signaling captured prey, was the subject until a fly hit and the death drama ensued.

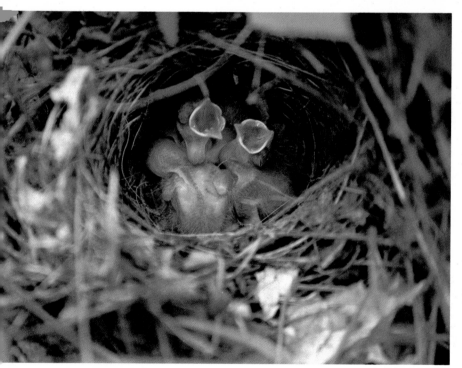

Fledgling birds in a nest show that no matter which way the photographer tried there was no possibility of obtaining enough depth of field. Without his flash unit, the photographer had to resort to a large lens opening to secure adequate hand-holdable exposures. Focus was very carefully placed on the wide open beaks for the best effect.

PROBLEMS AND SOLUTIONS

You may end up with unsharp pictures due to motion caused by wind. On any scale, motion combined with a slow shutter speed will cause blur. Try to choose a day with no wind, if possible; setting up a tent of barriers may not be sufficient to keep your subject still—and in some cases, it may be impractical. It may be more practical to trap your subject and move it to a more sheltered environment.

It is very difficult to get a picture of a fast-moving creature; one, for example, where an insect's wings are still and sharp, because the wings move at a speed faster than available shutter speeds for closeup work. One solution, shown in this chapter (where a bumble bee is feeding on yellow flowers), was that the photographer rose at dawn and was there before the bee woke up. The shot was made before the bee got its wings going.

The only other solution is to develop split-second timing, so that you can grab the shot while the insect rests for an instant. Look at the image of the dragonfly. It flew to a blade of grass, and after the photographer chased it from blade of grass to blade of grass for some time, he was finally able to get the picture. Patience is the better part of this solution!

Cooling a creature's environment may slow it down and make photography more practical. Placing it in a refrigerator for a few minutes might be helpful at times if the subject is a very active animal or insect.

If you shoot with your lens wide open, you may be disappointed later with the greatly limited depth of field this causes. Stop down as far as you can to extend the depth of field, but remember, in closeups the difference between wide open and stopped down when encountered as depth of field is a matter of fractions of an inch. Learn to place the zone of sharpness on an important line, area, or aspect of the picture, and keep the film plane parallel to the plane you wish to be sharp in the final image.

Look at the picture of the ladybug in this chapter. This was shot at the lens's widest aperture, which rendered most of the ladybug sharp—but nothing else in the image. Think of closeup depth of field as a narrow curtain of sharpness, and take care to place the area of focus appropriately in an image.

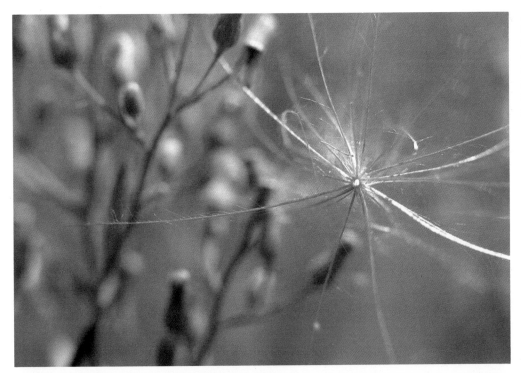

A flying seed pod caught in midair illustrates the adeptness the close-up photographer can achieve while learning to preset the lens and move himself and the camera back and forth for accurate focus, rather than remaining still and adjusting the lens.

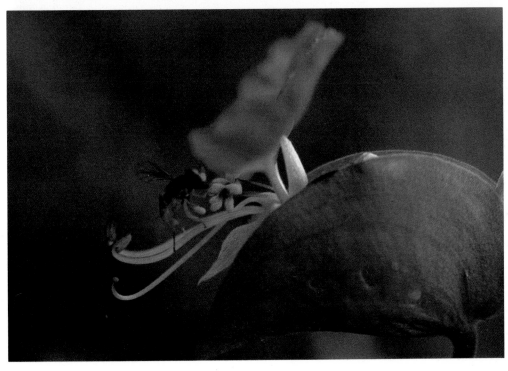

A bee feeding from a deadly night shade was shot very early in the morning. It was a breezy morning, and the blue blossom was never still, so the photographer composed a graceful image and made the best of difficult shooting conditions.

A dragonfly perched on a blade of grass necessitates quick shooting. Photographing swift-moving insects requires one of two approaches: either setting up a camera and tripod and waiting until a creature arrives within the subject area, or chasing the creature around with a hand-held camera. The latter approach was used, with a 55mm lens preset for rapid shooting.

The Red Admiral butterfly demonstrates that butterflies are quick and wary in warm weather so the photographer must be ready. An auto-winder was also used, allowing the photographer to shoot a rapid series of pictures at different angles and not disturb the insect while allowing the camera to be kept at the eye and not displaced as it would if manual film advance were used.

A grasshopper on a twig, highlighted by "natural spotlights" filtering through surrounding plants, suggested an angular composition, so the photographer waited until the insect arrived at a graphically successful point amid the branches.

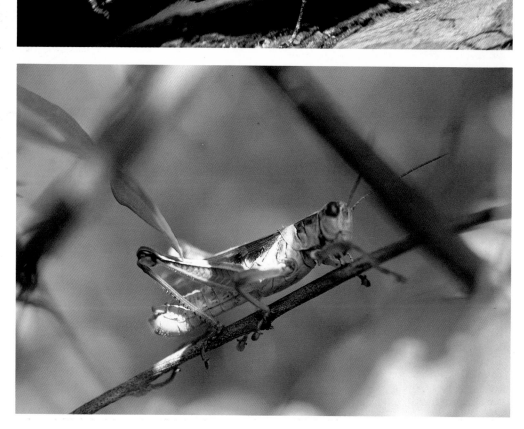

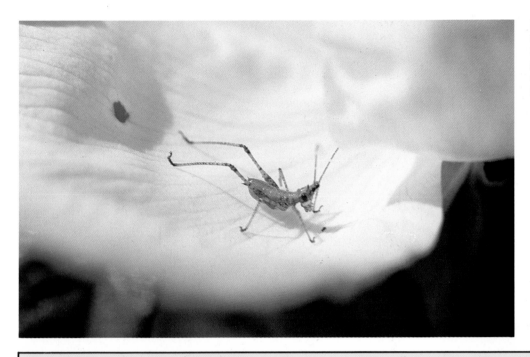

This insect on a white flower petal shows that sometimes when there are no obvious subjects, it is a good idea to wait, with the camera preset, near a particular flower until an insect comes along.

WORKING WITH A TERRARIUM FOR SMALL, LIVE CREATURES

Once you have caught your subject the next trick is to get it to stay where you want it while you photograph it. Glass pie plates and similar containers will do in a pinch, providing the glass is of sufficient quality to allow you to shoot through it and the walls are high enough to prevent the subject from jumping out.

Small terrariums or sets can be made for closeup subjects, and they will live in these mini landscapes quite happily until you have finished with them. A small aquarium tank is useful since it is open at the top but has high sides that prevent the subject getting out while you are shooting. Setting the glass container out in the sun for lighting is fine just as long as you make sure to watch the temperature inside the box. Insects don't seem to care how hot it gets, but you can cause small reptiles and mammals a lot of distress if you are thoughtless.

Another advantage of glass-sided containers is that you can fire your flash straight through the sides and so obtain almost any lighting angle you may require. Be careful if you are using a self-sensing automatic flash unit. Make sure that the sensing eye is close to the glass or at least angle it so that you cannot see a reflection of the flash in the glass, otherwise you may end up with an incorrect exposure. Tungsten lamps can be used with such containers; in fact a high-intensity desk lamp makes an excellent spot lamp. Remember, the same rules about heat apply to tungsten lamps as much as they do to sunlight with small creatures in enclosed spaces.

You can place your captured subject in a terrarium, or a glass container as shown here. The container should have a wide enough opening for you to photograph through.

As you can see, this is the perfect way to obtain closeup photographs of subjects that might prove uncooperative if not restrained.

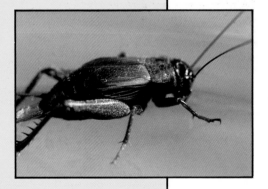

After many unsuccessful attempts at showing the delicate tracery of a bee's wings, the photographer finally realized that when an insect or animal is cold, it slows down. After waiting in an area where bees are usually found, the photographer succeeded in photographing a bee as it "woke up" in the morning before its wings got moving. Another way to do this is to catch a creature and chill it briefly in a refrigerator.

Dew on clover at dawn is one possible solution to working with low light, and relatively slow color film, without a flash. The photographer stooped until the dew drops were illuminated, establishing an effective contrast with the somber tones of the background.

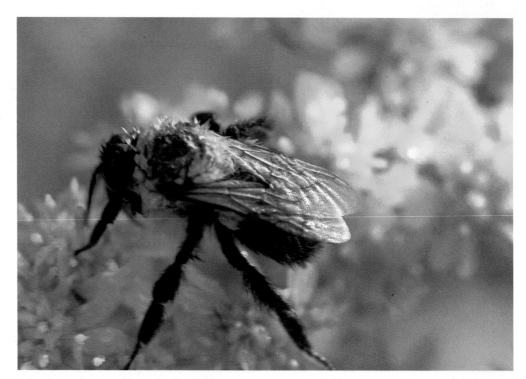

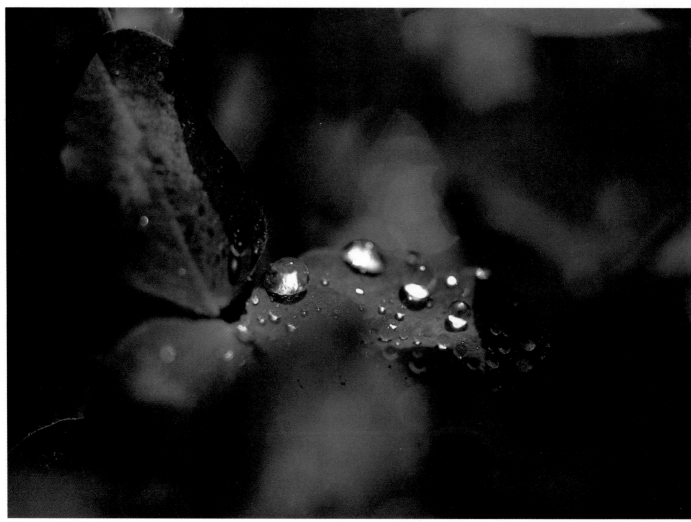

IN YOUR HOME

Home is a place we tend to take for granted. This project is designed to refresh your observation and help you record the elements that make your home a place of comfort, enjoyment, activity, or retreat.

Which corner or room do you enjoy most? What part of the exterior of your home most often catches your attention? Choose an area and study it through your camera. Study the materials or fabrics, the light at different times of day, colors, textures; look closely for the subtle details that endear this part of your home to you.

Spend a while just experiencing your favorite corner or room. Now think how you want to express the details of this familiar place: as a sequence of pictures or story? For instance, if what you really like best is the passing of light across a favorite object, you could show this as a series of images.

Or is it the color that attracts you? Decide how you can abstract parts of the colors to express your appreciation of the environment. Is it a single object? How is it made? What is it made of? How can you express these qualities in closeup photography?

Your approach may be to study an area and preplan a group of images, or you may prefer to just start, covering the area without any particular plan, letting your creativity lead the way.

It takes some time to learn to see closeups. They are easy to think of intellectually, but something quite different through the viewfinder. Try this experiment: think of a tiny area, imagine it as a photograph and then check it through your viewfinder. Is it what you expected?

EQUIPMENT RECOMMENDATIONS

Camera

Closeup lens

Daylight-balanced film (for window light)

Exposure meter

Flash

Reflector card

Tripod

Tungsten film (Type A and B)

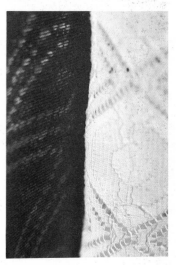

These three photographs represent the variety of images that can be found in one small area of a window. They show pure graphic interpretation of the contrasts of color, texture, depth, and form.

APPROACHING THE SUBJECT

There are many approaches you can use to help you see your home in a new way. After you've chosen a favorite area, draw an imaginary grid over it and document elements in the grid. Lighting approaches can be as varied as you like, both indoors and out. Try working with window light indoors or flash when ambient light is not sufficient.

Outdoors you might photograph the same details at different times of day. One particularly interesting effect is using flash at dusk. It will give you a sharp, crisply illuminated subject and often a misty background. Though many people think of flash alone as a light source, using it in combination with sunlight at any time of day can produce very effective, often mysterious-looking images.

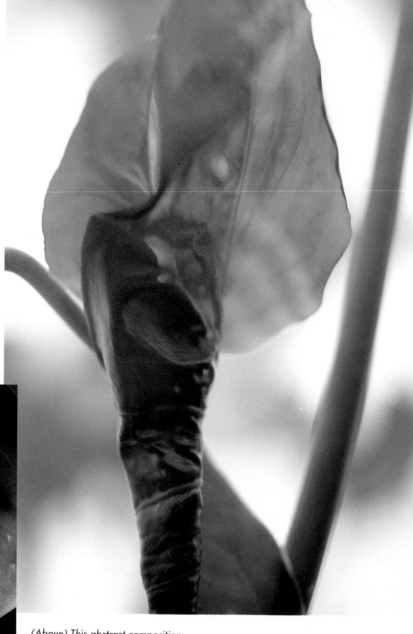

(Above) This abstract composition of a leaf about to unfurl shows the effects that can be obtained with successful backlighting. Notice how dimension is added to the leaf by the transmission of light through the more translucent areas.

(Left) This leaf silhouetted with rim light was photographed in the same window as the others, but was chosen for its background of shadow. Deliberate underexposure let the relative shadow of the room's interior go black for dramatic effect.

CORRECT EXPOSURE CALCULATION WITH BACKLIGHTING

Correct exposure with a 35mm camera is not difficult. In fact, with the inclusion of coupled and through-the-lens metering the camera automatically for the most part gets the exposure right. It's simply a matter of pointing the camera and letting the automatic or match needle system do its stuff. The difference between auto-exposure and manual metering with meters in cameras is as follows.

Automatic exposure systems in cameras are divided into three rough categories: aperture priority, where you select the lens aperture and the camera selects the shutter speed to match; shutter priority, where you select the shutter speed and the camera chooses the lens aperture; and, finally, full-program, where the camera selects both. Don't sneer at program automation. The camera makes much the same decisions as you would. Manual metering simply requires that you provide the driving force for both the lens aperture ring and the shutter speed dial.

Since meters in cameras are generally quite heavily biased toward the center of the screen, they will work quite well unless you present them with areas of uniform brightness or vice versa, hard side or backlit subjects, or areas where there are bright reflections and so on. Here applying a little thought to the metering is necessary. The simplest way is to meter normally and then bracket, if you have time; otherwise you have to look at a scene and make a few simple decisions: If the light is from behind the subject and you let the camera do the work, then the result will be at best a silhouette and at worst a compromise in which no part of the scene is properly exposed. The photographer should move in for a closeup reading and hold that reading by using the exposure lock on the camera, if it has one, or switching to manual metering to achieve the same result. If the camera has an exposure compensation control, judicious use will eliminate metering problems for tricky situations. Add on one or even two stops for backlit subjects and about one stop for sand and snow scenes. If all else fails, fool the camera's film speed dial; setting the ISO rating one number below the proper speed effectively deceives the camera into making an automatic exposure compensation since it believes it has a slower film. Do not forget to cancel exposure compensations, no matter how achieved, after you've used them.

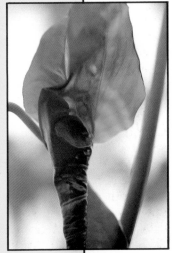

Both of the photographs shown here display excellent exposure for backlit subjects. The background is evenly balanced, and the subject is rendered in sharp detail. Notice that there is good use of transillumination as well. In the first photograph, the form is shown by light passing through the thinner areas of the plant, while the thicker areas are opaque.

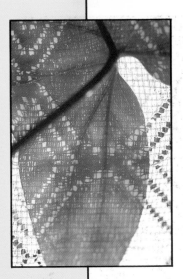

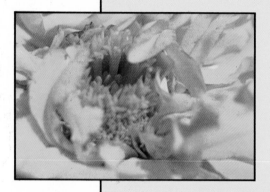

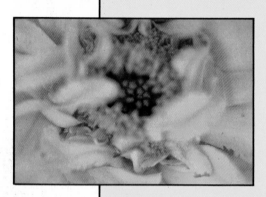

The color of light is quite different depending on the time of day. Notice the difference in the color of this flower. The first photograph was taken at midday, when the sun is very bright, while the second was taken in late afternoon.

UNDERSTANDING THE COLOR OF NATURAL LIGHT

To most people light is simply light. It is either bright or dim, and it is noticeable only by its presence or absence. To the photographer or the painter light is a living entity; it not only has intensity, it also has quality, angle, color, and texture. Look at the two photographs shown here. The first shows a marigold photographed at noon, and the second shows the same flower at the end of the day when natural light is "warmer."

Here we are dealing with the color of light, sometimes referred to as its "color temperature". Color temperature may be explained as follows. If you were to go out at daybreak but before the sun had risen and were to take pictures with daylight film, the pictures would tend to have a cold tint; that is, blue would predominate. Here's why. Daylight color film is balanced, that is, designed, to give its best color rendition at mean noon sunlight. At noon's bright sunlight the film reproduces colors at optimum accuracy. Before sunrise there is no balancing factor, that is, the sun itself, to supply enough red, orange, and yellow light to help the film produce a properly balanced color exposure. There is more blue in the light than there should be. So the pictures tend to have a blue "mood." Of course that is how the scene really is, so it is actually accurate as far as the eye is concerned.

As the sun appears over the horizon a reverse effect occurs. Pictures generally have a heavy red to orange cast. They are said to be "warm." This too is perfectly natural. As the sun climbs toward its zenith, pictures move toward what the film manufacturer considers to be the correct value. And at noon the scene arrives at the optimum color balance of the film.

PROBLEMS AND SOLUTIONS

A major problem in taking closeup pictures in and around your home is the availability of adequate or usable lighting. Indoors your home is probably lit by tungsten lamps, which are far from correctly balanced for almost any color film even if you use type A or B. Average domestic lamps are very warm in their light output and tend to induce an orange cast in a picture. Using an artificial light film improves matters considerably since it is biased toward blue to compensate for the lack of blue in lamps; even so it does not always meet requirements. Adding a fairly light blue filter can help balance the

film. Indeed if you are really concerned with color accuracy, you can buy many color-correcting filters that will help. The problem is that to really exploit such filters you need a color temperature meter. Type A tungsten film is balanced for 3400K. Type B tungsten film is balanced for approximately 3200K and is better for household lamps.

Probably the best light source is the electronic flash unit, which is, of course, daylight balanced and allows you to use daylight-balanced color film. But a word to the wise: if you are after faithful color reproduction, don't mix your light sources. For

example, don't mix daylight and/or electronic flash with tungsten lamps. Generally you get areas in the shot that have an orange tone when you mix lighting sources. However, you can mix daylight with flash and even, in some instances, with fluorescent lamps. You can mix photofloods with common light bulbs, although there will be some color inaccuracies.

Depending upon the size of the area to be photographed, flash is probably the easiest to use. It may be aimed directly, or it may be bounced. There are one or two electronic flash units designed to work with a flash head that has no reflector. This is called "bare bulb," and it produces a very soft, lifelike illumination with almost no shadow. Shooting closeups in your home with bounce flash is wasteful of light and battery energy if you bounce the flash off a ceiling. It's a good idea to make a false ceiling with a white card held a foot or so above the flash head. Some flash units offer an accessory that clips on the flash head and acts as a miniature white reflector. It's convenient, but you can make your own in a few minutes.

Outdoors there are few problems as far as lighting and choice of film are concerned. If it's bright enough for hand-held exposures and small lens apertures, then shoot as you normally would. For inaccessible corners or where you are using long bellows extensions or a long extension tube, you might find that you have to boost the light somewhat by using a crumpled aluminum foil reflector or even a flash unit.

Don't let the use of flash coupled with daylight worry you. If the camera and/or flash unit are automatic, they are quite capable of figuring the math out for you. If you don't have such equipment, it is really not difficult to figure out how to do it. Simply determine the exposure for, say, sunlight, and then set your flash unit to supply a little less exposure than the sunlight reading. To do this you may have to move the flash toward or away from the subject, since with manual flash the flash will generally let fly with all it has unless it has a power reduction dial. The use of a long flash synch cord makes this simpler; alternatively calculate the exposure for bounce and use a card reflector.

Remember that the flash-to-subject distance is the factor by which to figure the exposure. With bounce you measure the distance to the reflecting surface and then

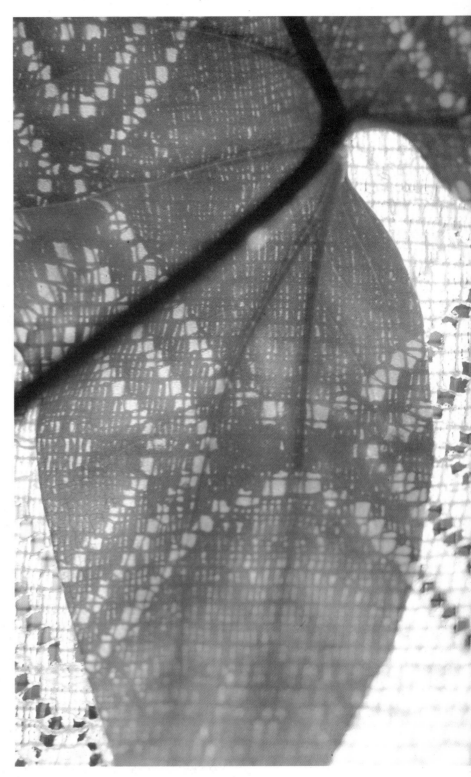

back to the subject. For example, let's say you are holding a white card 2 feet (61 cm) above the subject. If the flash is 2 feet from the card and aimed for bounce, the total distance would be 4 feet (122 cm). Divide that total distance into the manufacturer's stated guide number for the specific film you are using, and it will give you an approximate lens aperture to use.

The leaf of a flamingo plant pressed against a lacy curtain, backlit by natural morning light, becomes a lovely study in design, with the soft forms of the leaf contrasting with the geometric pattern in the curtain.

AT THE SUPERMARKET

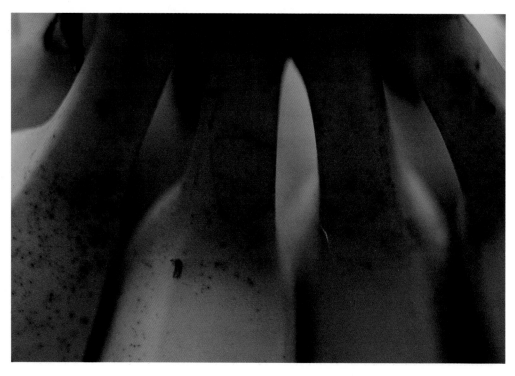

EQUIPMENT RECOMMENDATIONS

Camera

Closeup lens

Daylight-balanced film

Exposure meter

Extra batteries

Flash

FLD filter

Lens cleaning kit

Reflector card

Tungsten film (Type A and B)

Have you ever taken a picture in a supermarket? Why not? Though at first a supermarket may not seem the most photogenic environment, a creative approach can produce some striking images. Packaging predominates in a supermarket. Rarely do you find one of anything; more commonly, there are dozens or even hundreds of an item. Expressing repetition or pattern as design is one approach. Or parts of packages—abstracted details of labels or tins—can be exciting. Learn to see not only the one among the many, but aspects, details, and graphic elements in a single item.

Going into a supermarket—or many other stores, for that matter—will increase your awareness of an element in that environment that probably has only been subliminal before: the lighting. In order to make the items look appetizing, varying types and color temperatures of light are used in the supermarket, and in general the overall light level is kept to an economical minimum. Studying the differences in the lighting of various departments will sharpen your "eye" for light.

The graphic and abstract possibilities of fruit become apparent when viewed in abundance. The overhead banks of fluorescent lights add an eery, almost unnatural quality to the tops of this bunch of bananas.

APPROACHING THE SUBJECT

Find your favorite foods or products, and experiment with them as parts of a series. Pretend you're doing a picture for an advertisement. How can you make this product look terrific close-up? What parts of the product or package are interesting images in themselves? Try looking at products from a new perspective: look at them as an advertising photographer would. Then look at them with the eyes of an artist. Now find a unique way to express what only you see.

Taking closeups in a supermarket, or in any store for that matter, provides an opportunity to graphically render one of the most outstanding aspects of commercial centers: objects in quantity. The repeated use of some graphic element is a design concept called "using a motif." If after trying some closeups in the supermarket you find that the colors seem unsatisfactory, you can always take objects outdoors after you've purchased them and work in natural light. If you really like true, bright colors, this approach might work best for you.

Remember that taking photographs is not an activity commonly seen in supermarkets and other stores. Not only will the shoppers view your activities with quizzical eyes, but the staff of the establishment may become concerned. Speak to the manager before you begin, and assure him that your work is for your own personal creative purposes.

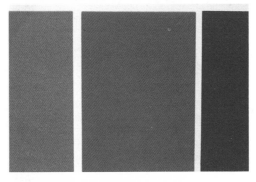

The logo of a cereal box becomes a graphic composition that extends beyond its original meaning. The colors, forms, and tight composition in the 35mm format make this an interesting series of abstractions. The package was taken outdoors into a bright environment for maximum color, unavailable under the supermarket's fluorescent lighting.

PHOTOGRAPHING IN FLUORESCENT LIGHT

Most people assume that fluorescent is the same as all other artificial light in that it is like light from domestic light bulbs. Not so. Fluorescent light is odd in that it is neither tungsten nor daylight, although it more nearly resembles daylight than tungsten. That's why daylight film should be used for fluorescent light. The results may be a little green as far as color film is concerned, but they will be more acceptable. The greenish tint may be removed or balanced out by using a special FLD filter, which is simply a dyed piece of glass specifically designed to straighten out the discrepancies in the light source.

Not all fluorescent lights are the same—even the so-called daylight type—so a little judicious experimentation is called for. If the fluorescents are proper daylight types, you may not even need an FLD filter. It is also a good idea to experiment with different brands or types of color film since some work better with fluorescent lamps than others. Above all try to avoid situations where there is a mixture of fluorescent and tungsten illumination, since one is bound to be right and the other wrong as far as color balance is concerned.

Bringing your subjects outdoors to be photographed in natural light will assure the retention of true, bright colors.

Photographing under fluorescent light will alter the colors of the subject in the final image to a certain extent. Notice the unnaturally dark red and the slightly green tinted white on this package.

PROBLEMS AND SOLUTIONS

Supermarkets are generally lit with banks of overhead fluorescent tubes. They are sometimes, but not often, the type that simulate daylight. Without a color meter it is quite difficult to tell which type of tube is used, so you have to rely on guesstimation.

All fluorescent lamps produce a slight greenish cast with color film. So if you are shooting color, you should use daylight-balanced film. If your shots still take on a greenish cast, it's up to you to decide whether it's acceptable.

Determining exposure is largely the same as when shooting outdoors. Fluorescent lamps do have one advantage: they produce a virtually shadowless light so it is unlikely that you'll find harsh lighting contrasts.

It is advisable to take careful note of the quality of light around the meat and fruit counters. The tubes are pinkish to make the meat and produce look better. Such lighting will warm up color shots, and again, it's up to you to decide whether such effects are pleasing. If you feel that the lighting is too warm, you can cool it down with a light blue filter, but here you should certainly experiment with and without the filter. You might want to take your electronic flash with you. The store manager might give you funny looks, but then, photographers are considered to be slightly crazy.

Moving in for an extremely close view will render the most common objects unrecognizable, as is the case with this photograph of a portion of a coffee can.

A very small area of the label of a can of baking soda, greatly magnified, becomes an abstract picture, no longer retaining any identity as part of the original product.

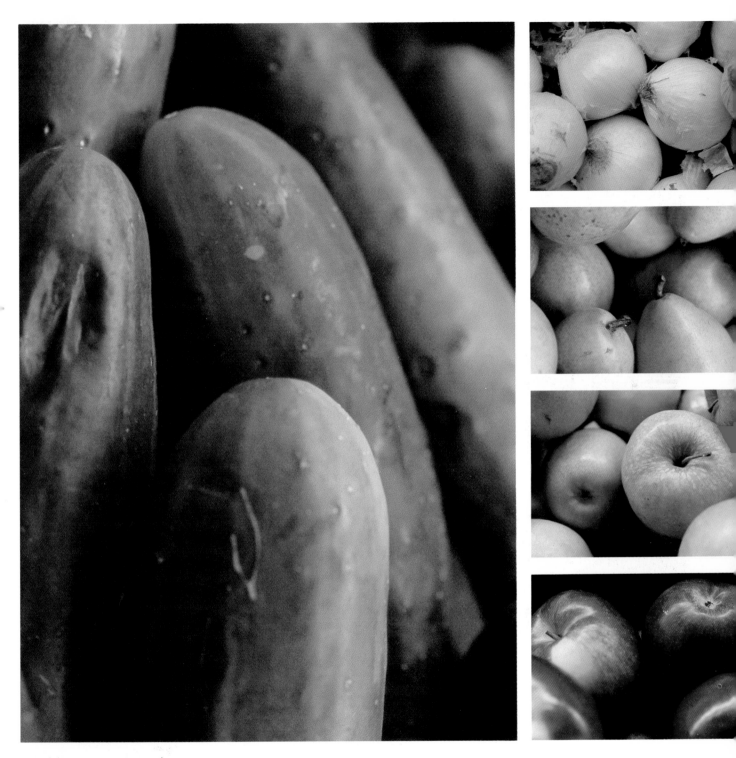

One of the most interesting results of an afternoon spent photographing in a supermarket is this series of studies of the repetitive patterns and structural formations of large groups of fruits and vegetables.

PARTS OF CARS

EQUIPMENT RECOMMENDATIONS

Camera

Closeup lens

Daylight-balanced film

Dulling spray

Exposure meter

Extra batteries

Flash

Lens cleaning kit

Reflector card

Tripod

UV filter

Cars and trucks are complex, complete machines. Equipped with a camera and closeup equipment, we can approach them as rich sources of closeup photographs.

What *materials* is your car made of? Investigate the chrome, bare and painted metal, glass, and plastic. What about its *surfaces?* And what are the *parts* of the whole? Can you express a series of parts that perform a role through closeup photographs?

How far can you abstract details from your car or truck while maintaining good image quality? Try a series of images, each successively more distant from the identity of the object, until you have some that you find visually interesting, though they no longer bear any resemblance to the original. This is a visualization process that will enhance your photographic seeing. Much of what underlies the process of subject selection is that ability to *see* parts of the real world that are inherently attractive, to isolate and record them for their own value—not their value as part of a total environment. Closeup photography relies on taking this process of selection as far as you possibly can.

Photographing your car with closeup techniques is a good opportunity to study the properties of manufactured materials in natural light. You will learn how to overcome problems of glare—for example, off shiny surfaces—by changing your angle of view. You will find images that express not only parts of your car, but a new understanding of a familiar everyday machine. This attitude can lead you to discover imagery in the workings of any machine you use.

Because we are so accustomed to viewing a car as a single object, studying how it is made offers some opportunities for highly abstract, intriguing imagery. Making the effort to isolate small details from a car or any other machine can be a valuable exercise in expanding your ability to "see" photographically. The visual artist develops this skill cumulatively, through each successive experience of approaching a subject or concept in visual terms. The more effort you make to stretch and refine your visual skills, the more skillful you become as a photographer in all situations. Musicians practice scales; photographers practice "seeing."

When viewed in closeup, even a recognizable subject can create an image of pure graphic impact. Notice how the letters of this license plate become a study in three-dimensional form when shown from extremely close range.

APPROACHING THE SUBJECT

A car is a car is a car, right? Right. But, on the other hand, cars and trucks, so much a part of life that we hardly give them a second glance, are certainly worth a second glance from a photographic point of view. We are not talking about the glossy brochure-type pictures that are designed to lure you into the showroom, but a more analytical look aimed at finding interesting, even abstract representations.

It's a good idea to start by photographing the entire vehicle. A few establishing shots help lead off a collection of pictures and help the viewer orient him- or herself visually.

Try to figure out what the salient features of each vehicle are—its "signatures" as it were. Come in close for detail and try to isolate that detail by judicious use of depth of field for emphasis. Depth of field works both ways with this type of photography. Obviously automobiles and trucks are highly dimensional—that is, they are *not* flat. Increasing the depth of field allows you to select a specific area and have most of it pin sharp. If you cannot have it all, then think of the finished picture. What will be the first point in the image that meets your eye? If you opt for a larger lens opening and its subsequent limited depth of field, you will be able to emphasize exactly what you want and let the out-of-focus areas lead into or away from that point.

Decals and insignia make for interesting graphics. Closeup shots of grilles, chromework, even wheels also produce impact-laden shots. If you can open the hood and shoot the engine, so much the better. You should figuratively dissect the vehicle with your eye, working from closeup to macro as more and more details appear to you.

What is imperfect about your car may be a source of terrific images, just as much as that which is sparkling new. Is your car old and prone to rust? Take another look at the rust, and notice the colors and textures in it.

Many cars today have dashboard lights designed with such a high-tech look that they give the appearance of a space capsule. Imagine that you had to produce pictures of the driver's controls for an advertisement—how would you photograph them?

Not only cars, but trucks, motorcycles, and even large vehicles such as firetrucks can offer a collection of unique closeup images. Try this project with a number of vehicles, looking for the small areas of each that are visually stimulating.

Abstracting an object from its normal surroundings can lead to many different interpretations of everyday subjects. These dashboard knobs create an interesting composition of shapes and colors.

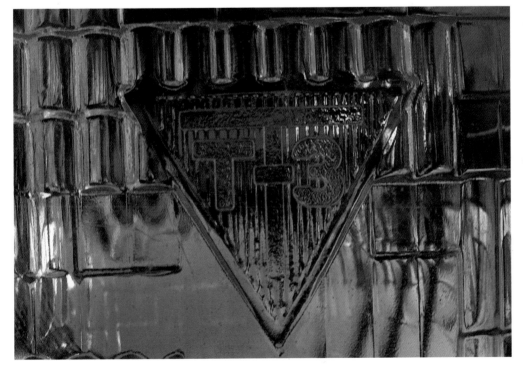

The center of a headlight on the same car is a basically monochromatic image, interesting because of how the object's own design is used compositionally with emphasis on its surface and reflectance.

Four graphic compositions explore parts of the vent on the sides of the car. The photographer moved the angle of view slightly to change the pattern and amount of shadow area. This series illustrates the form of motion through design.

(Opposite page) A closeup view of a tail light reflector offers a strong geometric and color composition.

PROBLEMS AND SOLUTIONS

The biggest problem with photographing motor vehicles, and most other kinds of machinery, is that they are usually shiny and thus highly reflective. A polarizing filter will help remove unwanted reflections from glass, and metal painted surfaces, but will not remove direct reflections from any shiny surface. For these areas you will have to move around while looking through the viewfinder to obtain an angle that presents the least glare. Use your flash unit to bounce light into dark areas and to even out the lighting. A reflector card or crumpled piece of aluminum foil can also help here.

If you can't eliminate the reflection entirely, this is a good opportunity to learn how to use reflections effectively. What was once a problem can become part of the solution. The reflection of metal is one of the inherent properties of an automobile, and can become an attractive graphic element in your photographs. Choose your angle of view so that the reflection does not obscure your subject entirely, but rather enhances and makes a statement about the subject. Let the reflection define the object you are photographing.

Whether you are using a hand-held exposure meter or have through-the-lens metering, you should choose your exposure with care. Reflected light can deceive your meter, so it is a good idea to bracket your exposures for safety's sake.

You might consider working with filters for variety in color, or to emphasize colors in the details you are photographing.

Don't forget the interior of your car—the materials used there, and small details such as door locks and moldings can also be a source of highly graphic imagery. You will probably need to use a flash working inside your car, so make sure you set it correctly, and use a reflector when possible.

If you happen to attend a show of antique cars or machinery, you can try a new version of this project. Much has changed in the continual updating of our motor vehicles and you can document this as part of a theme.

Another element of cars that can provide unusual images is license plates. Since many states allow people to request their own combination of letters and numbers, many vehicles have interesting, and often funny, license plates.

IN A MARSHLAND

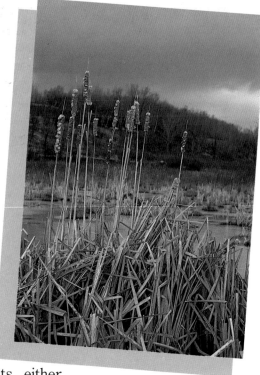

EQUIPMENT RECOMMENDATIONS

Camera

Closeup lens

Daylight-balanced film

Exposure meter

Extra batteries

Flash

Insect repellent

Polarizing filter

Small containers

Telephoto lens

Terrarium or glass bottomed container

Tripod

UV filter

Water-repellent boots

(Right) Water lilies make good closeup subjects, especially the tropical species. The picture was made using a telephoto lens with a short extension tube for larger image reproduction ratios. The bee just happened by. Lighting was by low-angle sunlight, and a polarizing filter was used to help clean up the colors and eliminate most of the reflections off the wet lily pads.

(Opposite page) This picture of a water lily is the best of three shot in a sequential bracket around the base exposure. The meter will normally take the darker green leaves into account when determining exposure, causing the detail in the pure white flower to be lost. This shot was taken at one full stop under what the meter registered.

Marsh areas, be they fresh or salt water, offer the photographer almost limitless picture possibilities. For anyone specializing in closeup work they offer an endless feast for the camera. Water plants naturally grow in or close to water so a marshlike environment can usually be found in a park or a botanical garden if you live in a city. Such environments, either natural or artificially created, soon draw insects and creatures that enjoy wet environments, and large dragonflies, for example, may be seen even in the heart of a city. Water birds are generally shy and you may need to travel out of town to photograph them. No matter which marsh area you choose, it's a good idea to take plenty of film along with you.

Too many people—even photographers—have a habitual level of view that they never think to change. So while you're out at a marsh, or anywhere for that matter, seek out images *above and below eye level.* Look for nests in trees and tracks on the ground, among other subjects.

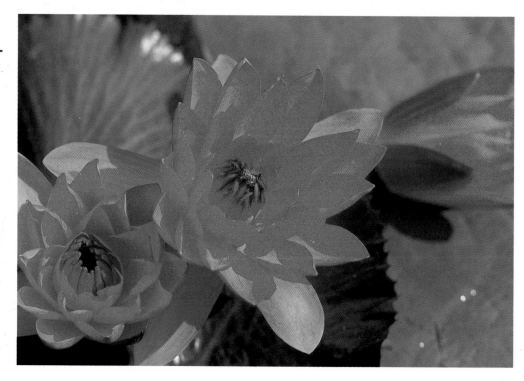

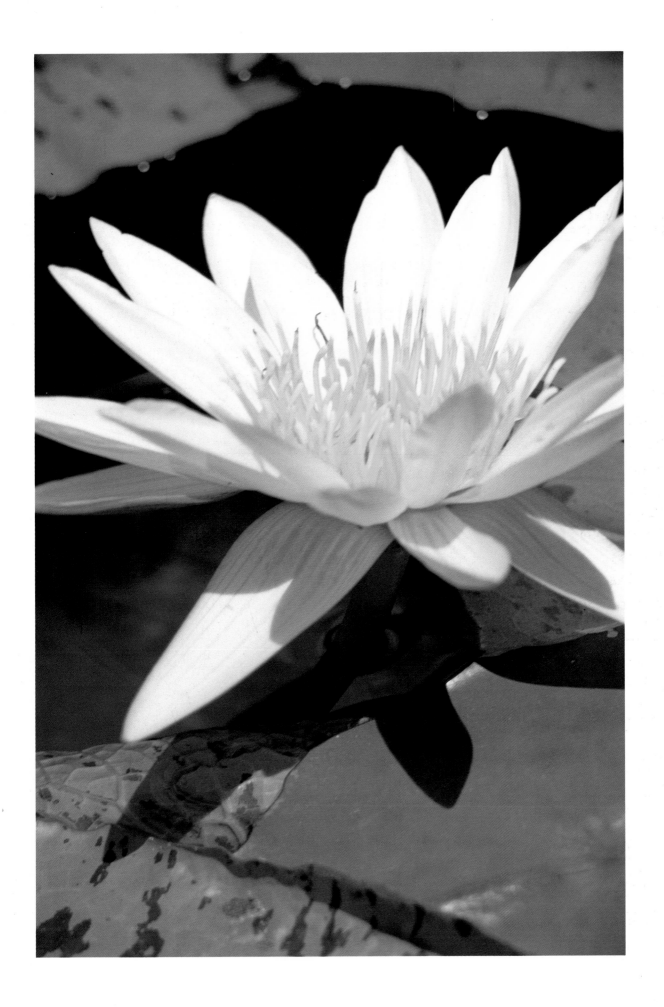

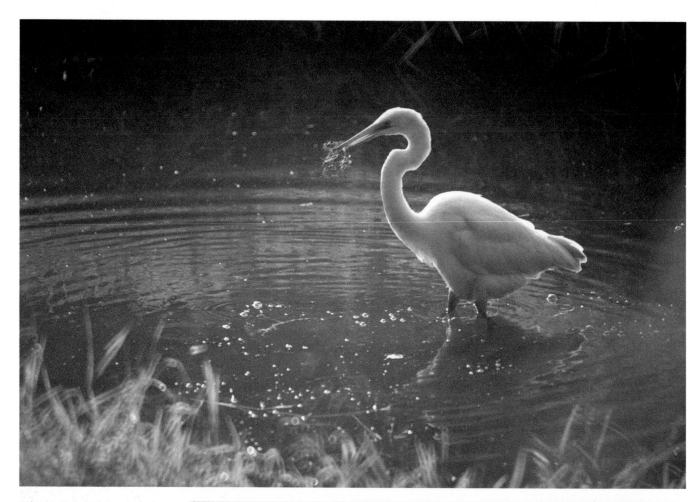

(Above) A closeup does not always have to be the extreme enlargement of a small detail. This photograph was taken with a 1000mm mirror super telephoto used at its closest point of focus. The essential element for successful wildlife photography is patience and stillness. Backlighting was employed to get the sparkle around the egret as it quietly fished a few feet from the photographer's makeshift blind. The out-of-focus weeds in the foreground are deliberate to draw the eye to the subject.

(Right) This photograph of a dragonfly nymph casing has a 1:1 image ratio, taken with a 100mm macro lens and available light. Depth of field is extremely limited, and the photographer should focus carefully and to best effect. Flash could have been used, of course, or in the case of this subject there would be no harm in taking it home and setting it up in more controlled circumstances.

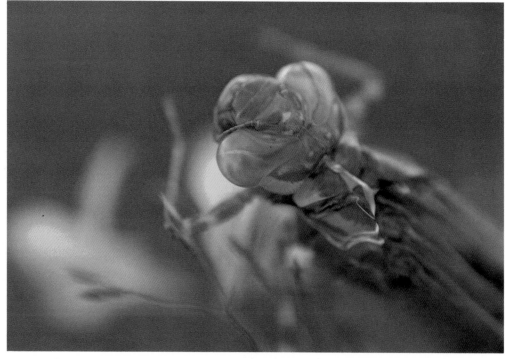

APPROACHING THE SUBJECT

It's a fact of life that the most interesting specimens in a marsh will generally be beyond your reach and growing in several feet of water. But there are ways to approach such subjects and obtain large images of comparatively small subjects without having to wade in the water with a camera. Here a medium to long telephoto lens with a short extension tube behind it will provide you with a closeup lens of enormous reach. Indeed the shots of water lilies used in this section were shot using such a technique. The lens was a 300mm telephoto lens with a short extension tube between it and the camera, and it behaved splendidly.

Photographing marshland birds requires a bit of skill and a lot of patience. Herons and egrets, for instance, have sharp eyes and easily detect the slightest movement. Cutting a few leafy branches to screen yourself works well. Once ensconced in your hiding place, be still and patient.

Very close shots of insects that visit marshland flowers are not at all difficult; once again, it requires patience. Dragonflies spend half their lives underwater, emerging eventually from the nymph stage to take wing. If you can find a newly emerged nymph clinging to a water plant, sit and wait as it begins to hatch.

A tripod is useful in most of these circumstances and, as long as you do not exceed its operating range, there is no reason why you cannot use your electronic flash unit if daylight is insufficient or you wish to try for action-stopping speeds beyond those that the light allows.

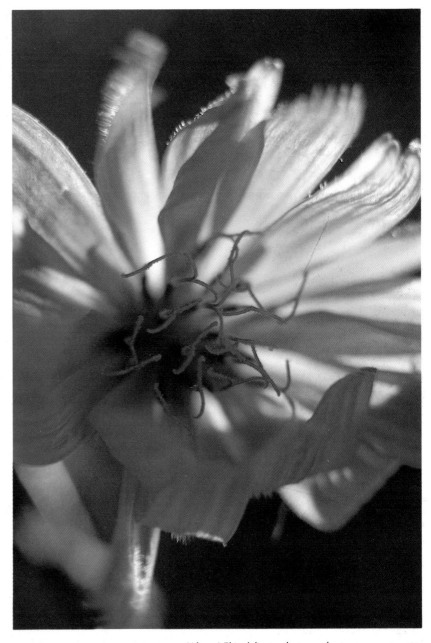

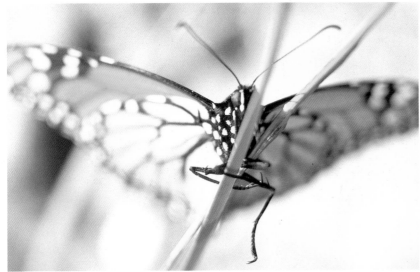

(Above) This delicate photograph shows excellent use of natural backlighting to create a gentle rim light and translucence through the flower petals while the center remains visible through silhouette.

(Left) Limited depth of field can be used effectively to draw attention to certain areas of the subject. For example, tight focus is held on the body and legs of this butterfly to show clearly how it is clinging to the blade of grass. The wings, while thrown out of focus, are still a strong recognizable element.

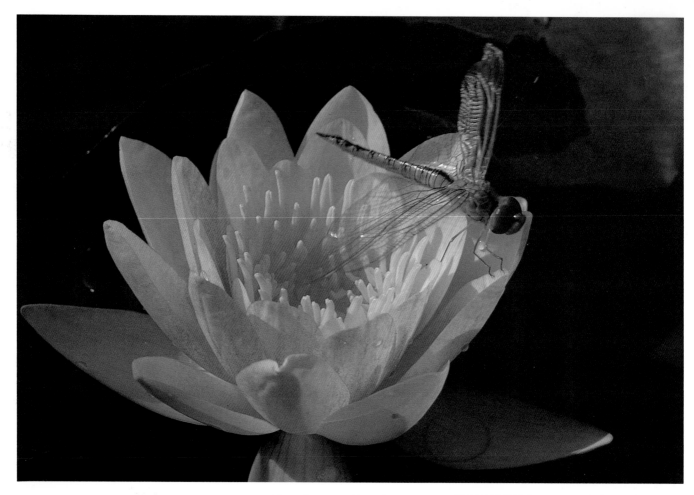

This yellow water lily with dragon-fly is lit with fairly strong backlight to emphasize the texture and color of the flower. A polarizer was used to help saturate the colors and remove reflections from the leaves, allowing the flower to stand out in the picture. Despite the use of an extension tube, a small lens aperture was available, offering excellent control over depth of field.

PROBLEMS AND SOLUTIONS

The problem with all wildlife photography is that the subjects are seldom cooperative and often unreliable as far as being where you want them when you want them.

Birds generally have quite set routines for feeding, and this requires a bit of detective work on your part. The white egret shown in this section was eventually photographed after three days of waiting. Insects get more and more active as the day warms up, so try to catch them early.

One final point concerning problems—take a good insect repellent along. Marshes breed mosquitoes and biting flies, and if you are to be quiet and comfortable, you don't need to be eaten alive.

Flowers and plants are no big problem, but it is useful to keep an eye on flower buds so as to catch the opening flower at its peak. If you want a bit of sparkle on your flower shots, splash some water over the plant—or arrive just after dawn when the dew is still on its petals. You could take a spray bottle with you to have it handy as needed.

IN YOUR REFRIGERATOR

Think for a second about the contents of your refrigerator—fruits, vegetables, ice cubes, milk, eggs, meat, butter. There are many items that, if used creatively, can provide unusual closeup images. You can set up still-life arrangements of your favorite foods or even photograph closeups that look like advertisements for a product.

The average refrigerator, whether sparse in content or a well-stocked larder, contains a wide variety of shapes, sizes, textures, and colors. Take the simplicity of an egg, with its pristine white surface. Now crack it open—you immediately have a sharp, jagged edge encircling a bright yellow yolk. Indeed, eggs, with their attractive oval shape, will provide many photographic opportunities for experimentation with still-life arrangement and lighting techniques. Think of products that can change from solid to liquid state, or vice versa. An ice cube will melt rapidly into unusual shapes—so will a stick of butter.

Now look at the different types of fruits and vegetables you have—from apples, pears, peaches, and oranges to peppers, tomatoes, and onions. Cut them open, photograph closeups of their seeds and fleshy centers. Think of the sensual qualities of food and express them in your photographs.

EQUIPMENT RECOMMENDATIONS

Camera

Closeup lens

Exposure meter

Extra batteries

Flash

Lens cleaning kit

Light box

Photolamps (3400K)

Polarizing filter

Reflector card

Spray bottle of water

Tabletop set

Table tripod

Tripod

Tungsten film (Type A)

The garlic and gold thread were photographed in the kitchen in a tabletop set built with a large sheet of white paper, curved to form a seamless background, taped to the kitchen counter and a cabinet door above. One photolamp was used, affixed to the cabinet door so that the light fell from above and slightly to the right of center of the garlic. A shadow was desired to give weight and substance, but a second light could have been used to photograph the garlic with no shadow at all.

APPROACHING THE SUBJECT

Many a commonplace object will display a totally different aspect of itself if the inquiring closeup photographer takes the time to actually see rather than look cursorily at the object. Try an experiment. Take an ordinary cabbage and cut it cleanly in half. Now look at the spiral structure of one of the halves. The spirals photographed close up reveal a totally different way of seeing a common vegetable. Or make a very thin slice of the cabbage and illuminate it from behind (stick it on a window in the sun if you like) and shoot it transilluminated. You can use any of the contents of your vegetable crisper if you like.

Strong side lighting changes the way an object looks. Use a flash for easy shooting. What does a closeup shot of the end of a handful of dry spaghetti resemble when taken out of context? Perfectly ordinary objects take on a mysterious air when shot without any visual reference and scale.

(Top) The skins of fruits and vegetables offer a variety of unusually textured surfaces for abstract closeup images. Notice how the photographer has sprayed the surface of this eggplant with water to add further interest to the photograph.

PROBLEMS AND SOLUTIONS

The average domestic refrigerator can be a bountiful source of closeup subjects on a rainy day when you don't feel like going into the field. Take the ordinary egg, for example. Eggs are quite tricky to photograph so that you end up with a picture that has dimension and does not look like a flattened oval on a surface. Lighting is the key to dimensionality. If you light your subjects carefully, you can achieve a three-dimensional effect in a flat medium.

How do you light such objects? A good small lighting unit is a high-intensity Tensor desk lamp. It has an angled arm that allows you to move the lamp into almost any position around the subject, and it puts out a very bright light for closeup work. The film in the camera, if it isn't black-and-white, should be Type B color film balanced for tungsten light. Experiment by moving your subject in relation to the light source. You will see, either by observation or by looking through the camera, just what strong side lighting as opposed to full flat lighting can do. If the shadows are too harsh on one side—remember that color film is not very tolerant of wide lighting contrasts—use a white card close to but outside the angle of view of the lens to modify the shadow.

If you are using a flash, then you should position the flash head as close to the work light as you can. Turn on the lamp to com-pose and light the shot, and when you have the lighting to your satisfaction, turn off the lamp and shoot with your flash. Don't forget to use a daylight-balanced color film for the flash if you are shooting in color. If you like, you can use a colored card as a background, but bear in mind that any colored surface with light bouncing off it may tint the light that hits the subject. Light bounced off a red card, for example, will give you a red- or pink-tinted egg.

Ice cubes out of the freezer can be quite tricky to photograph because ice melts. You must work quickly or you might find that your subject is changing rapidly before your eyes and might be a puddle before you get a shot of it. Try illuminating a stack or a jumble of ice cubes from below. You can stack them on a clear glass plate if you are worried about a mess. Photograph with the flash directly under the plate, but be sure not to get any water on a flash head or on a tungsten lamp for that matter. Getting water into a flash may cause it to blow up or give you a nasty shock. Water dripping onto a hot light bulb will cause it to explode in short order.

Exposure for such shots is best done by bracketing and then filing the information for future reference. If you have a hand-held meter or flash meter, make sure it is reading the entire scope of dark and light areas.

Fruit on a plate creates color and design when placed below a photolamp directly over one side of a tabletop set, composed of two white cardboard panels joined at a 90-degree angle. White paper is used as the floor of the set, so that light is bounced up to fill in bottom areas. Depth of field is given a directional aspect, as the area of sharp focus is placed where the three pieces of fruit meet. The line of the edge of the banana leads the eye into the area of sharp focus.

47

The photographs at left demonstrate how a tabletop set can be made to simulate studio techniques on a small scale. White cardboard is utilized to create a neutral, reflective environment. Setting up still lifes for closeup photography in this manner offers the photographer complete control over lighting conditions.

WORKING WITH A SINGLE PHOTO LAMP

Many photographers rely on the convenience of flash units to supplement lighting in their images. Though flash is certainly a good choice, it does not give the photographer as much control in modeling lighting effects as the use of photolamps. With lights that you arrange, you more or less "paint" your subject with illumination, and you can make adjustments to perfect your picture that you cannot do during the split-second burst of light a flash unit emits.

Since light bounces off everything in its path, and can absorb a color cast in the process, this set-up included a white cardboard background, white paper under the set-up, and a white plate on which the vegetables were placed. This kept the artificial lighting brilliant and untinted.

When setting up a tabletop closeup project, consider all the surfaces in the environment as use their reflectivity as best as you can for perfect illumination.

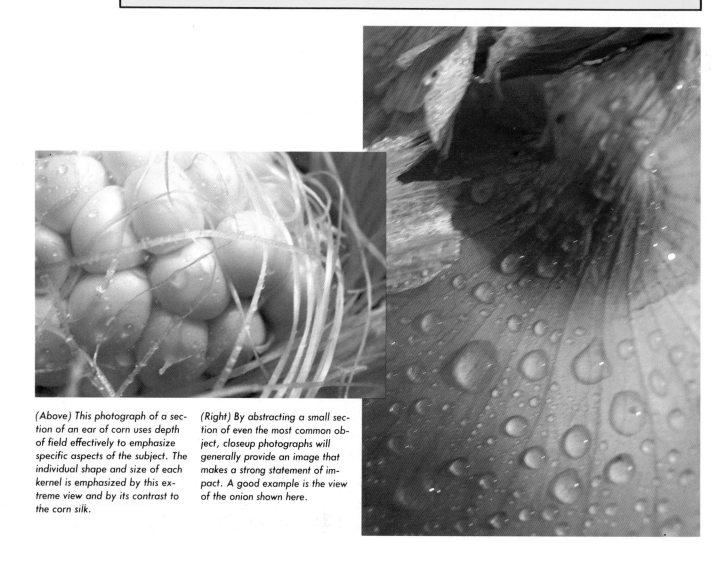

(Above) This photograph of a section of an ear of corn uses depth of field effectively to emphasize specific aspects of the subject. The individual shape and size of each kernel is emphasized by this extreme view and by its contrast to the corn silk.

(Right) By abstracting a small section of even the most common object, closeup photographs will generally provide an image that makes a strong statement of impact. A good example is the view of the onion shown here.

(Left) Using subjects from the refrigerator does not limit a photographer to mere still lifes. This photograph of milk being poured into a glass employs skillful use of a tripod and proper setup of artificial lighting for a well-controlled shutter speed.

(Right) A hardboiled egg with its shell broken is another example of an abstract image derived from an ordinary object. One photolamp, suspended above the egg, lights the upper portion of the image, and bounced light from the white cardboard set fills in the lower portion enough to suggest the shape and identity of the image. Seen close up, the texture of the eggshell and the tracery of the cracks become major elements in the picture.

A COLOR THEME

EQUIPMENT RECOMMENDATIONS

Camera

Closeup lens

Daylight balanced film

Dulling spray

Exposure meter

Extra batteries

Lens cleaning kit

Polarizing filter

Reflector card

Tungsten film (Type A and B)

UV Filter

The most important point to keep in mind when photographing a color theme is that one color should always be present in the same tone. This closeup view of the stripes of the American flag shown above contains the secondary element of white stripes, but it is the color red that makes the statement.

Selecting one color, or a group of concordant colors, can become a self-assignment that will give you a sharper eye. Take a moment to look around you at everything that is red. Keep looking at all the varieties of red that are within visual reach. Now look for blue in all of its manifestations.

Already you've discovered something new about your environment, and this discovery is a legitimate photographic theme. This project uses a red concept, but you can apply the idea to any color or group of colors. Keep this in mind both indoors and out. A collection of closeup images based on one color can become a striking wall display.

Also keep this concept in mind to cure an occasional bout of "photographer's block"—if there should ever arise a time when nothing visual seems to excite you. It may begin as a conscious exercise, but it will soon free your creativity, and you may be surprised at the quality of the images you make.

APPROACHING THE SUBJECT

The basic approach of the project is quite simple: choose a color and photograph closeups of it. You may quickly become aware that a given color actually encompasses a wide range of hues. This project can refine your color sense in the way a painter refines his by mixing and remixing color variations.

Seek out texture in your images. It would hardly be satisfying to photograph pieces of colored paper. However, with strong sidelighting, even the texture of a piece of paper may become a suitable subject. Photograph your color theme indoors and out.

Look for lighting variations, and use your full range of lighting techniques to make the most of a single color theme. Some objects are most beautiful when transilluminated by a light source behind them. Others may be made more attractive with back lighting that causes a halo. For others, toplighting or direct frontal light will make the most successful image.

Other variations on this project that you might consider are to discover a color you have not liked; to use a team of colors such as red, white, and blue or red and black; or to photograph black and white on color film. You may be surprised at the tones and hues in "black" or "white."

(Above and left) These photographs show how the same subject can be photographed in different ways while still expressing a color statement. At left, a piece of grosgrain ribbon is suspended in front of a red plastic tabletop set and illuminated with a photolamp placed behind the background, producing a graphic image of red and black. Some light passing through the thinner areas of the ribbon emphasizes its texture. In the photograph above, the same piece of ribbon is illuminated from above, with a piece of blue ribbon added to create a linear design.

The diagrams at left represent a photographic image shown as a series of lines. Notice in the first diagram how the lines move in a definite direction, leading the eye toward the center of the flower. In the second diagram, we move in closer to the center of the flower, where the lines begin to converge and create a sense of countermotion.

MOTION AND COUNTER-MOTION IN AN IMAGE

If you analyze the rose shown here and other examples shown in Adventure 11 and consider what lines you would need to sketch these images, you begin to see that these images are based on lines that seem to move. They describe what is called a "vortex." This sense of *motion* through lines is an important aspect of composition. So are variations and other elements that create contrast, called "counter motion." Notice that in the photograph of the rose there is a spiral that is essentially the structure of the heart of a rose in its simplest visual form.

Look for lines that suggest visual motion and counter motion. They add excitement to an image.

Using tungsten film outdoors can alter the color of your photographs in a pleasing way. The first photograph shown here was taken under normal conditions with daylight-balanced film. The second photograph was taken with tungsten film and has much warmer tones.

WHAT HAPPENS IF YOU USE TUNGSTEN FILM OUTDOORS

Just an additional comment about the color of the light and color film. You use a daylight-balanced film in daylight and a tungsten-balanced film (type A and B) in artificial light such as household lamps and photofloods.

If you were to load your camera with the wrong film, the following would occur: Daylight film used under tungsten light would appear orange. Why? Because there is very little blue in such lights. Solution? Use a tungsten-type film (type A or type B depending on the color temperature of your light source) in tungsten lighting situations. Why is a type A or type B film different? Simple, type B has more blue bias in its emulsion to compensate for the lack of blue in the light. What happens if you use a type B film in daylight? Your pictures turn blue! Can you adapt daylight film to artificial light? Yes, by adding a blue filter. Is it a good idea? Not really. Filters reduce the speed of the film.

Can you use a type A or B film in daylight? Yes, by adding an orangy/red filter to the lens. Is this a viable alternative? Yes, because although filters reduce the speed of a film, it's brighter in the daylight than in artificial light so you can get away with it. On the whole though, it's best to use the right film for the job.

PROBLEMS AND SOLUTIONS

Working on the principal that less is often more, your pictures that feature a strong single primary color can be powerful and effective. An example is a red rose isolated from its surroundings or a huge yellow sunflower staring at you with a demanding directness. Single color themes work because other colors are eliminated. However, you are not going to be able to eliminate tints,

they are part of any primary color in nature. On the other hand, by careful framing and even by using a neutral background, you can get some spectacular results.

For color saturation use your polarizing filter. If you wish to increase the effect of a particular color, try using a colored filter to enhance the effect. But don't overdo it—you still want to retain a natural tone.

Color can be combined with other elements in a photograph with striking success. Here, the textural design of weathered wood is enhanced by graphic addition of red paint.

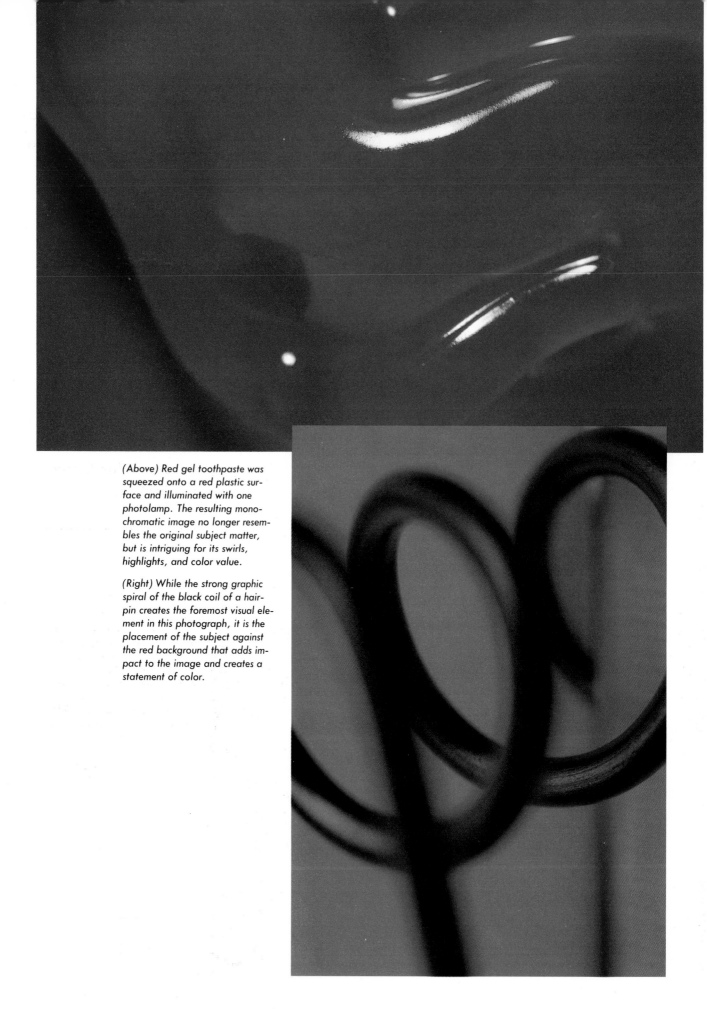

(Above) Red gel toothpaste was squeezed onto a red plastic surface and illuminated with one photolamp. The resulting monochromatic image no longer resembles the original subject matter, but is intriguing for its swirls, highlights, and color value.

(Right) While the strong graphic spiral of the black coil of a hairpin creates the foremost visual element in this photograph, it is the placement of the subject against the red background that adds impact to the image and creates a statement of color.

NOSE TO NOSE WITH PETS

In most households a pet is as much a member of the family as the human beings. Think about your pets and those of your friends, why do we find them so attractive as companions? We enjoy their physical characteristics, admire their activities, and are fascinated by their different lifestyles and manners. What is characteristic of cats and dogs that could make an effective closeup? The examples shown here suggest some ideas for you to try with your own pets. Try photographing their eyes, noses, tongues, and paws close-up. It isn't easy, as you'll soon see—pets rarely pose for any length of time without squirming or leaving the scene entirely. But with patience, you'll achieve good results.

Taking closeups means that you will be closer to your pet than usual, and you may see your pets differently through such proximity. Stooping to take a picture of a dog's nose at eye level, for example, may not be something you've ever done or at least not since you were a child. This suggests another lesson in visualizing: what exactly does a child see? Imagine having a field of view that extends basically from the ground to about 4 feet high. Pets are major characters in a child's environment, which is part of their mutual attraction.

EQUIPMENT RECOMMENDATIONS

Camera

Closeup lens

Daylight-Balanced film Type A

Exposure meter

Extra batteries

Flash

Lens cleaning kit

Tungsten film (Type A and B)

UV filter

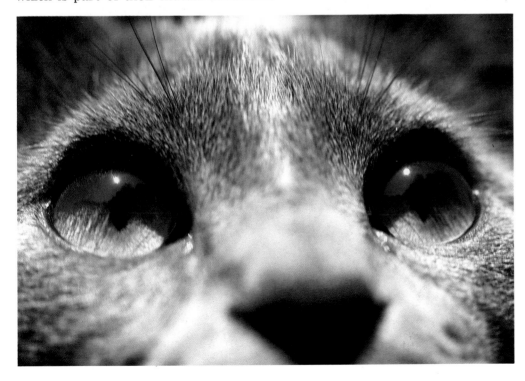

A gray kitten's shining eyes, looking beyond to some new adventure, is a lucky hand-held shot. Kittens rarely hold still, so the photographer simply prefocused the camera and moved himself and the camera as a unit until the image was sharp in the viewfinder.

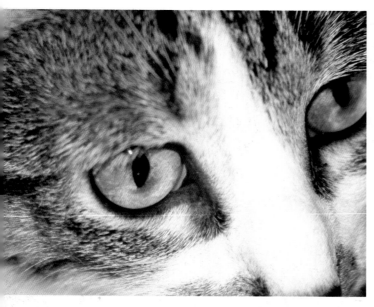

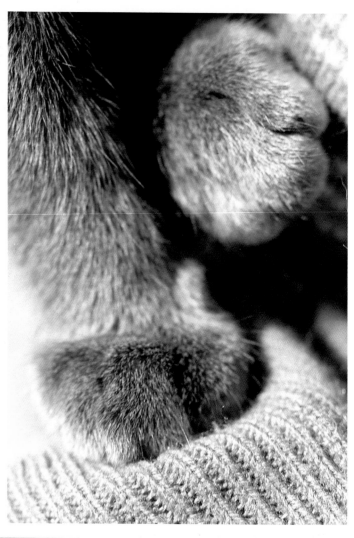

(Above) This cat closeup was shot with a 100mm–500mm zoom lens and a +1 diopter. The exposure was made by electronic flash to improve the illumination and allow for a small lens aperture for sufficient depth of field.

(Right) This photograph of a gray kitten resting on a young woman's arm isolates the lovely texture and form of a cat's paw. The photographer bracketed to make sure the woman's skin tone as well as the cat's fur would be correctly exposed.

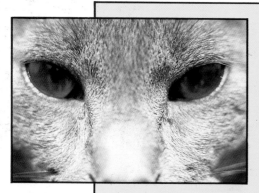

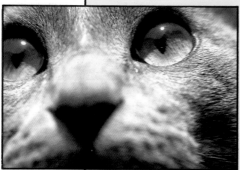

One of the most difficult problems encountered in trying to photograph your pet close up is the limitations inherent in shallow depth of field. Animals have a more varied facial plane than humans and you must therefore choose your angle of view carefully to compensate. Notice how the top photograph at left is composed so that while the cat's nose is out of focus it does not detract from the image as it does in the lower photograph.

USING LIMITED DEPTH OF FIELD EFFECTIVELY

Closeup photography almost always means shallow or limited depth of field. However, this limited area of sharpness can be used to the photographer's advantage especially when shooting portraits of people or pets. The most important thing to remember when shooting a face, any face, is to get the eyes sharp. If you focus the eyes carefully, the portrait will come alive. If you place the sharpness and the depth of field wrongly, then the portrait will look uninteresting.

You should consider the subject carefully and decide whether or not you want to portray that subject with a view to maximizing the effect of depth of field or the lack of it.

APPROACHING THE SUBJECT

Photographing animals, even pets, can be most frustrating. The trouble is that pets seldom stay still long enough for you to get the shot you want. Dogs are generally more amenable, cats will humor you for a short while, a pet tortoise will generally retire into its shell and sulk, and fish—did you ever see a trained fish?

Obviously it's best to get down to your pet's level, even if it means crawling about on the rug. Try to shoot with the frame and background in mind to obtain a pleasing composition. It takes a lot of patience,—animals have a short attention span.

PROBLEMS AND SOLUTIONS

It is almost impossible to light a pet for portraiture, and when you do, the shots look fake. It's easier to use a flash unit—on or off camera as you prefer. Off the camera is better since it provides better modeling effects. Usually you have to prefocus the lens and than move the camera toward the subject, keeping your eye to the finder until the subject's eye comes in sharp, and then shoot. If you have an autowinder or a motor drive, so much the better, since these allow you to get off shots as fast as the flash will recycle.

Now let's consider how to solve the problems that various animals present. Fish live in water. That means you have to shoot through the sides of the aquarium while trying to keep the lens and the flash unit as close to the glass as possible to eliminate some reflections or use a polarizing filter. Your fish are likely to be about 2 to 4 inches long at the maximum. This means you are going to be working in close with either diopters or extension tubes, or a macro lens if you have one. Bellows are not helpful since they tend to be bulkier than, say, a lens and extension tube combination that is rigid. Small lens apertures are required because fish are restless creatures and you will need all the help you can get from depth of field.

Conventional aquarium tank lighting is not really adequate for good photography, so you will probably end up using a flash. Try to prefocus on a spot where your intended subject will cross, and shoot as it reaches that point. It's a good idea to carefully scrape the algae off the side of the tank you intend to shoot through. It is surprising how algae builds up unnoticed until you hit it with a burst of light from a flash unit.

Cage bars are a problem, and about the only way to get around the bars for pictures of birds and other pets in cages is to make sure that the lens is very close to the bars themselves. They will be thrown so out of focus that they will hardly register. Again, flash is best since it provides the most manageable lighting. Don't light the poor creatures with hot tungsten lamps unless perhaps your pets are lizards that don't seem to mind. In fact, even reptiles overheat quite rapidly. Be careful and be kind. The heat from a tungsten lamp is quite fierce and will certainly distress your pet.

(Top) The canine tooth and tongue of a dog become imposing when isolated, although in reality the dog yawned and the photographer was prepared with a preset camera.

(Above) This dog's nose in a closeup profile was difficult because the dog was not inclined to stand still or to tolerate a lens only inches from its face, but the photographer persevered. Photographed outdoors in bright sunlight, the shot was taken with a hand-held camera preset for rapid shooting.

A WALK ON THE BEACH

EQUIPMENT RECOMMENDATIONS

Camera

Closeup lens

Cooler

Daylight-balanced film

Dulling spray

Exposure meter

Extra batteries

Insect repellent

Lens cleaning kit

Plastic "camera raincoat" bag

Polarizing filter

Reflector card

Small containers

Small jar of honey or sugar water

Spray bottle of water

Terrarium or glass-bottomed container

UV filter

A beach is a universe of specially adapted animals and plants that have evolved to fit an environment that is partially land, partially water. Going to a beach with closeup equipment provides a unique opportunity to study a particular ecology system.

What is a beach made of? It is an enviroment made of grains of sand, water following tidal patterns, weathered wood, and rusted metal; it has shells and fish, seaweed, plants, and even flowers. The materials and plant and animal life at a beach are full of contrast and visual beauty.

Study the sand around you as you walk. Look for patterns in it left by the waves or by shoes. Look at the materials that have washed in with the tide. Depending on the time of day and the tide, you may find creatures such as a jellyfish stranded until the next high tide. If there are piers and boats, look at the wood and paint and how these surfaces have become weathered and textured. Experiment with your closeup equipment to express texture.

Don't forget to look at what is underwater. You can photograph in clear, shallow water if you attach a polarizing filter to your lens to minimize glare. Minnows, crabs, and small fish are easily visible in shallow water, and if you work quickly, you can obtain quite good pictures of these subjects.

Shells are particularly lovely objects that are available in abundance at most beaches. You can collect them and take them home or to another location for ease in photographing, but with good handheld technique, it is just as simple to photograph them as you find them. An ecologically aware photographer thinks of the delicate balance of the environment and tries to leave each place as he or she found it.

A clam shell washed up by the waves is an example of the symmetry of natural objects. The concentric lines indicating the shell's growth create a vortex effect in the center of the photograph through subtle but effective composition. The shell's color was enhanced by being wet and by being photographed on a sunny afternoon.

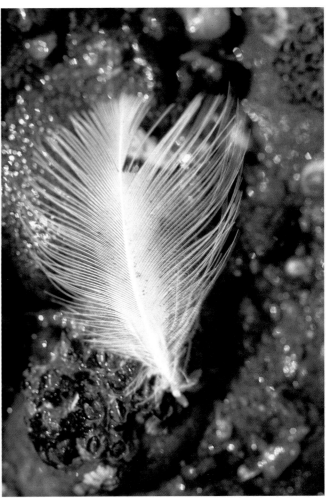

APPROACHING THE SUBJECT

The beach is usually a vast area encompassing a variety of different photographic subjects. You may want to walk around and explore the area before you begin taking pictures, and then go back and concentrate on specific subjects that you have found. There is no doubt that you will find more than enough subject material.

Choose the time of day of your visit to the beach to match the type of imagery you want to find, and make sure to investigate tide levels before you go. Low tide is the time to find stranded creatures such as horseshoe crabs and pools full of minnows, shells, and seaweed in abundance.

Noon can be a difficult time to work at the beach. Not only is it the hottest time of day, but you will also encounter more problems in the way of glare off the water and sand. Try to go either earlier or later in the day,

especially if you want to photograph crabs or other underwater creatures. The qualities of the light can be very lovely at these times and will produce more attractive images.

You should be particularly well-prepared before you set off for the beach. Protection for your equipment as well as yourself is the watch-word here. Bring along a good sun screen, particularly if your skin is sensitive, and a wide-brimmed hat. Also remember that you may need to enter the water, so bring a pair of boots if the water is cold. Take care not to immerse your camera or any portion of the lens into the water. It is a good idea to make a small glass-bottomed box. You can immerse the box into the water and shoot through the bottom of it. If you are using a tripod, wrap the legs in plastic to protect the girders and tubes from sand and salt water.

(Above, left) A clam shell with lichens and seaweed makes a mini-still-life. The picture contains a lot of tightly framed textural elements—from soft seaweed to firm shell to rough lichens. Notice the color of the light passing through the seaweed onto the shell in the right side of the picture. If you look closely, you may be surprised at the colors in what you may have thought were merely shadows.

(Above, right) A seagull feather on the beach at low tide expresses contrast: the delicacy of the feather rests atop sturdy beach materials that will soon undergo high tide. Contrast is further emphasized through the whiteness of the feather and the deep tones of the background. The angle of view had to be carefully chosen to minimize glare on the wet pebbles behind the feather, and as the photographer shot this from above the feather, care was taken to keep that shadow out of the image.

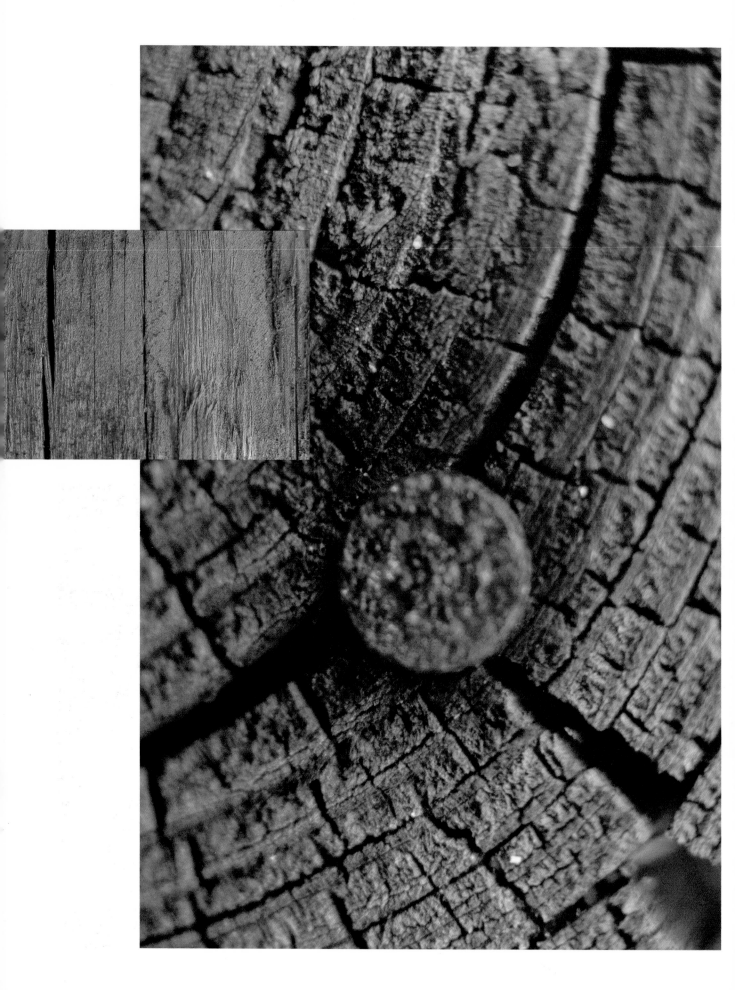

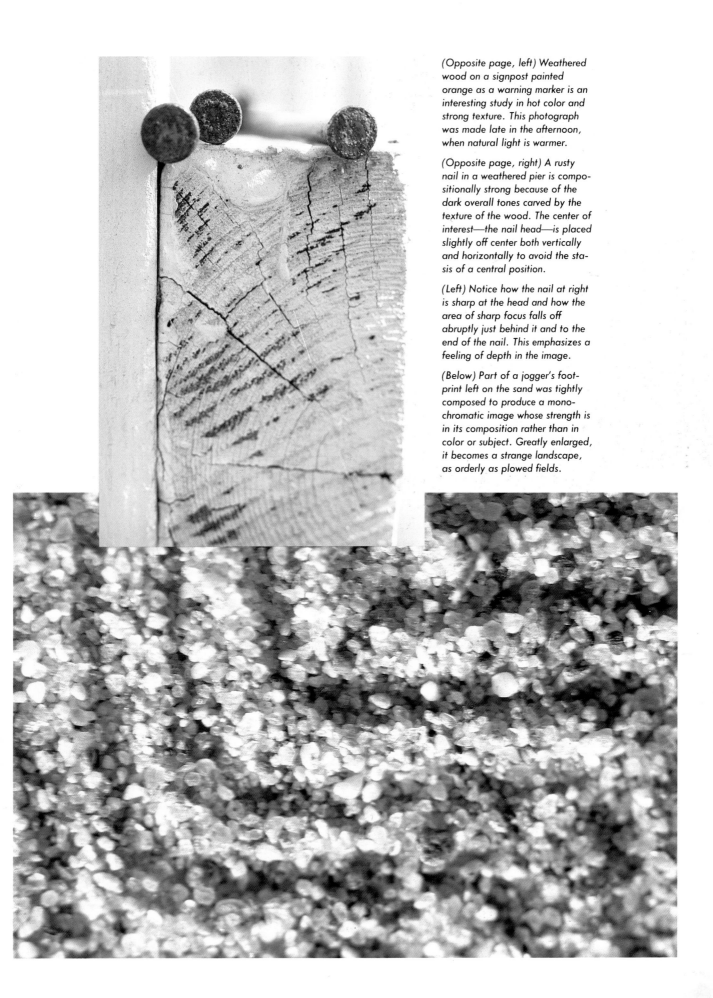

(Opposite page, left) Weathered wood on a signpost painted orange as a warning marker is an interesting study in hot color and strong texture. This photograph was made late in the afternoon, when natural light is warmer.

(Opposite page, right) A rusty nail in a weathered pier is compositionally strong because of the dark overall tones carved by the texture of the wood. The center of interest—the nail head—is placed slightly off center both vertically and horizontally to avoid the stasis of a central position.

(Left) Notice how the nail at right is sharp at the head and how the area of sharp focus falls off abruptly just behind it and to the end of the nail. This emphasizes a feeling of depth in the image.

(Below) Part of a jogger's footprint left on the sand was tightly composed to produce a monochromatic image whose strength is in its composition rather than in color or subject. Greatly enlarged, it becomes a strange landscape, as orderly as plowed fields.

The two photographs at left represent the before and after images showing the effectiveness of a polarizing filter. Notice the glare present in the top photograph from reflections off of the surface of the water. By adding a polarizing filter and turning it until the glare disappeared, the photographer was able to produce the bottom photograph.

CONTROLLING GLARE AND REFLECTIONS ON WATER

Shooting through water can create problems with your pictures unless you take a few elementary precautions. The easiest way to help eliminate surface reflections and glare is to use a polarizing filter over your lens. Looking through the filter on the lens, you rotate the filter until the reflections disappear or are at least minimized. How much reflection you can get rid of with a polarizing filter depends upon the light angle at the time of shooting. Maximum polarization effect is usually obtained when the sun or light source is at about a 90-degree angle to the subject.

If you have no polarizing filter or the day is too cloudy for it to be effective, you might try changing the angle from which you are shooting. A change in angle can make a dramatic difference in the final image. Slight underexposure will also help to saturate the colors better. Many photographers fail to realize that focus has a lot to do with whether reflections will appear in the shot or not. If you focus on the surface of the water, then you will generally end up with a mirror effect. Focusing through the surface of the water eliminates a lot of this.

Seaweed, though photographed in its environment, becomes a softly colored scene of abstract tendrils. The photographer lay in the sand and shot the material from its level to maintain the natural background. Of course, if it is inconvenient to photograph something lying on the ground, you can always transport it to another level.

PROBLEMS AND SOLUTIONS

There are a few problems that should be taken into consideration when taking pictures at the beach. The problems and solutions apply to both general and closeup photography. Not surprisingly beaches are comprised of both sand and water—both potent reflectors. A bright area of sand or water can deceive an exposure meter into supplying you with a reading that will translate sunlit water or sand into muddy tones and underexposure, because the meter tries to average out the scene. The photographer has to guide the camera under such circumstances. Generally, the rule of thumb for sand is to increase the exposure by about one stop. This may be done by using the exposure compensation dial on the camera, by operating the meter lock while taking a reading from a gray tone such as your hand and then recomposing the shot, or if your camera has none of these options, by cheating on the film speed setting. Setting the film speed to the next lowest setting from the one the film is actually rated at is equivalent to adding one *f*/stop to the exposure. If you use the last technique don't forget to correct the setting when you've finished the shot.

Of course, if your primary interest is the bright reflections off the water, then meter normally since you want the reflections to be correctly exposed. Just think about your subject for a moment before using your film, and if at all in doubt, bracket the exposures for safety's sake.

When you work in closeup, much the same applies except you now have a miniature sea- or beachscape to contend with. You might be surprised how tiny reflective particles in sand are capable of affecting the camera's metering ability.

For glare reduction off water and bright areas a polarizing filter is undoubtedly the best solution. Mount it on your lens and rotate it slowly as you look through the viewfinder. Not only will a polarizing filter help saturate colors, it will also allow you, under some circumstances, to see through the water and photograph objects on the sea bottom. It is particularly useful when shooting small creatures in tidal pools.

Where there is salt water there is salt spray. You might think that on a calm, windless day there is no problem, but salt is always present in the water vapor at the shore so protect your camera by keeping it under cover until you are ready to shoot. Salt spray when deposited on a lens or a camera feels slightly greasy. Clean it off the lens with an appropriate lens cleaner and tissue, although you might note that it does not readily wipe off. Prevention is better than cure so it's advisable to mount a clear UV filter over your lenses. Never let a camera or any accessories get soaked with sea water or even heavy sea spray. Both are corrosive.

Sand is another problem. If it gets onto lens surfaces and you try to wipe it off, you will, at the very least scratch the delicate lens coating. At worst it will scratch the glass itself. Use a soft brush to remove sand and grit particles. You may also use compressed air to blow off particles. Never open the back of a camera if there is sand on it. Blow or clean off the particles first. If you have any suspicion that sand might have fallen into the camera when you opened it, turn the camera upside down over your head and gently blow out the grit. Don't use a gas cannister too close to the shutter; the gas pressure is quite high and you can damage the shutter while attempting to blow off particles. Keep your camera bag zipped closed except when you need to get something out of it. Getting sand into the bag will invariably get it onto the camera and lenses.

Beaches, like deserts, get hot. Protect equipment and film from heat. If a film gets too much heat, it will ruin your pictures.

Generally, it does not matter what type or speed of film you use, as long as it is daylight balanced if you are working in color. Since beaches are usually bright, you may find that you can switch to the slower high-resolution films. Remember that there is a high proportion of ultraviolet light near water and reflected off sand so use a UV filter, or better yet a polarizing filter, even when glare is not obvious.

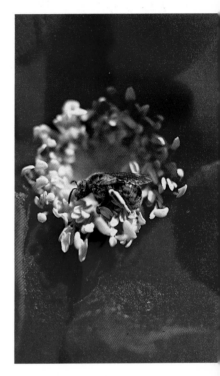

A green bee in a fuschia beach rose is strong because of the intensity of the yellow, fuschia, and green in the image. The photographer bent over the flower, taking care to maintain the film plane parallel with the center of the flower, while avoiding casting a shadow into the picture. This is not as simple as it sounds when you are working only inches away from your subject. At noon, for example, shooting directly downward would pose more problems with your own (or the camera's) shadow falling into the image area than would be possible earlier or later in the day.

The first diagram shows how a photographer can depict symmetry and asymmetry in the same subject, simply by moving closer and choosing your frame carefully. Notice how the initial illustration of the bivalve expresses the symmetry of the two halves of the shell, while the inner frame shows that you can move in closer and alter the position of the meeting point of the shell and express asymmetry.

To express an entirely different view of the shell shown in the illustration above, change your angle of view and photograph the shell from the inside. Here you will be expressing something that is unique to the shell, rather than making a statement as to the uniformity of its outer design.

To further show the graphic possibilities of a single subject, notice the effects that imaginative framing can create in the illustration shown here of a footprint in the sand.

BALANCE: SYMMETRY AND ASYMMETRY

This is an occasion when you can break a rule of the fine art of composition. Generally it is not advisable to place the center of the subject in the center of the image because it produces a static composition. But when the purpose of the composition is to express symmetry and balance, it is effective to put the center of the bivalve in the center of the picture. This expresses a symmetrical subject as a balanced image.

Another approach would be to consider the meeting point of the shell as part of an imaginary vertical line to be moved to the right or left in order to express the mirror-image halves through asymmetry.

Either approach is equally viable for a composition, but one may please you more than another. Composition is a very personal and subjective quality of visual expression. Do what pleases your eye.

To express *what is unique* in one shell as opposed to billions of others of the same species, try closeups of the inside or outside of one half of a mollusk. Isolating one part in this way and filling the frame with it makes a unique image. If your equipment won't go so far as a lifesize closeup, consider the background and place your subject in the frame in a way that will give it importance. Don't put it in the center of your picture, but experiment with having it a bit to the left or right of center, or a bit higher or lower than your first impulse. Wait to take the picture until you see an exciting composition.

One of the most exciting compositional techniques in closeup photography is to experiment with parts of a pattern. In this case, a runner left a series of footprints in the sand. After considering the strongest placement of *that pattern in the rectangular frame*, the photographer decided to place a corner of the sand pattern in the corner of the frame so that there is a strong diagonal line made of corners of the sand pattern.

The photographer could have made several exciting pictures using different compositional approaches. She could have placed the corners as a vertical pattern within a rectangular frame or extracted a horizontal picture from the same pattern.

These ideas apply to any camera and any format. However, if you are not using a 35mm camera, study the shape of the pictures your camera does produce and apply all compositional ideas to the frame type you are working with.

FALL FOLIAGE

One of nature's most extravagant activities is changing the color of autumn leaves. A tree appreciated in early spring for its first misty green buds, then in the summer for its rich green shade from hot sunlight, suddenly explodes into spectacular color before the leaves fall and another spring renews the cycle.

Closeup photography can give you a new appreciation of autumn leaves, for as you examine a single leaf, you will see a marvel of symmetry and design. The pattern of veins in a leaf is truly remarkable. All the leaves of a particular tree share a common pattern—but no two are exactly alike. Even the colors of the leaves on a single tree differ, depending on the amount of sunlight the leaves receive (for instance, more exposure to sunlight makes leaves turn redder).

Investigate everything about autumn leaves as you take pictures. Look at the outline of the leaf, the center with its tracery of veins, the color. Hold a leaf up in the air so that sunlight comes through the back and see how transillumination emphasizes the color. Hold a leaf so that sunlight comes from one side, and notice the shadows produced by the ridges and texture of the leaf. Sidelighting draws the most texture out of a subject and can be used effectively with autumn leaves.

Each leaf provides an opportunity for new photographic ideas. Study each one; try to express color, symmetry, and individuality; make the most of its particular visual identity.

EQUIPMENT RECOMMENDATIONS

Camera

Closeup lens

Daylight-balanced film (Type A)

Exposure meter

Extra batteries

Flash

Lens cleaning kit

Polarizing filter

Spray bottle of water

Tripod

UV filter

These photographs demonstrate how the natural designs of leaves can lend themselves to strong compositional treatments. At left, sharp focus was placed near the center. At right the photograph is sharp overall.

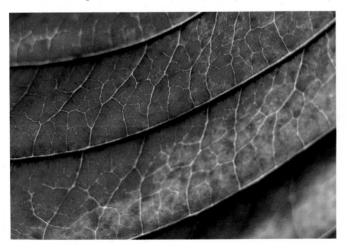

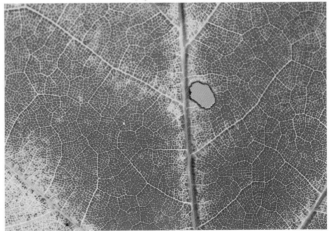

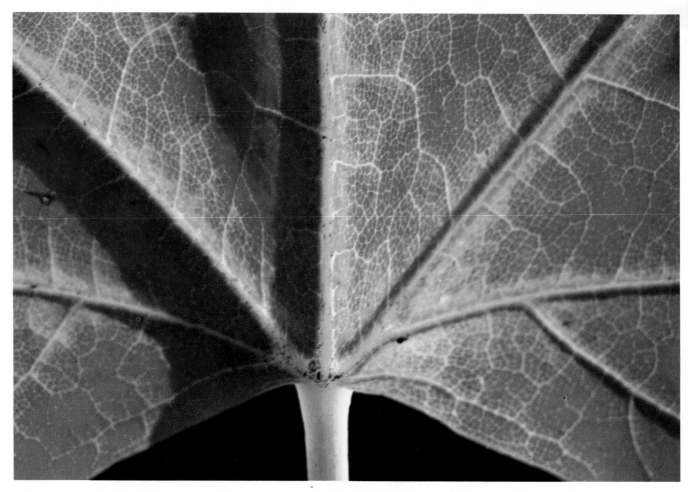

This dramatic shot of maple leaf base and stem was photographed late in the afternoon with the leaf held in the photographer's left hand, positioned in front of a distant dark area, and then deliberately underexposed so that the background would go black and the leaf would have a rich red color. Sidelighting from the sun (at the photographer's right) emphasizes the veins of the leaf and produces shadows that are quite complementary elements of the overall picture.

APPROACHING THE SUBJECT

Selectivity is the key here. Go out and make a few autumn shots for your portfolio. Subtlety is often more effective than a blow between the eyes, so look for delicate shades of color as well as bold, hard, solid effects. Note that a maple leaf which has lain on the woodland floor for a while shows a rapid series of color changes according to the dryness or dampness of the weather.

Holding a leaf up to the light allows you to shoot through it—like a stained glass window, although the leading of the glass is, in this case, the fine veins and cellular structure of the leaf itself. You can photograph groups of leaves, or one leaf alone as a study in solitary form and color. If you roughly prefocus it's quite easy to photograph a leaf while holding it in your hand. Don't try to focus one-handed; just move the camera and lens and the leaf-holding hand toward one another. Pick a fast shutter speed; lens apertures are not too important here as far as depth of field is concerned since a leaf is fairly one-dimensional to the camera, but can be a problem when photographing leaves in groups.

Exposure is simple. Meter the entire leaf as it fills the frame. If you are shooting with the light transilluminating the leaf, meter it the same way. The through-the-lens meter will be right almost 100 percent of the time. If it's a dull day, you might like to use your flash. Again there is no special technique and there is nothing to stop you from placing the flash head behind the subject. If you do this though, you should remember that if the flash is an automatic self-sensing unit, its sensing eye will be looking at the back of the leaf and you must adapt the exposure accordingly—perhaps by going to manual. If the camera meters the flash through the lens, then it's a straight shoot. Taking specimens home is acceptable; you can wet them and stick them on the glass of a sunny window and work at your leisure. Just don't let them dry out or they will shrivel and roll up. You can also dip them in glycerin to keep them longer, but it's a bit messy.

HOW TO AVOID LENS FLARE

Lens flare is a series of reflections or even a massive sweep of light that occurs within the lens system when the lens is pointed too close to a bright light source. For the most part it shows up as a series of disklike forms that are generally the shape of the lens diaphragm.

Flare can occur in any lens, even the most highly corrected, if you are a little careless when pointing the lens at bright lights, such as the sun or street or spot lights. A bright light will bounce off each element on the lens and produce annoying or interesting spots depending on how you regard them.

The first cure is to be careful how you point your lens. The second, and the most used, is to add a lens shade—it's like screening your eyes with your hand. The lens shade should suit the focal length of the lens. Otherwise it will be ineffective or if, for example, you put a lens shade designed for a telephoto lens on a wide-angle lens, it will cut off the edges of the picture and vignette. Zoom lenses tend to flare more because there are a lot more elements in the lens barrel, and they also tend to have lens shades that are effective only at the shortest end of the zoom. However, since flare will show itself on the viewfinder, you need only watch out for it and change your shooting angle slightly. Another technique is to stand in the shade and shoot out of it.

You can eliminate lens flare in your photographs simply by changing your angle of view. Notice that the two photographs at right are of the same leaf, but in the lower photograph the photographer moved slightly until the flare was not present.

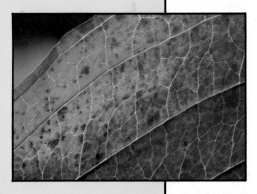

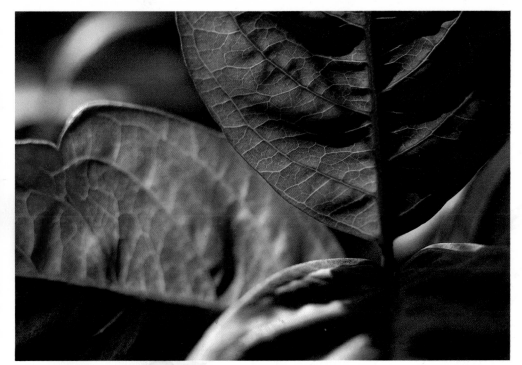

This medium closeup of a dogwood branch taken very late in the day shows variations in lighting on each of the leaves in the picture. Two are backlit, which highlights their symmetry. The others are partially illuminated: by direct light where the leaf is exposed to the sun and in shadow when other leaves block the light's path. This is a simple composition of three basically similar shapes seen from different points of view. The main point of interest is not in the center, but rather offset to the right. If you hold your hand over one leaf at a time, you will quickly see what part each plays in making the overall composition succeed.

PROBLEMS AND SOLUTIONS

When removing the leaves from the trees and shooting them as solitary objects, you will probably encounter few problems. Since photographing a leaf head-on requires little depth of field, the choice of film is a matter of personal taste. Here you have the opportunity to use the slower, sharper films in both black-and-white and color. Depth-of-field requirements will be, at best, a few millimeters, so you will probably be able to shoot with the faster apertures of your lens. The extreme fine grain of the slower films will allow you to ably depict the beautiful textures and intricately veined patterns of leaves more easily as well.

However, when photographing leaves in groups on their branches, you will encounter the usual problems of limited depth of field.

In autumn daylight seems to shift very rapidly. This may pose a problem when you are trying to capture a highlight on a leaf on a tree. You must watch carefully and shoot quickly or the moment you were trying to capture will be lost. Your flash can help in these situations.

Another problem you might encounter in photographing autumn leaves can be sudden gusts of wind. Even a gentle breeze can cause leaves to flutter just as you are clicking your shutter. Use your tripod to free one hand for holding a branch steady while shooting.

The two photographs on this page show the different effects that can be obtained by backlighting. The photograph above is backlit naturally by warm late afternoon sunlight. The photographer had to be patient, as even light breezes move the leaf and make sharp focus impossible. The leaf in the photograph at right was found underneath a tree at the side of the road. The photographer held it up to the sun so that the light would pass through the back of the leaf and framed to make a composition with a strong diagonal line of force through the image.

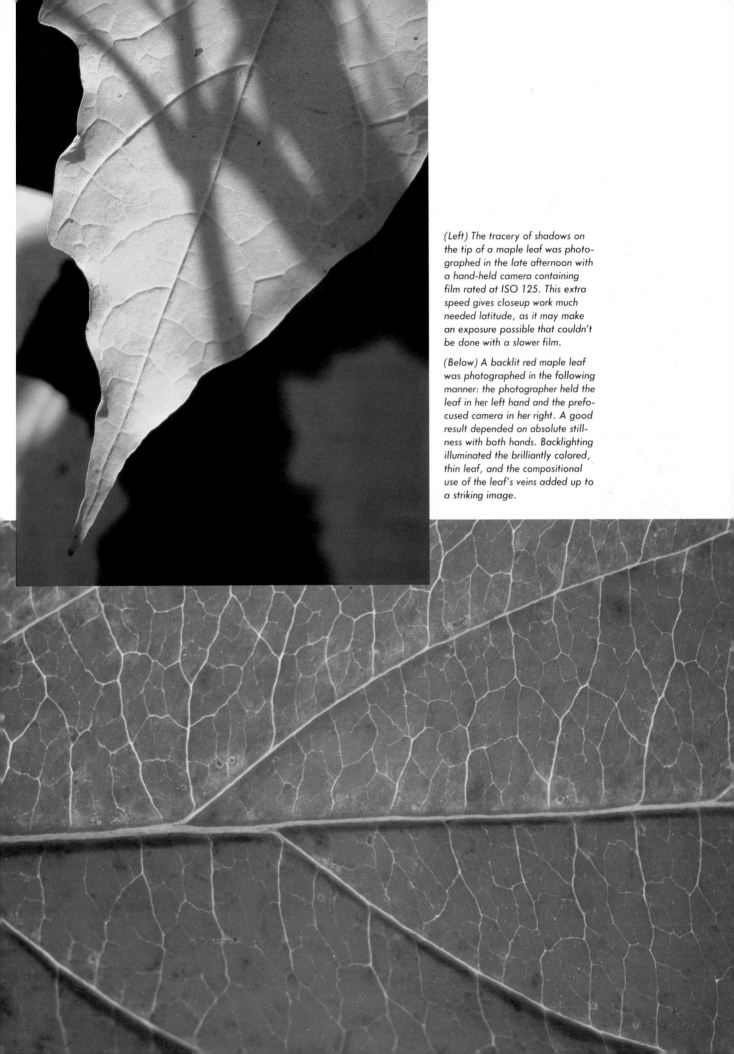

(Left) The tracery of shadows on the tip of a maple leaf was photographed in the late afternoon with a hand-held camera containing film rated at ISO 125. This extra speed gives closeup work much needed latitude, as it may make an exposure possible that couldn't be done with a slower film.

(Below) A backlit red maple leaf was photographed in the following manner: the photographer held the leaf in her left hand and the prefocused camera in her right. A good result depended on absolute stillness with both hands. Backlighting illuminated the brilliantly colored, thin leaf, and the compositional use of the leaf's veins added up to a striking image.

A ROSE IS A ROSE

EQUIPMENT RECOMMENDATIONS

Camera

Closeup lens

Colored background paper

Daylight-balanced film

Exposure meter

Extra batteries

Flash

Insect repellent

Lens cleaning tissue

Reflector card

Small jar of honey or sugar water

Spray bottle of water

Tripod

UV filter

Roses are symbolic in our culture of romance and love. Photographs of roses are among the most popular of all subjects for closeup pictures. Many objects in our daily lives have taken roses as their symbol or theme—greeting cards, fabrics, perfumes, works of art. We treasure these blossoms for their color, scent, and sensual appearance. Centuries of rose cultivation in the Middle East and meticulous hybridization have produced today's most loved flowers.

If you have a rose garden, you will have several months each summer in which to photograph blossoms. And if you are an avid gardener, or live near one, you will have an almost infinite variety of colors, sizes, and shapes of roses to choose from. Roses appear in every shade from the most delicate of whites to the deepest of scarlet reds and in blossoms ranging from the robust floribunda to the miniature tea rose. And if your roses are especially beautiful, prize-winning varieties, a group of closeup photographs documenting their perfection would be a good way to collect and preserve them for the future.

If you do not have a rose garden, it is easy to go to a local florist, buy some, and then photograph them at home. The spectacular rose on page 71 shows a rosebud that was picked to avoid the first frost and then photographed in a vase. You can take the vase and flowers outdoors for natural lighting conditions and produce closeups as beautiful as if you had an entire rose garden in your yard. This photograph involved the combination of outdoor light with a hand-held daylight bulb in a reflector lamp plus deliberate underexposure to produce its rich color.

Because roses are so popular, they offer the photographer an excellent opportunity to share closeup photographs with others. Closeup images of beautiful roses are very successful for use as stock photographs. Your local newspaper or regional magazine might be interested in an article about how roses are grown successfully in your locale. You might have them printed to use as greeting cards or notes. A group of closeups of roses makes a particularly spectacular wall arrangement when enlarged.

(Left) A pink rosebud against the sky shows how to emphasize a flower with a richly colored, natural, flat background. Shooting up from a very low angle brought the sky in as background, and exposure compensation rendered it a rich blue, which flatters the pink rosebud.

(Opposite page) The core of a red rosebud is intensely red because the photographer used a technique called "saturating the color." This means that the image is deliberately underexposed to make the red redder. The photographer did this by "lying" to the exposure meter. Though the film had an ISO rating of 125, the photographer set the ISO at 160. Many photographers saturate color by setting their ISO slightly higher than the film's rating. The intensified color, together with the exaggerated, extremely closeup view of this flower, creates an image of sensual, linear design.

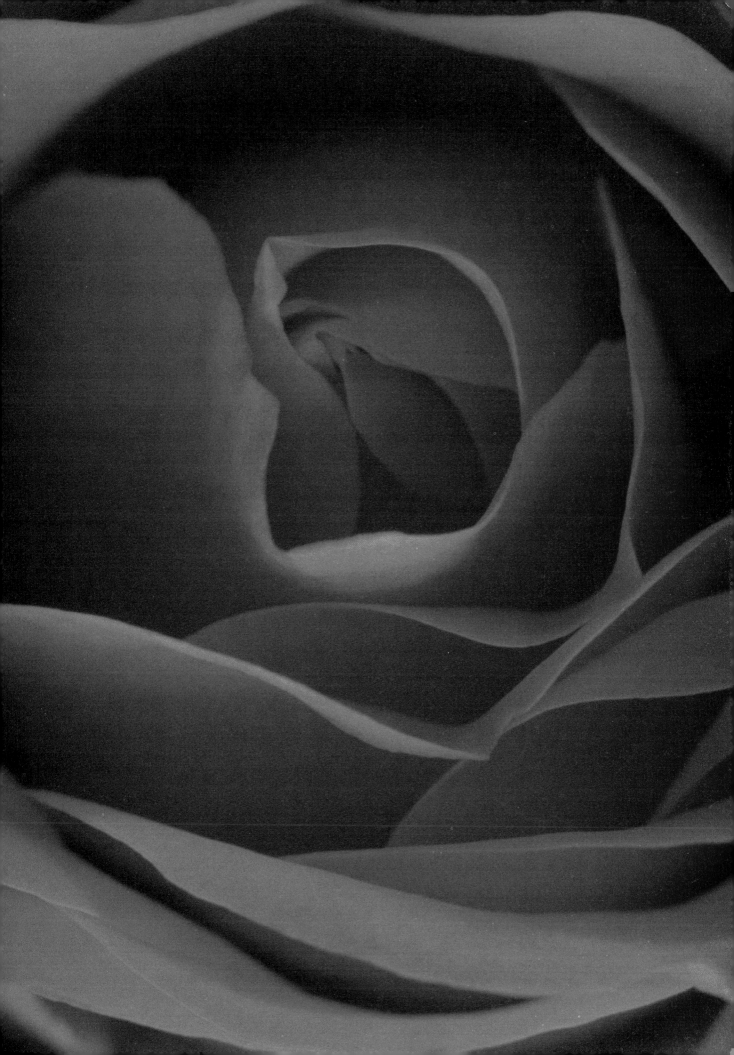

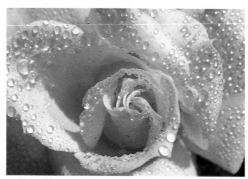

The three photographs at right show the effects of natural light at different times of the day. The first photograph was taken in the very early morning, while natural dew was still on the petals. The lighting adds to the softness and warm tones of the overall image. The second photograph was taken at midday. The "dew" is actually water from a spray bottle. The bright light of midday adds depth to the center of the rose. The third photograph was taken in late afternoon. Notice the effect of natural sidelighting, which creates gentle highlights and shadows among the petals.

APPROACHING THE SUBJECT

If you're working outside in a rose garden, you may choose to photograph roses in strong natural light to get the most of their rich colors. Try bracketing your exposures if your camera allows, as it will give you a range of color values, some of which may please you more than others. When you are trying to retain retain roses' color, bracketing is more appropriately done by underexposure. For example, if you determine that the right exposure is $1/125$ sec. at $f/16$, shoot four pictures, each at a shutter speed of $1/125$ sec. at $f/5.6$, $f/8$, $f/11$, and $f/16$.

As for conceptual approaches to photographing roses, think about the importance of singling one out of many. One rose can be photographed close-up in many ways to express its perfection. Look at the rose that is your subject. Look at the petals and how they are arranged. Look at rosebuds as well as full-blown blossoms. Look at the leaves and stems and thorns. Watch how light enhances these flowers' beauty. Try to record the many aspects of that beauty.

Vary your angle. Try photographs looking down on the rose. (Make sure your shadow doesn't cover it, or if this is unavoidable, make sure your shadow covers the *entire* image area.) Stoop low, and look *up* at the rose. Wait for backlighting to place a halo around the delicate edges of the plant. Experiment with backgrounds of paper and fabric; emphasize a rose with a completely flat background. Try placing a rose on a mirror and photographing its double image. (But be careful that reflections and hot spots don't damage the image.) If you are a real rose fan, you might extend your photographic theme to silk roses or roses found on such materials as fabrics.

This photograph of a sidelit red rosebud is a lovely composition of rich red and vibrant green. The lighting is attractive, and other plants are sufficiently out of focus to provide a soft, noncompetitive background.

SUBSTITUTING BACKGROUNDS

You don't have to put up with messy or distracting backgrounds. Just as the studio photographer has huge rolls of seamless background paper, so the closeup photographer has an endless supply of interesting and portable background materials readily available. Colored tissue paper, Bristol board, and aluminum foil all make good mini-backgrounds for close-up and macro work. Another advantage is that such backgrounds may also be pressed into service as reflectors, but you should be careful with colored material as it may reflect an unwanted hue onto the subject. To soften the effect of aluminum foil, it should first be crumpled and then straightened out. This will prevent hot spots with specific and directional light sources.

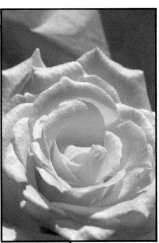

Any artificial background can be used to make your subject stand out in the photograph. Here, blue paper was chosen as a complementary, yet unobtrusive background.

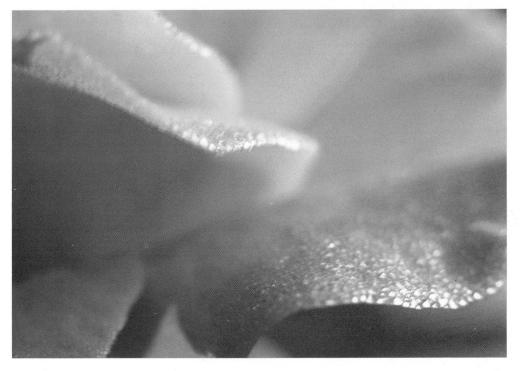

A photograph of pink rose petals at dawn is an extreme closeup done in very low light conditions. This is real dew—notice how fine and delicately graduated natural dewdrops are. It is difficult to work at dawn, because there is so little available light. The photographer chose in this case to have a soft image, with a very narrow band of sharp focus on the dewdrops for a soft effect in keeping with the soft color and composition of the image. Flash is also a good choice when working at dawn, though it would block the softness of warm natural light at the beginning of the day.

PROBLEMS AND SOLUTIONS

Inherent in closeup photography is loss of depth of field when a lens is used closer than its normally designed focusing range. You will be working in milliemeters instead of inches as far as depth of field is concerned.

Since there is almost no way around this, you must learn to work within the limitations placed upon you. Place your area of sharp focus carefully with regard to the subject. If you can orient the line of sharpness parallel to the film in the camera, so much the better. For example, let's say you are photographing a petunia. If you shoot it head-on, chances are only the foremost petals will be sharp. If you shoot it from the side, you will have a flower sharp from head to stem.

Inasmuch as limited depth of field may work against you, it can also be made to work for you. Shallow depth of field allows you to isolate the subject from a distracting background—sort of differential focusing in miniature. This effect when used well emphasises the subject and adds dimensionality to the final picture.

Some bellows units have the capability of swinging or tilting the lens mount. This capability allows the photographer to align the lens somewhat parallel to the subject, so as to sweep the depth of field across the area of interest. Since the camera itself does not have a comparable swing or tilt, the effect is limited—but it's still useful to know.

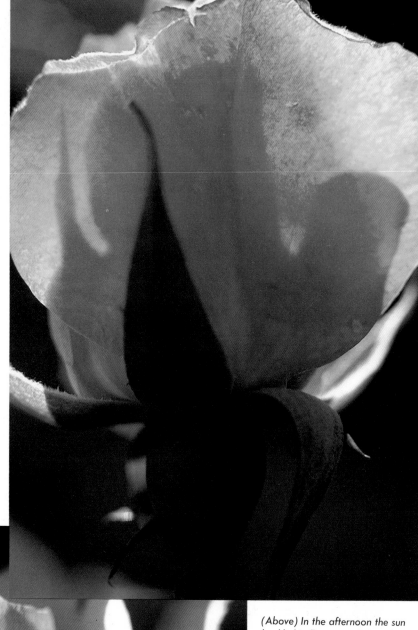

(Above) In the afternoon the sun backlights flowers and the colors of petals become translucent. Deliberate exposure compensation is necessary, as through-the-lens exposure meters can become misled by backlight.

(Left and opposite page) These two photographs demonstrate the graphic possibilities of flowers and leaves. The photograph at left uses natural light to highlight parts of the rosebud, while the photograph shown opposite portrays the essence of the flower without showing the entire blossom.

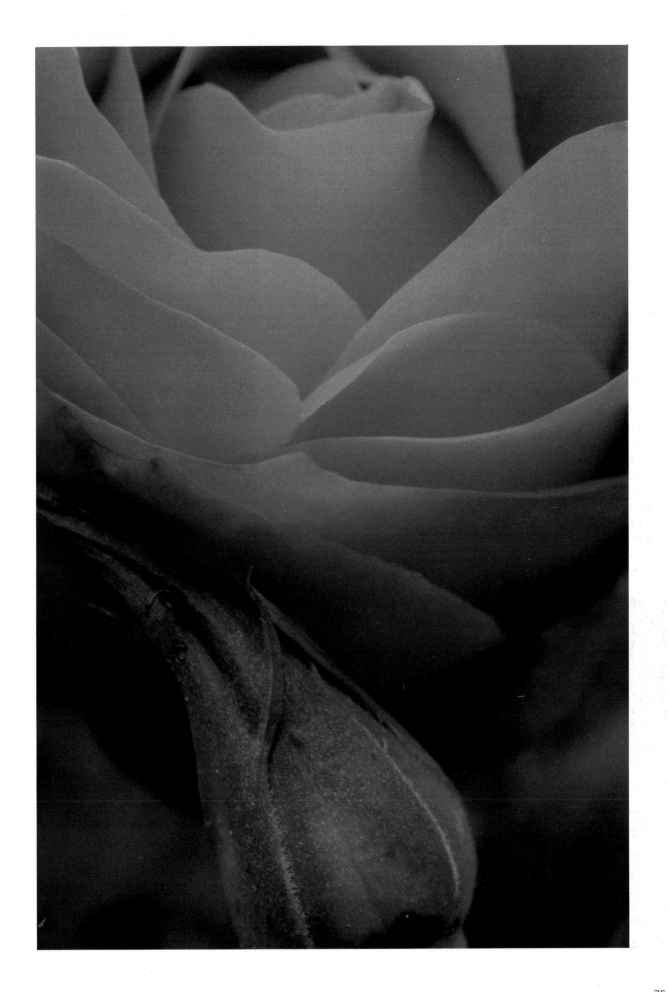

PARTS OF PEOPLE

EQUIPMENT RECOMMENDATIONS

Camera

Closeup lens

Daylight-balanced film

Exposure meter

Extra batteries

Flash

Lens cleaning kit

UV filter

Think about a person you enjoy looking at. What exactly do you see? Most often it is the eyes that hold your attention longest. So why not take a picture of someone's eyes? Or his hair or mouth? These are the elements of our attraction and of the sensuality of the human body.

However, many photographers are uncomfortable photographing people. They show this by staying as far away from their subjects as they can. Closeup photography of people breaks down our invisible barriers by requiring the photographer to work very near to another person. For this reason, closeup pictures of "people parts" will not appeal to every photographer, but for those who are interested in exploring the fine details of someone's physical beauty, some remarkable images may result.

Clothing, jewelry, and makeup are also part of a person's appearance. We are accustomed to such closeups in advertising, but rarely do we think of expressing just a small part of a person in a photograph. You might like to pretend that you are taking closeups for advertisements and see how your photographs compare with those that you have seen in magazines and newspapers. Or you might enjoy taking a picture of one aspect of a person you know well that you find exquisitely beautiful.

This is a case when beauty is definitely in the eye of the photographer. If you take a closup of someone's eye, for example, you may find it gorgeous, but others may not. Others may only see that the eye is a bit tired or even that the makeup is imperfect. Particularly if you are in love with your subject, your closeup images may only please you and no one else. For many photographers, this is perfectly acceptable: they take images for their own pleasure, and no one else's is necessary.

Picture editors commonly run into the problem of photographers bringing in groups of pictures that obviously have great meaning for the photographer, which he or she can talk about, but which is not shown in the picture. It is a fine point of photography to *visually* express feelings, and closeup photography of parts of people is a challenge in this respect. Your picture has to show something lovely or interesting or sensual, and the picture has to stand on its own, without a verbal explanation. If you need to talk about the picture for it to mean anything, then it should remain for your eyes only.

This project is the most private and profound, perhaps, of all the ones in this book. Closeups of people can express the love and the appreciation of the sensuality you see in them.

The eyes are said to be the most expressive part of a person. When viewed close up the eyes can become a strong image that make a highly personal statement about the subject.

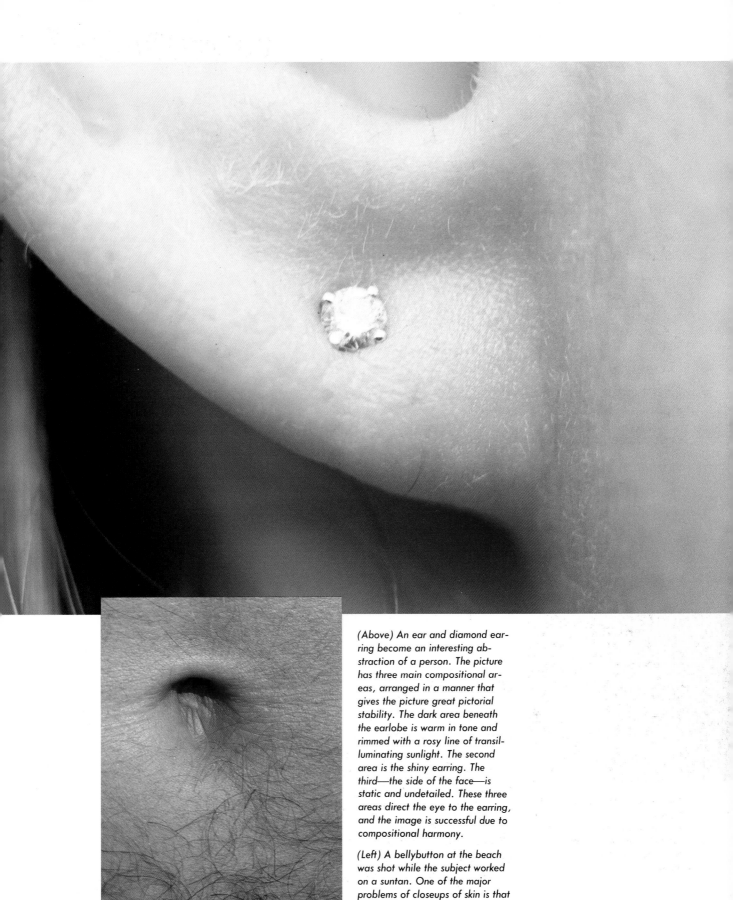

(Above) An ear and diamond earring become an interesting abstraction of a person. The picture has three main compositional areas, arranged in a manner that gives the picture great pictorial stability. The dark area beneath the earlobe is warm in tone and rimmed with a rosy line of transilluminating sunlight. The second area is the shiny earring. The third—the side of the face—is static and undetailed. These three areas direct the eye to the earring, and the image is successful due to compositional harmony.

(Left) A bellybutton at the beach was shot while the subject worked on a suntan. One of the major problems of closeups of skin is that it takes deliberate exposure compensation to render skin acceptably warm. This image was underexposed a stop and photographed late in the afternoon.

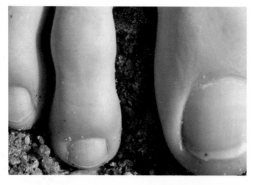

Fingers and toes can provide some interesting subjects for closeups, as shown by the photographs at right. This picture of toes in sand (top) required a rather undignified posture on the part of the photographer but the image is worth the effort. Working with a 55mm macro lens, the photographer had to be about 2½ inches (6 cm) from the subject's toes, photographed lifesize on 35mm. A hand with fingers resting on the palm (center) has a strong diagonal created by the fingertips. The shadow area defines them through contrast. Our hands are among the most remarkably adapted parts of our bodies and offer innumerable possibilities for striking closeup pictures. These intertwined fingers (bottom) provide an interesting composition of repeating nearly horizontal lines. The image was deliberately underexposed to render the skin tone very warm. The rings are emphasized through lighting and provide two interesting accents.

(Below) This man's mouth belongs to one of the photographer's favorite people. Closeup photography is an opportunity to express those details of a person that we especially like. More than a whole portrait, one detail may be what draws us to a particular person.

APPROACHING THE SUBJECT

We generally see other people in natural light, so working with flash is somewhat appropriate for partial portraits. A beach is an ideal location for this project, as there is generally a high level of ambient illumination, reflected from both the water and the sand.

Natural diffused light occurs on gray days with heavy cloud cover. The clouds bounce light in a softer manner than on sunny days and can provide more attractive lighting for any kind of people pictures.

Study light on the person for a moment before you start to take pictures. See how the light sparkles in the hair and the eyes and makes the skin glow. Backlighting, for instance, can be very helpful in highlighting hair. Sidelighting, on the other hand, known for its tendency to draw the most texture out of subjects, may be unflattering for certain types of people-parts photographs. For example, sidelighting may emphasize the pores on someone's face and age in the skin. Direct and preferably diffused light is the most flattering.

Composition is important in these images. How you choose to place your subject can make it powerful or weak. Study the images here. They have a strong compositional component that helps make the most of their subjects.

PROBLEMS AND SOLUTIONS

Unlike many of the other projects in this book, when photographing people, it is assumed that you will have a willing subject and therefore have the luxury of time to adjust your camera properly and not hurry to get the perfect shot. As such, the problems you may encounter with this adventure are of a technical nature rather than of the physical kind.

Bracketing is a useful technique in assuring yourself perfectly exposed photographs. Unfortunately, many times there is just not time to practice it. If you normally use your camera in the automatic exposure mode, switch to manual control so that you can adjust both the shutter speed and *f*-stop. Take the same picture at, say ¹/125 sec. and at a series of *f*-stops: *f*/5.6, *f*/8, and *f*/11 (assuming that *f*/8 represents the original exposure). One may be underexposed, one perfect, and one over-exposed.

POSITIVE AND NEGATIVE SPACE

One of the compositional qualities of a visual image is called "*positive and negative space.*" The first example shown here demonstrates the area of *negative space* around the back of a man's head and neck. The area of negative space is roughly the same size as the area of positive space. Most images work better if there is a balance between positive and negative space, although variation here is often effective. The secret of any visual rules is to know when to adapt them for a better purpose.

Subject area is not the only thing that constitutes positive space in an image: contrasting areas of color, pattern, or lightness/darkness can also establish a positive-negative space relationship.

The second example shows an extreme variant on the use of positive-negative space. The positive area fills nearly the whole frame, and the negative space is a thin band along the bottom and right of the picture.

To demonstrate to yourself the function of negative space—since it seems at first just to be empty space—cover the negative areas of this picture and notice how the subject loses its definition. This thin area with no subject matter defines the line that tells us this is a picture of a man's nose. Without it, there may be enough visual clues to guess, but the picture reads faster thanks to the compositional element of negative space.

Part of the effectiveness of this image of the nape of a person's neck set against the background of the ocean lies in the fact that it is composed half of positive space (the hair and neck) and an area roughly the same size and shape (although upside-down) of negative space.

This detail of a profile is strengthened by the thin band of negative space along the right side of the picture. This image gives the nose a sculptural weight it would not have had as part of a full portrait.

A breast enclosed in blue lace conveys sensuality. The lace detail assumes importance when shown close up—when abstracted, the rounded lines and delicate fabric are emphasized.

FROM YOUR TV SCREEN

EQUIPMENT RECOMMENDATIONS

Camera

Closeup lens

Daylight-balanced film

Exposure meter

Extra batteries

Polarizing filter

Tripod

The two photographs below are examples of the variety of pure graphic images that can be produced from the television screen. Since television images are edited to cut quickly from one scene to another, there isn't enough time to refocus for each shot. The best approach is to prefocus your camera and watch one area until a pleasing image arrives.

Shooting closeup pictures off a TV screen isn't difficult, but it does require some thought. A TV picture is not a static subject; it is continually being built up and erased by a form called a "raster scan." That is, the picture is drawn as a series of lines and almost as swiftly erased. You see it as a moving picture because the human eye has an interesting and useful ability known as "persistence of vision," that is, the tendency of an image to linger on the human retina for a short while after that image or stimulus has been eliminated. Without this, TV and movies would not work.

Try an experiment. Sit in front of your TV and blink your eyes rapidly. The picture will appear to break up into a series of separate shots, much like the flicker of old movies. If we think in terms of a still camera taking only one picture, we will realize that it is necessary to catch the image when it is fully scanned on the TV screen. Trying to use a fast shutter speed when photographing a TV screen will not produce sharper pictures. It will simply produce part of the picture because high shutter speeds catch the electron beam, the entity that writes the picture on the screen in the act. The scan rate of a TV depends on the phase of the current driving it. In the United States this phase is 50 cycles per second; in Europe it is 60 cycles per second, which are your clues to the correct shutter speed to use in getting a satisfactory picture from a TV screen.

APPROACHING THE SUBJECT

Your camera should be set at about ¹/₅₀ sec. or even probably at ¹/₃₀ sec. to get the whole TV picture. Shutter speeds higher and lower than those will produce only part of the picture. You will get a black bar across part of the picture due to cancellation or production of what is known as the "scan effect." Slightly faster shutter speeds are possible in Europe due to the faster current cycle.

The reader should be aware that, for the most part, pictures on a TV or movie screen are not necessarily the sharpest from a motion-stopping point of view. How could they be? The equivalent shutter speed is either ¹/₃₀ or ¹/₆₀ sec., and you are aware that such slow shutter speeds are not fast enough to arrest any but the slowest motion in a subject. Watch the TV screen carefully and see what the TV or movie camera operator was doing.

If a static object was being shot, then the picture you take off the screen will likely as not be sharp. If a moving subject was being panned, the same applies because the subject was being matched by the panning action. If a moving subject was not panned, then the final picture will only have the illusion of being sharp because you are being presented with a series of moving images that fuse into one through the persistance-of-vision effect.

TV sets are designed to be viewed from the distance of a few feet unless they are the tiny pocket type. The closer you get to a TV screen the coarser the picture becomes. Why? Because the picture is laid down as a series of lines and, if it's a color TV, through a special mask that is comprised of dots or lines. With a color TV set the color is made up of groups of colored dots, which are rapidly scanned and excited so that they will glow momentarily when hit with the electron beam. The best definition in your stills will come from using your camera lens at its normal close focusing distance so that the whole screen fills the frame. The closer you go, the more the picture will be converted into its component dots or lines, and the more abstract the results will be.

If you are shooting with color, it's best to use daylight-balanced film. If you are shooting with black-and-white, it's largely a matter of personal preference.

One of the most interesting uses of photographs from your television screen can be the permanent recording of historical events. These photographs are from television coverage of a NASA space probe on an exploratory mission to Saturn.

These closeup photographs create unusual effects because the dots on the screen are clear. You can have fun with this type of image by using them to imitate elements of "pop" art or even the medium of television itself.

PROBLEMS AND SOLUTIONS

Aside from using the correct shutter speeds when taking pictures of your television screen, about the only problems you may encounter are: correct film-plane-to-television-screen alignment and excluding extraneous light that will degrade the screen image and brightness. The first is simple to solve: use a good tripod and carefully align the camera and lens to the screen. If you use a zoom lens, alignment is even easier. Zoom back so that you see the edges or the frame of the screen. This way you can check for off-alignment effects like horizontal or vertical keystoning. Once you have the alignment set up, simply zoom in to the required framing.

Excluding stray light can be as simple as turning all the lights off in the room and drawing the window shades or curtains, or it can be as complex as erecting a hood over the camera and television screen with a black cloth.

Where do you focus on a television screen? You focus on the screen itself and not on the glass safety window in front of the screen. If you focus carefully you may be able to see the stripe or screen matrix patterns that are an integral part of a color television screen. If the stripes or dots are sharp, so is your picture.

Color balance and image contrast may be augmented by adjusting the color balance, brightness, and contrast controls of the set. Be sure to turn off the automatic controls that monitor the television image before making your admustments, or it will fight your attempts. Careful use of the tuning control will allow you to arrive at the best incoming signal and help get rid of ghost images on the screen.

What about film? Daylight color film should be used, not, as many think, tungsten films. A television image is essentially the same as the light produced by a fluorescent light source. Exposure can be determined automatically by the camera if you are using an automatic exposure camera. About all you need to be aware of is that if the central part of the television image is considerably brighter than the rest, you might have to adjust the exposure slightly for best results so as to avoid under- or overexposure. It is interesting to note that with most television shows the main area of interest is kept well within the central area of the screen.

You can even capture photographs of your favorite actor or actress from your television screen. The photograph above demonstrates that extremely sharp closeup images can be obtained when desired.

HOW TO BEAT THE SCAN FOR PICTURES OFF YOUR TV

Shooting pictures off your TV screen is not difficult if you know how. First you have to know just a little about how a TV picture is built up on your screen. A TV picture is a series of lines scanned or written onto the phosphorus on the screen. It takes about 1/30 of a second for each picture to be completely written on the screen if the power derived from the household outlet is 50 cycles per second as it is in the United States. TV sets designed for countries having 50-cycle AC power also have a 1/30-sec. scan rate even if they are battery-powered. For countries with a 60-cycle AC power system, the TV picture scan rate is a little faster—the equivalent of approximately 1/60 sec. It's good to know this if you are traveling. The use of faster shutter speeds will show you either a black bar or part of the picture when shooting a TV screen. You could use a slightly slower shutter speed, but there really isn't any reason to.

These photographs show the reasons for careful exposure selection when photographing off your television screen. Notice the black band in the top photograph, which is present because of incorrect exposure. The second image is perfectly acceptable because the proper setting was used.

IN A FLOWER GARDEN

EQUIPMENT RECOMMENDATIONS

Camera

Closeup lens

Daylight-balanced film

Exposure meter

Flash

Reflector card

Small jar of honey or sugar water

Spray bottle of water

Tripod

As these two photographs demonstrate, light-colored flowers are easier to photograph than ones with deep colors because light flowers bounce more light around and allow the photographer to stop down to an aperture where more of the picture can be brought into focus. Notice the difference in exposure under the same lighting conditions.

A lot of people take delight in photographing flowers, as they are beautiful and totally non-threatening. They don't comment on the success or failure of the photograph as humans do; they just stand there and let you take pictures. Unfortunately flowers are uncooperative in that they often grow in areas not exactly conducive to picture-taking especially when you are working close-up.

Another thing about flowers is that they blaze with splashes of color that look just fine on location in the garden, but tend to be overwhelming on a slide or a negative. It is said that nature paints with a big brush but that the artist must learn to select what he or she lays down on canvas. The same is true for a photographer. Often less is more; a single blossom or flower is more expressive of the whole than a field of flowers. Closeup photography tends to automatically move the photographer into the area of photo-minimalism by its very approach.

The closeup photographer soon learns a few interesting things about light when working with flowers—the way light manipulates the way we see and record things. Morning and evening light produces fairly hard sidelighting that brings out texture in a flower and leaf. Noon sun, less desirable for photography other than closeup work, allows the photographer to probe the open flower with the lens. Backlighting will rim a flower or leaf with a halo of light, or if the flower or leaf is thin enough, it will allow you to shoot your subject transilluminated like a stained glass window. In this light inner details are revealed that at first glance are often passed over by the eye.

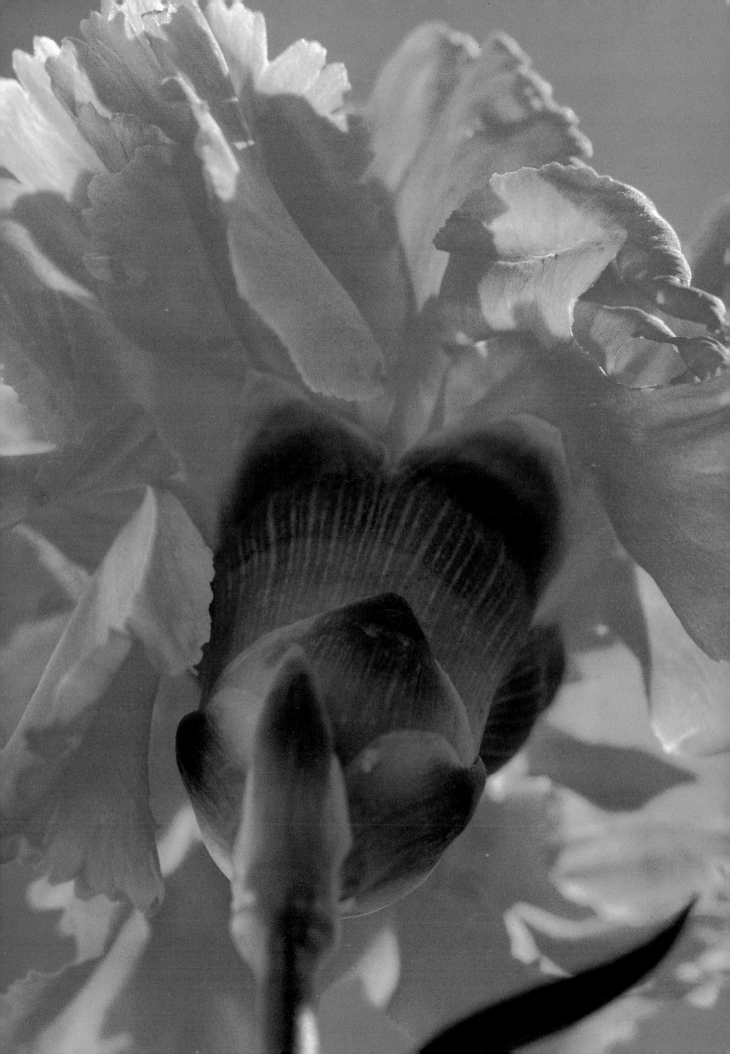

(Preceding page) This bug's-eye view of a chrysanthemum is the result of a decision about background. The photographer didn't like a background of more flowers, so she held one in her left hand and photographed it against a clear blue sky. It takes a bit of skill to manage a camera one-handed, but this is a useful skill to develop for closeup work. The flower is backlit, which required exposure compensation that is necessary to make the best of the flower and the sky.

(Below) The center of a carnation entirely fills the frame. Even in closeup photography, many people have a tendency to stay back too far, trying to get everything in. Practice not doing this. Try getting details, even of such a small object as a tiny blossom. This will enhance your creative eye.

It seems simple; after all the flower just stands there and you take its picture. This may be true, but there are a few minor problems to consider. The first is light. If the flower is a shade-lover or makes its habitat on the forest or garden floor, lighting can be tricky. Here your flash unit may be the best solution. With the flash you can duplicate all the lighting situations that daylight can offer: flat light, side, back, and even noon overhead lighting.

Motion is another problem. While the flower is hardly likely to get up and run away, flowers are sensitive to the lightest breeze. That apparently slight sway of the stalk and flower head is amplified tenfold when you move in for a tight closeup. Careful observation often allows for quite slow shutter speeds even in breezy weather if you watch and wait and then press the shutter when the plant has finished bobbing about. Or you can erect a small screen to keep the wind off. Picking the plants and

taking them indoors is one solution, but it's also cheating! A light screen will generally solve the movement problem. The surest way is to rely on your flash unit. The flash may be the sole light source or to balance daylight as a sort of closeup synchronized sunlight. It's very easy, and with a self-sensing electronic flash, there is virtually no calculation involved. A little is required if you are using an extension tube or a macro lens.

If you are not an early riser, then you will probably miss the effect of mist depositing dew drops on your subject. The solution is to take a small spray bottle along with you and create your own dew effect. This way you will be able to get sparkles on the flower, which really do add life to the final picture. With high-image magnifications you will notice that the depth of field at any lens aperture, even the smallest, will be fractional—a few milliemeters at the most. Stop the lens down as far as you can and choose your area of sharp focus with care. Better to have the tips of the stamens of the flower sharp and let the petals emerge from soft focus than the other way around. It's a little like shooting a portrait. If the eyes are sharp, then the viewer accepts the rest of the image even though the sharpness falls away rapidly.

Try to isolate one flower from the rest and concentrate your photography on it. Because of the extremely limited depth of field any blooms behind the target will be recorded as a blur of unsharp color, with your specimen standing off in an almost three-dimensional effect.

Most people think of flowers as the wonders you see in the florist's window. Not so. Some are so tiny as to require quite high image magnification to fill the frame with just one of them. Trees and shrubs have flowers, some of which are large and almost vulgar and some are tiny creatures on a twig and only show color when it is revealed by a good macro lens or when an extension tube or bellows is used. If you look carefully, a very small area of a garden will provide an epic of exploration.

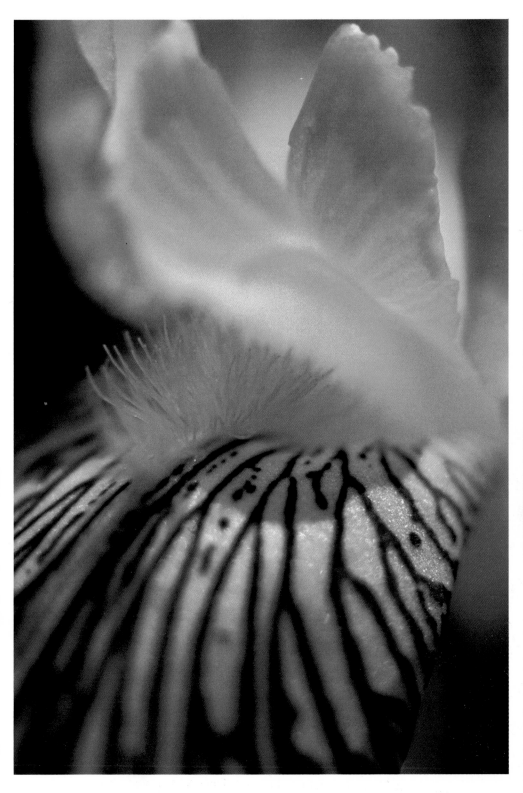

The photographs shown on this page display only a small portion of the ways that a flower can be photographed. The full-frame photograph of the petunia shows off the structure of the entire blossom (top), while bright sunlight draws the most from the colors of a geranium (center). The tight framing of this photograph emphasizes an infinite pattern of blossoms. An extreme closeup view (bottom) shows a composition created purely for its color and design. The photograph of the yellow iris (left) makes the most of the exotic structure of this flower. The limited depth of field has been used creatively to emphasize the texture and stamen of this unusual blossom.

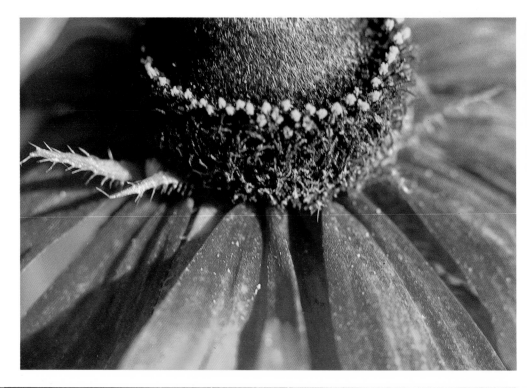

A zinnia photographed in the late afternoon shows one of the many variations of this flower. The ambient light allowed the photographer to stop down to a smaller aperture. Compositionally, this is an effective picture because the radiating design of the petals is used to lead the eye to the raised center with its delicate yellow crown.

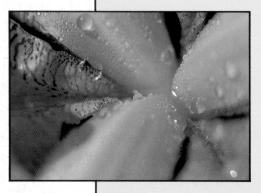

These two unique views of an iris show flowers can be photographed to display a number of unusual abstract images. Taken with available light early on a gray morning, the photographer shot the flower at the camera's widest aperture out of necessity. The area of sharp focus is severely limited, but is used creatively for a pair of soft, colorful images.

NEW APPROACHES TO CLOSEUPS OF FLOWERS

Flowers are among the most popular subjects for photographers, whether seen in closeup or from the normal view. But for the most part the flower pictures that we see are often conventional in approach and execution. Once you are familiar with your equipment and approaches to closeup photography, it is a good idea to extend your vision by experimentation. The only thing lost by experimentation is the cost of a few frames of film if the experiment fails. So if something out of the ordinary strikes your mind's eye, go ahead and snap it—after all, nothing ventured, nothing gained.

Use your closeup equipment to explore and analyze a flower or plant. Note the way the petals appear under various lighting effects, such as sidelighting, backlighting, and transmitted light. Move in even closer to examine the individual stems, stamens, and leaves. Think of the flowers in terms of their color values alone. Many times, flowers are associated with feelings or emotions—the innocence of a daisy for example. Often the seed pods of a flower or plant are as interesting as the more flamboyant blooms. In short, even the singular subject of a flower allows the photographer working in closeup to explore the world around him in terms of details and magnificent imagery that were previously beyond the reaches of the imagination.

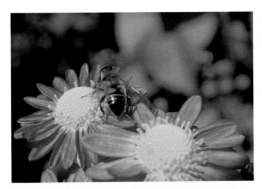

(Top) A bee perched on a yellow zinnia is an example of the kind of interaction that occurs in the world of plants and small animals. Notice the green-tinted shadow beneath the bee, caused by light passing through an overhead leaf.

(Center) A marigold and grass photographed very late in the afternoon have a rich golden-orange tone. This effect was achieved when the sun falls and approaches sunset and red rays are perceived longer than other parts of the spectrum. When you choose to warm an image, remember that one way to do this is to photograph late in the day.

(Below) White daisies with water drops were photographed outdoors, with a white reflector card positioned behind them and on both sides to maximize available light. This allowed a small aperture to be used and gave maximum depth of field.

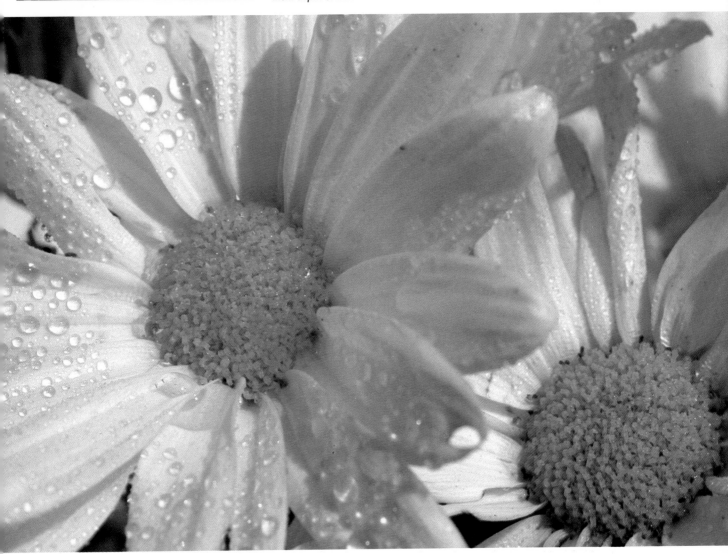

PROBLEMS AND SOLUTIONS

As we stated previously, the chief problem is lighting and subject movement. The former may be solved with judicious choice of a specimen, faster films, and, alternately, an electronic flash unit. Movement may be eliminated with careful choice of shooting days, small screens to keep the wind off, or stopped by using faster shutter speeds or an electronic flash unit. The choice of film is governed by the factors outlined above and by the amount of magnification you intend to apply to the image. If you are shooting at fairly low magnification or with diopters, you will not lose lens speed nor need to take special precautions. At higher magnifications where lens speed and depth of field become critical, you might like to go to the faster color and black-and-white films just to give you that extra edge.

(Above) Even the smallest of flower gardens will contain a large variety of different shapes and colors. This combination of pink carnations and red salvia creates a pleasing study in structural contrast and color harmony.

(Right) The thin, almost transparent petals of flowers lend themselves to interesting lighting effects. Here, backlighting provides a delicate view of the structure of snapdragons.

AROUND YOUR TOWN

Whether you live in the city, a suburban setting, or a rural town, you can discover more details than you would have ever imagined if you look close enough. Many cities are world-famous for the beauty of their tall buildings or their carefully landscaped gardens and parks. If you live in such a large metropolitan area, look beyond the notable landmarks—an exciting closeup may be contained in a detail of a piece of statuary or at your feet in the intricate pattern of that manhole cover you step on every day. Perhaps your town contains well-maintained examples of period houses. Examine them close up and document the interesting embellishments of a door frame or other exterior decoration.

Choose a theme for this photographic excursion—there's no doubt that your city or town can provide enough subject matter for it. Is there a particular color that seems predominant in your area? If so, photograph it in all its variations. Think about textures—the roughness of weathered stone, the polished gleam of newer structures, the peeling paint of that run-down building nearby. Strong graphic shapes and lines usually abound in details of buildings.

EQUIPMENT RECOMMENDATIONS

Camera

Closeup lens

Daylight-balanced film

Dulling spray

Exposure meter

Extra batteries

Flash

Lens cleaning kit

Polarizing filter

Tripod

UV filter

The strong directional lighting on this utility grating allows the embossed letters to come forward from the background, as well as the textures present in the gritty surface of the metal.

APPROACHING THE SUBJECT

The photographs shown in this chapter give ideas that can be applied in most cities. Look for window boxes, trimming and borders on buildings, colorful signs, details of unusual things. Set aside an afternoon for looking at things you usually don't look at—the tops of buildings or sidewalks. Take time to study houses, posters, storefronts. With some practice, your eye will soon discover small areas of beautiful color, design, and pattern that you may have never seen before, even in places you pass every day.

Try taking the route you normally take to work, and document details along the way. It can be truly amazing how much you do not see in your daily rush and how much detail you've overlooked through mere habit.

Take this opportunity to rediscover places and things that are part of your everyday life. Try several varieties of closeups with mailboxes, signs, posters, bus tokens, newspapers and magazines at a newsstand, doors, storefronts, walls of brick, stone, concrete. Look upwards and downwards. You may find wonderful images by looking consciously at a different level than you would ordinarily.

If your city has a park, and even small towns usually do, there are nature images, statues, and perhaps even a zoo. Keep your eye out for unusual elements or colorful spots.

Use the photographs in this chapter to give you some ideas. If you keep them in mind in your travels, they will help you see. You will notice that you are more aware of designs and trimmings on buildings, objects people have left behind, potted flowers maintained by meticulous homeowners, exciting textures in manufactured objects. An afternoon spent on this project may permanently upgrade your visual awareness.

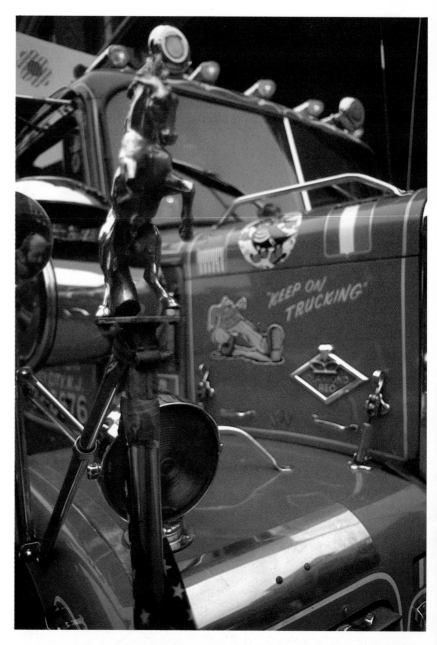

(Top) An elegant red garbage truck was shot with a 28mm wide-angle lens set to its closest focusing point of about 1 1/2 feet (46 cm), which helps exaggerate the overall perspective of the scene. Metering was for the red of the truck and not the shiny chrome.

You will find that unusual abstract images abound in many areas of a city or town. This attractive design pattern is actually a pile of pipes, recently delivered to a construction site.

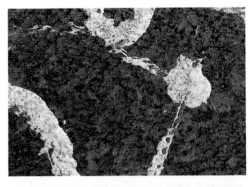

(Below) An extreme closeup view with very sharp focus aids in creating an image of strong emotional content. The texture of rusting metal and the tensile strength of this piece of barbed wire evokes a feeling of constriction and bondage.

(Above) Texture will be found wherever you see flaking paint and corroding metal. Strong directional light is a key element in bringing out texture on flat surfaces. It will help to maintain sharp focus through good depth of field.

93

There is a lot of beauty and a lot of wonderful picture material in the city. If you can't stand the overview, then shoot the fine detail. In other words, go for closeups rather than cityscapes.

Are there any problems? Not unless you count the difficulty of taking the exact shot you wish to take. A small piece of scroll work or a caryatid high on the facade of a building is difficult to shoot unless you have a scaffold—or a telephoto lens. It is quite likely that you could even put a short extension tube between the lens and the camera to increase the image size for a better frame fit. This technique is good for shooting over railings and for general access to difficult material.

Most city dwellers are so accustomed to cameras that they are hardly aware of them and don't care if you point one at them. Even so be discrete. Some people do object to having their picture taken. Try to see things from another's point of view, and take that into consideration before you start waving a camera around.

Watch out for lighting in a city, especially one with tall buildings. On the sunny side of the street the meter may try to climb off the scale; in the shadows it will plummet. That means part of the scene is in bright sunlight and the rest is in shadow. Very few films will be able to handle the contrast, especially color films with their narrow tolerances.

Where there are buildings mainly of glass, watch out for reflections. The bright flash of sun off such a facade will deceive your meter. Pick your subject matter with the light in mind and always be conscious of its intensity and color.

When you go out with your camera, it's a good idea to make sure that you are not caught with too few rolls of film. But don't carry too much equipment. It's a sad statement of our times that cameras and lenses have a high resale value to the thief. Putting a loaded camera bag down while you wander off to take pictures is asking to find it missing when you return. If you take your car, don't leave equipment even inside a locked car.

Stores and store windows make excellent closeup pictures. You will almost certainly require a polarizing filter to get through the reflections. Watch out for paranoid store owners, especially if you are trying to shoot expensive jewelry! The same applies to banks, which generally have intricately engraved designs on their outside night deposit boxes. Bank guards are a bit nervous about photographers hanging around taking pictures. If in doubt or if you are queried, see the manager or another bank official.

A white fence with geraniums shows that often part of the scene is indicative of the whole. Here the photographer chose to use a closeup approach and deep depth of field to emphasize the dramatic effect of the lines of the fence and the wall behind it. There are three basic planes of sharpness that required a small lens aperture to achieve overall sharpness in the shot.

The facade of a building was shot with a 400mm lens at its closest focusing point and stopped down to the smallest lens aperture to obtain sufficient depth of field across the areas of interest.

LINES OF STRENGTH

Composition based on lines of strength is an aspect of creativity shared by photographers with other visual artists. You can base a photograph on lines: radiating outward, or toward the center of interest. It is a good idea to learn all you can about composition and other visual concepts in any form available to you, and then think about how to use your understanding photographically.

Because leaves are symmetrical, isolating any part can be used to express the leaf's symmetry or to function alone as a graphic element. In this photograph the lower portion of the leaf and upper part of its stem are singled out. The center line of the leaf makes a strong central vertical, and the other veins of the leaf radiate outward, filling the frame with an essentially designed image.

Expressing lines and their inherent interest is another approach to composition with a leaf. In this case, just one edge of the leaf is photographed, with very graphic shadows, to make an angular image that is recognizable as part of a leaf, but that stands alone as an exciting photographic composition.

Another treatment of a leaf is to photograph it in a straightforward manner, with the heavy center line in the center of your image to give it strength and the curving lines of the mirror image filling it out in a regular and interesting manner. The photographer should know many options for placing a subject within the frame of a picture. Because of the refinement of his seeing, the photographer picks the composition that pleases him most— a process of going through compositional options. The photographer, wishing to shoot the center of an autumn leaf, might have thought through all these options and then chosen only one.

For a variation, the photographer has chosen to place the heavy center line of the leaf across the diagonal of the image. Diagonal lines are very powerful in composition. Study the difference between the third illustration, which shows a fairly calm and regular structure, and the fourth photograph with its powerful diagonal. Keep this in mind when you are photographing closeups, and before you take a picture, think about whether the lines and elements of your subject make the most of the frame of your eventual picture.

The illustrations shown here are but a few of the possibilities of linear design reflected in a single subject. In the first illustration, the bottom portion of a leaf is isolated, with the lines radiating upward and outward from the bottom of the image. In the second illustration, only the edge of the leaf is pictured, creating a strong graphic composition. In the third illustration, the central vein of the leaf becomes the horizontal plane of the image, while in the fourth illustration this same element is placed on the diagonal, creating an entirely different linear composition.

IN A DESERT

EQUIPMENT RECOMMENDATIONS

Camera

Closeup lens

Cooler

Daylight-balanced film

Exposure meter

Extra batteries

Flash

Lens cleaning kit

Polarizing filter

Terrarium

UV Filter

For most people the word "desert" generates images of the burning sands of the Sahara and the Kalahari—arid, hot, and lifeless. While it is true that a desert is an extreme environment where temperatures may soar during the day and plummet to freezing at night, it is absolutely wrong to think of a desert as an area devoid of life, or exciting subjects for photographs.

There are thousands of plants and animals, reptiles and insects that have adapted to this demanding terrain. Many of these creatures and plants are possessed of natural camouflage as a means of protection. While these patterns and textures make them more difficult to seek out and photograph, they are excellent subject matter for closeups. There are literally thousands of species of cactus to be found in these areas, many of which burst forth at certain times of year with glorious blooms that bring vibrant color to the desert floor.

The desert is not the most comfortable place for a photographic adventure and it takes much patience and tolerance for dust to be successful. But you will certainly find that your results are worth the effort.

A barrel cactus and prickly pears make formidable friends. A 28mm wide-angle lens was used to take this picture. The foreground cacti are only a few inches from the front of the lens. A very small lens aperture was used to sweep the sharpness across the entire thicket of cacti.

APPROACHING THE SUBJECT

Don't ever think that a walk, even a short walk in a desert area, should be taken lightly. Even if the desert is no more menacing than the arid area on the side of the highway, it is advisable to know what to expect. Some of the inhabitants, both plant and animal, have ways of protecting themselves against would-be aggressors. So if you aren't sure of it, don't touch it.

That's the nice thing about closeup photography though—you don't have to actually touch a cactus to photograph it. The lens does the touching for you. If you do meet up with an ill-tempered inhabitant of the bad lands, you can always stand off aways by using a telephoto lens and a short extension tube or even a closeup lens to increase the image size.

It's a good idea to make sure that you have some water and a good pair of boots and do wear a hat. You can get so involved in your photography that you don't realize that the sun is hot and pounding down on your head. Sunstroke is *not* a myth, and although it won't kill you, it can make you quite ill for a few hours. Try to get to your chosen area before or after noon; two or three hours either side of noon is best so that the light has some angle to it and the heat has not yet built up. You will get very shimmery establishing shots as the heat rises, and at such times anything except wide-angle, standard, or at the very best short telephoto lenses become largely useless if you intend to shoot an overview of the scene. Desert creatures tend to hide as it gets hot, so there is less and less to see as the sun climbs toward the zenith.

PROBLEMS AND SOLUTIONS

Closeup photography in the desert requires much the same lens, camera, and film as does any other type of closeup work. It is still a good idea to take your flash along to help balance the harsh desert light. Don't leave a camera bag in the sun. Heat fogging will soon result. Keep your film cool by wrapping it in an ordinary blanket and then wrapping a light, Mylar foil space blanket around that. Open the package as little and as quickly as possible. Keeping the wrapped film in a small polystyrene cooler in the trunk of your car is a good idea too.

Deserts are by nature dusty. Be careful when changing lenses; make sure that any dust or sand particles are blown off the lens and camera *before* you dismount the lens. The same applies when preparing to load and unload film. Blow the dust off before opening the camera back. Use a forced-air or Freon cannister if you must, but use it with caution. Don't blow the dust into the camera. Clean lenses with great caution if you are using tissues; it's a good idea to carry a soft brush to clean off the lens surfaces before wiping them with a tissue. As an added precaution it's not a bad idea to put a clear UV filter over all the lenses you intend to use in such areas.

If a dust storm starts, get your equipment safely away in its bag or box, and get into your car or head for cover. Even a mild dust storm will drive penetrating dust and sand particles into everything. One thing about dust storms in the desert, afterwards they usually make for splendid sunsets.

(Above) This cactus flower was shot with a 50mm macro lens from a distance of only a few inches. A lens aperture was chosen that would supply adequate depth of field to render the flower entirely sharp but throw off the background and thus isolate the bloom from its surroundings.

(Right) Here a 100mm macro lens was used to provide a good close-up of the ferocious spines from the safety of about 12 inches (31 cm). Focus was actually placed at the withered flowers on the top of the cactus and sufficient depth of field derived from a very small lens aperture.

TELLING YOUR METER WHAT TO DO

Exposure meters and exposure meter systems are essentially simple machines that do their work well, even if they somewhat lack initiative and imagination. With the exception of spot meters that are designed to read a narrowly defined area of an image, most meters read the amount of light in the entire scene, average out the brightness and the shadows, and come up with a usable exposure setting either manually or automatically. Special situations aside, these settings are, for the most part, ac-

The photographs at left show correct and incorrect exposure of the same subject. The first photograph is properly exposed, but it was not taken at the setting recommended by the camera's automatic meter. Instead, it is the result of a bracketed series of exposures that also produced the second picture, which is underexposed by a full stop.

curate and quite adequate. No matter how good the meter, it is no use at all if you forget to feed it the proper data concerning the speed of the film. Most exposure mistakes can be traced to this simple error: the photographer simply forgot to set the film speed into the meter.

The film box carries an important piece of information. Read this if you never read anything else—that is the speed, or sensitivity, of the film inside the box. If it states that the film is, say, 200 ISO, then that's what you set the meter to in the camera or the setting dial of a hand-held meter. Once set it's a simple matter to point the camera or the meter at the scene and arrive at an accurate evaluation of the amount of light in the scene. This information is then automatically interpreted by a small computer in the camera (if it has an automatic exposure) and translated into the correct selection of lens apertures and/or shutter speeds. If the camera requires manual metering, you have to turn the appropriate controls. If you are using a hand-held meter, then you transfer the information from the meter to the camera.

Taking the film manufacturer's speed rating for the film as gospel infers a lot of trust. Set the basic ISO and see if you like what you get. When using a new film, try a series of exposure brackets around the basic metered exposure and see which negative or slide gives you the most pleasing results. You may find that setting the film speed dial a little above or below the manufacturer's rating is more to your liking.

Another common source of exposure errors is failed batteries. Take care not to become so trusting of your camera's exposure-determining skills that you forget to check the viewfinder for exposure data. If you fall into the habit of leaving the exposure entirely up to the camera, and your batteries are dead, you eventually will end up with unusable pictures. Replace your camera's batteries at least once a year, or as needed.

ON A RAINY DAY

Photography is an art form that can be practiced at any time and under any conditions. Given an afternoon with dismal weather, a photographer can still take pictures indoors and, with some imagination, produce some fantastic images. This adventure will teach you to observe your surrounding and seek out found objects in an effort to turn the usual into the unusual.

The illustrations in this chapter use many household items as subjects. Look around you and try to see the common objects you use everyday in terms of their photographic possibilities—nothing is impossible as a subject for closeup photography, if you have the means to successfully light it and if it is basically photogenic.

During this project, you can learn many of the techniques of studio photography on a small scale. You can improvise sets from plastic, cardboard, and paper that function as moveable walls and scrims and rolls of seamless paper do in large-scale studios. Feel free to experiment with this project. You will learn many artificial lighting techniques.

EQUIPMENT RECOMMENDATIONS

Camera

Closeup lens

Dulling spray

Exposure meter

Extra batteries

Flash

Lens cleaning kit

Reflector card

Reflector lamps with 3400K bulbs

Table-top set

Table tripod

Tungsten film (Type A)

UV filter

A candle flame was photographed in front of a red plastic tabletop set improvised from a red plastic box, with its two halves at right angles. One photolamp with a reflector bulb was placed behind the red plastic background to make the red rich in saturation. This is a very simple, effective image with good color that might make an original greeting card.

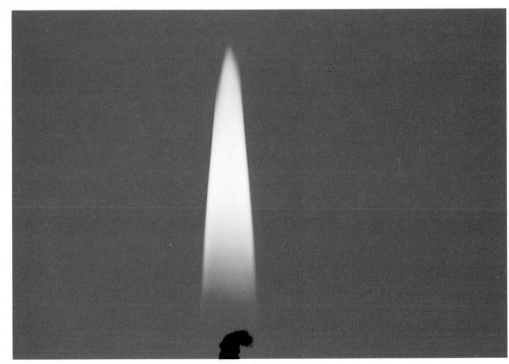

One setup may suggest another; follow your creative intuition until you have produced images that really satisfy you. Start by selecting a group of objects and materials as subjects. Then think about backgrounds and settings, and assemble some found materials that will serve these uses. Now think about illuminating your subjects and what sources of light you could use. Anything from a desk lamp to sophisticated photographic lighting equipment and flash can help you produce closeups.

Think about color, design, texture, composition, lighting. Take time to set up your shots. Vary each setup as much as you can to see how far you can stretch your technical knowledge and creative impulses. You will probably find that you will get so caught up in the improvisation and technical imagination of this project that the entire afternoon will pass in deep concentration and much entertainment.

Try some experiments based on color. Set up a red background, for instance, and photograph red subjects in front of it; then shiny subjects that take on red reflections; then green subjects—study how colors interrelate. Some colors when combined, seem to vibrate, creating a thin shadow that we may interpret as another color.

Try images you have seen in magazine advertisements—dripping syrup or carbonated beverages. These images are not as simple as they look. You can learn how to handle many such technical challenges in rainy day projects.

Experiment with lighting your sets and backgrounds. Try direct lighting from above, from a 45-degree angle, from other angles. Try backlighting a translucent environment, but take care that your exposure meter is not fooled by the backlighting. You need to

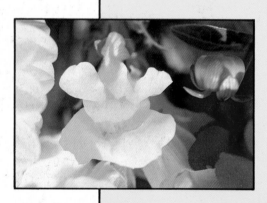

COMPOSING WITH COLOR
The use of color as a compositional tool can create powerful images, yet color is often one of the most misunderstood aspects of photographic technique. A simple rule of thumb to keep in mind when working with color is that less is more. It is far better to limit the number of different primary colors and tints than to jam everything in the frame of your photograph. Be selective; use color to emphasize or modify a particular element.

If you look at the two photographs used to illustrate this section, you will agree that the first picture has a messy composition, while the second picture is much tighter and more emphatic due to the use of bold colors and careful placement of the flowers.

Keep in mind as well the specific physical and emotional qualities of color. Cool colors will recede within a scene, while hot, bright colors advance toward the viewer. Colors are often used to represent emotions—red is associated with excitement, blue with peace and tranquillity. The vibrancy of specific hues and tints will affect the viewer's reaction to your photographs. Use color to work for your images—not against them.

Of course, anyone can slip a colored filter onto the front of the lens to alter and artificially enhance the colors present in a scene, but a skillful photographer will learn to employ nature's palette to obtain realistic, yet equally spectacular results.

Variations on a theme can be an entertaining and educational project for a rainy day. Work with a common object placed with a variety of incongruous articles, in different backgrounds and lighting setups.

(Above) Green cough syrup was poured into a glass and placed in front of a red plastic tabletop set to produce some fascinating effects and tinted reflections.

This abstract image is an egg painted with glossy nail polish and placed in front of a red plastic set and illuminated from the front with a single photolamp. This suggests one of an infinite number of close-up possibilities that can be created with an ordinary but distinctively shaped object and paints.

adapt your exposure just as you would with natural outdoor backlighting.

You can try a series of abstractions of some household object, with each image further removed from its use or normal relationship. Try this concept with a pair of scissors or a toothbrush or a wrench. Take a series of pictures for their pure aesthetic importance, deliberately trying to undo the ordinary sense of the object. There are many ways to do this. Experiment with angles other than straight on that will change the proportion and perspective of the object. Suspend the object so that you can take unusual shots along its planes or emphasize a minute part that is often ignored in everyday activities. Change the color of the object with filters or reflected tinted light.

Keeping notes on how you produced your images can be a useful self-teaching device, as many of your pictures may surprise you once they are processed. Though most photographers do not take the time to document their setup and exposure data, it is a good idea.

Any light source can be used, and the more powerful the better. At the simplest end of the equipment scale, you can use a high-intensity desk lamp; or you can go to your local hardware store and buy a clip-on lamp holder and fit it with a reflector bulb chosen according to the type of film you use. On the professional end of the equipment scale, you can use spotlights designed for professional studio work.

Since this is actually a still-life project, you may want to organize a simple set surrounded by reflective white cards or with a large sheet of paper as a seamless background. Or you may want to experiment with colorful glowing backgrounds produced by transilluminating a sheet of colored plastic.

Composition is important in still-life artwork. Arrange your subjects so that they have graphic appeal and are used to advantage in the frame of your image. A poorly composed image may be pretty, but it will lack the quality of one that is skillfully composed.

PROBLEMS AND SOLUTIONS

A rainy day adventure in closeup photography will teach you a lot about the problems of working with artificial light. The most common form of artificial light used by photographers is the electronic flash unit. This is a good opportunity to explore the problems encountered in using your flash and present some easy methods for overcoming them.

When used in closeup work, the flash is looking over the subject as is the sensing eye in the case of an automatic flash unit. This is known as "parallax."

To solve this problem, aim the flash so that the sensor is pointed at the subject. Use a flash that has a removable or remote sensor—one that you can put in an adaptor and slip into the camera hot shoe. The flash unit is than attached to the other end of the sensor cord and the flash head angled accordingly. But what if the flash unit is hot shoe only and the head does not swivel or bounce and the sensor is fixed? Use a PC cord hot shoe adaptor, but be sure that wherever the flash is, its sensor is aimed at the subject. Another trick that works well when the subject is too small for you to accurately predict where the sensor of the flash is aimed is to let the sensor see an 18 percent gray card held above the subject but at the same plane and distance. You can use your hand for this; it works well.

If your camera has a through-the-lens flash meter, all you do is aim and shoot.

Another problem is that by moving a lens away from the film plane more than it is supposed to be, you change the effective lens aperture. This frightens a lot of people away from using flash for very closeup work. Don't let it. Flash is the most useful tool for this type of photography. Let us assume that you have a self-sensing automatic flash unit and you wish to use it for closeup work. How do you tell it that you have actually altered the effective aperture—that $f/16$, say, is no longer $f/16$ but probably $f/22$ or even $f/45$? If you are using a macro lens, you will find a scale engraved on the lens barrel that tells you how much compensation to add to the exposure. Let's say that the lens exten-

Since the photographer has complete control in an indoor photo session, even the most fleeting of subjects can be successfully caught on film. This soap bubble was trapped inside an ordinary drinking glass so that a maximum of flat surface could be attained. Holding the glass under one direct overhead light, the photographer then tilted it until the desired amount of reflection was attained.

sion requires that you increase the exposure by one *f*/stop. Now opening the lens aperture of the camera might do the trick, but you need to work with your lens stopped down to, say, *f*/16, for the depth of field. How are you going to get that added light out of the flash? Set the flash unit's ISO film speed dial one notch lower. Here is an example. Imagine you are using a 400 ISO film and need to get the flash unit to put out more light than it would normally for a given lens aperture at a given film speed. If you set the ISO dial to 200, you have effectively cheated the flash into thinking it has a slower film and it will figure out the exposure for that film speed.

Moving in for a much closer view of the soap bubble shown on the previous page, the photographer has successfully imitated the type of photograph usually captured through a microscope. The amount of light reflected by a soap bubble is extremely high, so these photographs were underexposed 1 1/2 stops for proper color rendition. The heat given off by the light directly overhead will cause the bubble to burst, so photographs such as these should be taken very quickly.

ON A WINTER DAY

Winter is a wonderful time for the closeup photographer. Instead of shooting endless photographs of the frozen landscape, concentrate on the imagery that can be found on a snowy day if you look close enough.

Even if you don't live in the country, a quick frost overnight can turn a city into a beautiful place, if only for a few hours. And if you don't feel like getting out there before the new-fallen snow turns to slush, the patterns of ice crystals on your window make for wonderful closeup pictures, especially when the sun is shining through the frost.

If it is true that no two snowflakes are alike, then think of the variety of images you can capture on a winter day. When snow clings to the barren branches of a tree and icicles form to create natural sculpture they offer the ambitious and hardy photographer subject matter in an abundance equal to any flower garden on a warm summer day.

Light sparkling on ice can be a spectacular subject in its own right and even frost on windows can make a beautiful winter closeup.

EQUIPMENT RECOMMENDATIONS

Boots and gloves

Camera

Closeup lens

Daylight-balanced film

Exposure meter

Extra batteries

Flash

Lens cleaning kit

Plastic "camera raincoat" bag

Polarizing filter

Reflector card

Tripod

UV filter

A photograph of ice crystals on a puddle was a shot of a small puddle of rain water in the garden. A 100mm macro lens was used, stopped down for maximum depth of field. The use of a fast color film provided adequate hand-holdable shutter speeds. No special lighting was used—just diffused sunlight from an overcast sky.

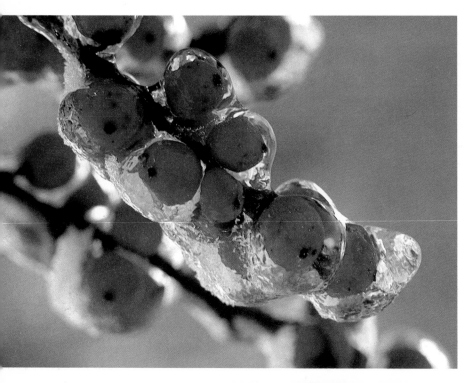

(Above) Shallow depth of field can be used effectively to separate the subject from the background, as in this photograph of berries encased in ice.

(Right) This ice crystal branch was found lying in a winter stream. Pulled out and propped up so that the setting sun shone through, it produced this interesting semi-closeup. The lens used was a 100mm macro at f/4. This allowed sufficient shutter speed for hand-holding and the best compromise needed for depth of field to sup-ply just enough sharpness and still throw off the background trees.

(Opposite page, top) A small area of ice over a waterfall re-quired that depth of field be again kept to the minimum to separate the subject from the background water. A slow shutter speed (around 1/30 sec.) was also used to make the water appear more like a sheet of silk than the actual splashing spray which formed the ice crystals. The camera was hand-held so that the sunlight struck the ice crystals at a very hard angle from the side. This closeup was shot with a 50mm lens at about 3 feet (91 cm) and with no special attachments.

APPROACHING THE SUBJECT

Generally, pictures of ice and ice crystal for-mations work best when the ice is treated like cut glass and carefully lit from the side or even from the back. Ice has texture, and lighting should be chosen to best show off that texture. Ideally the best time to go out looking for really impressive ice pictures is after a heavy freezing rain or ice storm when trees, bushes, and grass are coated with a myriad of gems. How do you know if the light is right? Just look. If there are miniature prisms of ice breaking the sunlight into rainbows, you are pointed the right way. Try to get the light behind or almost behind ice crystals and ice sculptures so that they are transilluminated and refract the light. If you can hide the sun itself behind a branch or the ice, so much the better, as it will eliminate the problem of lens flare. Ex-posure is a matter of experimentation. If you let the meter in the camera do its thing, you will indeed get crystal-looking ice, but you may well end up with an underexposed shot.

If you are shooting a fairly large piece of sunlit ice, remember that the meter will try to bring the exposure to an average 18 per-cent gray tone and muddy up the results. Increase the exposure indicated by one to one and a half stops to correct this tend-ency. You should also bracket, since such experiments with exposure often bring sur-prising results. There is no reason you can-not use your flash unit. It's best to use it with a remote sensor cord or an auxiliary PC cord and duplicate the same lighting as recommended for sunlight exposures.

If you cannot find branches encrusted with ice to your liking, it's easy to make your own. Find a suitable branch or twig and dip it in a nearby stream or run water over it. Hold it up in the freezing air, and it will coat with ice. Keep wetting it until the ice builds up to your liking and then photograph the result.

Special effect filters can also add to your ice pictures if used judiciously. When you are shooting into the twinkle of ice crystals, a star burst filter will produce breathtaking results, as will a rainbow filter. Special effect filters should not be overused though, since you and your audience will soon tire of the result. For the most part keep it simple and let the light and the ice do the work.

PROBLEMS AND SOLUTIONS

One of the most alarming facts that photographers encounter in their initial attempts of photographing snow is that snow has a tendency to appear blue in the final image. This is a pleasing effect in moderation and placing a UV filter over your lens will help to keep it under control.

You should also remember that ice and snow are strong reflectors of light and lens flare will frequently occur in your photographs if you don't watch out for it. Use lens flare creatively or change your angle of view to eliminate it from the frame.

If you are working outdoors on particularly cold days, remember that your camera doesn't like the cold any more than you do. Your batteries and film will be affected in extremely cold weather. Keep your camera under your coat until you are ready to use it. Your film will become more brittle in cold weather, so take care not to advance it too quickly.

EXPOSURE TECHNIQUES FOR ICE AND SNOW

Many of the problems encountered in the photographing of snow and ice can easily be avoided by simply observing the angle of light through the lens before shooting. In this way the observant photographer can eliminate lens flare or hot spots of glare from his pictures.

Bracketing exposures is an especially good idea when photographing snow and ice, as each is very reflective and can fool the exposure meter.

The two photographs shown here illustrate the results that can be obtained when you think about the final outcome of the picture before you shoot.

The first photograph was taken from a low angle so that the berries were against the blue winter sky. The sun was behind and above the ice crystals to help give dimension to the shot. A fast shutter speed was used with a fairly wide-open lens aperture. The limited depth of field was taken into account for the shot and the actual focus is only on the foreground group of berries. This technique causes the part of the subject that was in sharp focus to stand away from the background for more emphasis.

The second photograph was shot using a single electronic flash unit held at a similar angle to that of the sun to transilluminate the ice and add rim lighting to the berries.

Proper lighting for pictures of snow and ice can depend on the angle of light. In these two photographs you can see correct and incorrect exposure. In the top photograph, close attention to the angle of light and its reflections allows for excellent balance between the background, subject, and glistening highlights on the ice. In contrast, the second photograph has a muddied background and an intrusive spot of lens flare improperly placed within the frame.

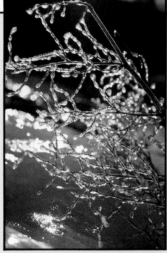

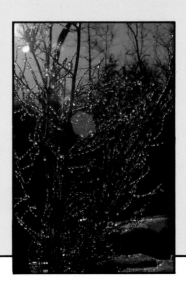

HOBBIES AND GAMES

EQUIPMENT RECOMMENDATIONS

Camera

Closeup lens

Daylight-balanced film

Dulling spray

Exposure meter

Extra batteries

Flash

Lens cleaning kit

Polarizing filter

Reflector card

Table tripod

Tungsten film (Type A and B)

UV filter

Nearly anything you enjoy doing can become the subject of exciting closeup pictures. The objects that you make or build, paint, play (musical instruments or electronic games) all offer good subject material. Collectors can document their stamps or buttons or even programs of great dance performances with closeup photography. The tools and equipment you work with can be photographed—as well as the *processes* you undergo in your work.

This project covers a wide range of subjects and a wide range of techniques. Flat objects need to be kept perfectly flat and well illuminated for best results. You may need flash or photolamps, or you may choose to use natural outdoor lighting.

Try taking your hobbies out of context and photographing them outdoors on a background of grass. Sometimes incongruity can add an important element to a picture. Or try doing the kind of closeups you see in catalogs—where a subject is well lighted without glare on a simple background. Previsualize your image and work with your lighting to make sure you achieve the kind of result you're after.

Closeups of a hobby are particularly exciting ones to use for decorating purposes—or as a unique gift for a fellow hobbyist. Rather than purchasing prints or any other kind of artwork for your home or apartment, try producing pictures that reflect your interests.

These playing cards were photographed outdoors flat on a white background with white card reflectors placed to give evenly bounced illumination. If your hobby is playing bridge, for instance, a closeup of some cards might make a unique decoration in your home.

APPROACHING THE SUBJECT

If you have a hobby other than or as well as your photography, you will almost certainly find exciting closeup possibilities. A philatelist might delight in making 1:1 closeup pictures of his or her collection of postage stamps. A model-maker can shoot very effective pictures of his or her models or of the fine detail in them. If flower arrangement brings you delight, then you have a colorful and beautiful still-life just begging to be photographed, and all but the largest arrangements will require some form of closeup technique to shoot them. The list is endless.

Your main interest should be in lighting your subjects. To bring out contrast, texture, and detail, very small items require careful lighting for best effect. For small objects such as models a perfectly ordinary high-intensity desk lamp in close is a useful light source. Just remember that where there is tungsten light there is heat. Alternately you can use your electronic flash unit to good effect, either using the light directly or bouncing it off a white card held at an angle or above the subject. Remember that the sensing eye of the flash unit must be aimed at the subject or object unless the flash is designed to meter through the camera.

As with all small objects it's best to try for a slower, finer grain film, be it color or black-and-white, for maximum definition. Since most closeup photography of such objects as models, stamps, pictures, and flower arrangements is static, you will be able to stop your lens down to its smallest opening for best depth of field.

(Above, left) Several hundred ink dot drawings executed on Japanese paper had to be shot for a slide show. The swiftest solution was to stick the drawings onto a sunlit window and shoot them transilluminated as one would a stained glass window. The camera was used on a tripod to ensure that the drawing and the film plane of the camera were exactly parallel so as to avoid keystoning the final image. (Art by Andrew Longo)

(Above, right) A detail taken of a pocket watercolor case was deliberately underexposed a stop to keep the red rich and maintain substance in the white areas of the plastic case. The photographer dropped water onto the cakes of color to bring out the richest possible color and photographed outdoors in warm natural daylight.

As these photographs show, any hobby can be photographed in closeup. You can depict a detail from a favorite painting or book illustration, and keep an attractive record of your stamp collection. A closeup of a map can be an interesting addition to the slide show from a recent vacation.

This photograph shows how simply a small tabletop set can be constructed from the most basic materials. A rich, red background was created for many of the photographs in this book by setting up the top and bottom of a plastic makeup kit. White poster board is used to simulate a reflective seamless environment.

SUBSTITUTING BACKGROUNDS
Shooting closeup pictures indoors does not present the large number of background problems that might be encountered, say, in a flower garden. Simply positioning your subject against a white wall or a white (or colored) card will do the trick. On the other hand, you might look around the house for creative backgrounds not readily available outdoors.

For example, many of the pictures in this section show the use of a translucent plastic box as a closeup background. The box can be illuminated from behind using a small high-intensity desk lamp or even a second flash unit. It could also be placed in a sunny window. Whichever way you light it, the effect is to get a colored background for your subjects. It pays to prowl around your house and see commonplace items with a new eye as to how they might be adapted to your shooting.

PROBLEMS AND SOLUTIONS

Taking closeup pictures of your other hobbies offers many opportunites for practicing the art. Of course, there is nothing to stop you from taking pictures of your cameras and lenses if photography is your only occupation, but let's assume that you have other interests as well!

The key to good closeup photography is lighting and the careful management of exposure and depth of field. We keep referring to these factors throughout this book. That should give you some idea of how important such matters are.

Metering for small objects: How are you going to get it right? Firstly, if you are using a camera with a through-the-lens meter, be it automatic exposure or manual, there is not too much of a problem when working with ambient light. Generally, the meter will base the exposure on what it sees through the lens. Even so it's a good idea to bracket your shots around what the meter sees. Bear in mind that if the meter sees a large bright area—perhaps the reflection off a musical instrument or a glass surface—that is going to mess up the meter reading. Try to meter an area that does not have spectral reflections or increase the exposure by at least one stop. If you are using a hand-held meter, then it gets just a little tricky. The best solution is to use an incident light attachment on the meter cell. Hold the meter by the subject and point the incident light receptor back toward the camera or even the light source. If you don't have or cannot use an incident light attachment, then get the meter as close to the subject as you can without casting a shadow on the subject and meter in a normal way.

Flash is a good illuminator of this type of photography, but it requires that you think before you let fly with a blast of light. If the flash unit is an automatic type with a sensing eye in the flash body, you have to make sure that the sensor is actually looking at the subject and not at the background. If you cannot get it to look where it should, then use a substitute target—a gray card or even your hand held at the same plane as the subject but out of the frame. If the flash is metered through the lens, there is really no problem except for the usual precautions via à vis reflections.

Remember that depth of field is at its worst when shooting closeup. Try to get the

Closeup photographs of subjects such as jacks and marbles can be an interesting way to remember the games of your childhood. Shiny plastic materials serve as excellent reflective environments for closeup photography. Notice how hexagonal spots of light appear on the jacks and marbles. There is too much light bounced into the lens to render these hot spots as highlights, but both photographs demonstrate the effective use of lens flare.

smallest lens aperture that you can for maximum sharpness across the entire area to be photographed. An object photographed parallel to the film plane is easier to deal with but less interesting than one that is at an angle to it. To get the maximum depth of field from your film and camera, try to get the light source as close to the subject as you can without frying it, if you are using a tungsten light source, or without getting too far inside the range of the flash unit if you elect to use your strobe. If you are shooting with sunlight, there isn't much you can do about getting the sun closer or brighter, but a good reflector often helps balance things out. The choice of film is governed by the type of light you are using. The speed of the film also determines the smallest lens apertures available for best depth of field in any given situation.

Creative use of lighting can render photographs of your hobbies as strong graphic images. Well-placed directional lighting brings out the texture of the hide of the baseball, while the seam becomes an important design element. The embossed lettering on a foreign coin is shown clearly, but careful consideration of framing and lighting add impact to the image.

IN A MEADOW

A meadow or open field in the spring-time can be one of the most enjoyable places to spend a day taking closeup photographs. The different varieties of grasses, wildflowers, and even weeds offer many opportunities for the photographer to capture nature at one of its most simplistic levels. In the most basic sense, a meadow is an attempt by nature to reclaim barren land. Keep this image of survival in mind and try to incorporate it into your photographs.

Once you have discovered a favorite meadow or field, you might want to return to it during the different seasons of the year and document the changes that occur. In the Spring, small plants and mosses begin to emerge from the thawing ground. Tiny buds appear and milk weeds begin to bulge before their pods finally burst open. In the summer, a meadow is dotted with delicate shades of purples, pinks, and blues, contrasted with a wide variety of greens and unusually textured leaves. By autumn, the plants of the meadow appear as naturally dried versions of their former selves, and often offer elaborate seed pods in their midst.

EQUIPMENT RECOMMENDATIONS

Camera

Closeup lens

Daylight-balanced film

Exposure meter

Extra batteries

Flash

Insect repellent

Lens cleaning kit

Polarizing filter

Reflector card

Tripod

UV filter

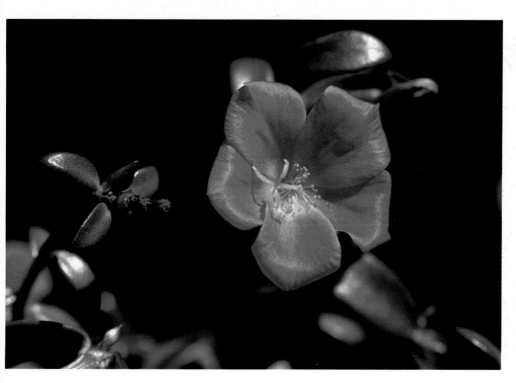

This flower is beautifully set off by its dark background and rich red color. Light bounces off everything in its path, and in the case of this flower, it bounces around among the petals, subtly adding to the glowing color. The flower is not placed absolutely in the middle of the picture because the photographer realized that moving it slightly off center improved the composition of the image.

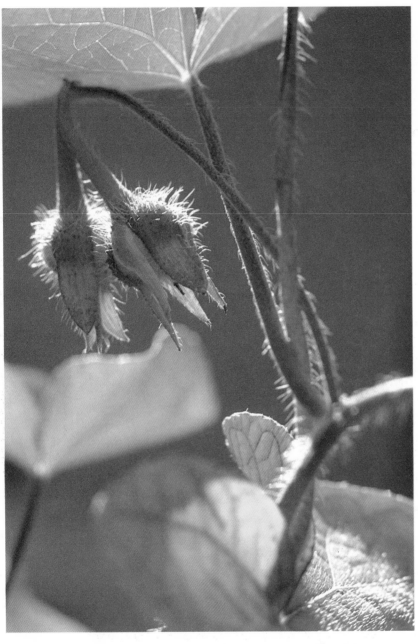

APPROACHING THE SUBJECT

Meadow is an ambiguous term applied to any open field containing a variety of low-lying plants and small animal life. The inquisitive photographer will find any number of interesting subjects, from the most common weed to a rare species of wild flower. A meadow will often be inhabited by an astounding number of butterflies in the Spring, as well as other photogenic insects such as grasshoppers and dragonflies.

A meadow in the country can be a peaceful setting, and the colors it presents are usually delicate and muted in tone. The wildflowers that you photograph here will offer quite a contrast to the normally vibrant colors of the average flower garden. Your choice of lighting can aid in depicting this particularly gentle mood in your photographs. Take some pictures in the delicate light of the early morning hours or just before dusk. Use your flash to imitate natural light for backlighting and sidelighting.

Many of the types of plants and flowers in a meadow grow close to the ground. Look carefully and keep your line of vision in accordance with the environment. Meadows often appear close to the edges of marshlands, so watch for unusual formations of mosses on rocks. And because the ground may be wet, don't forget to bring waterproof boots and other protective clothing.

(Above) The furry seed pods of a plant backlit against a flat blue background is a lovely image because of the quality of the light. Controlling the light creatively on a small scale is an important part of successful closeup photography.

(Right) This photograph of mittened fingers holding a wildflower is also a picture made beautiful because of the quality of light. It was taken in the afternoon to give the rosy tone you see here. Notice how the background is completely out of focus, but retains a lovely range of delicate pastel tints.

(Opposite page, top) One lone white flower found in a meadow

(perhaps a sole survivor of a house long since gone) underplays the petals in relation to the interesting green and yellow area in the center of the blossom.

(Opposite page, bottom) This image of a backlit chicory flower, made up of soft shapes and tones, is a delicate picture overall. The purple stamens in the center of the flower seem to have a kind of motion all their own and are singled out here as an aspect of this common flower that is rarely highlighted. To put some originality in your photography, try to show aspects or parts of things that you've never seen photographed before.

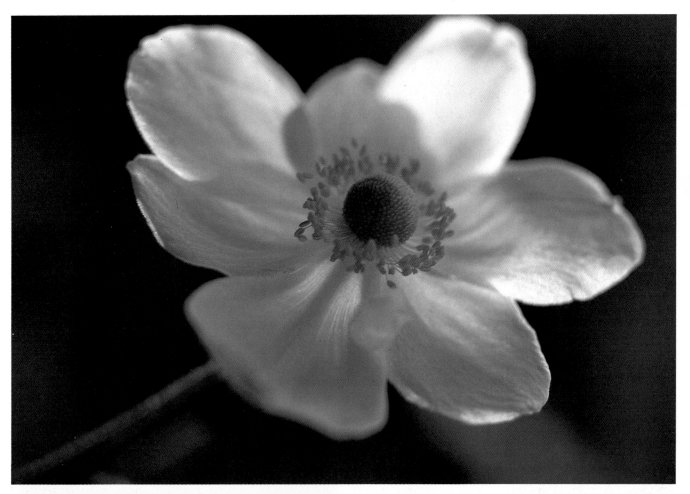

PROBLEMS AND SOLUTIONS

When taking closeup photographs in a meadow you will encounter all of the problems inherent in photographing nature compounded by the technical idiosyncrasies of your closeup equipment. But as we have previously seen, all of these problems—shallow depth of field, sudden movement of spontaneous subjects—can be easily solved by the thoughtful photographer.

However, the subjects that you will be photographing in a meadow will more than likely be slightly smaller in their natural state than you have previously experienced. The blossoms of flowers in the wild are usually smaller than the cultivated varieties found in domestic gardens. This means that you will have to move in even closer with your camera to fill the frame with their images. For this reason, you may want to work in the range of medium closeups and incorporate more of the surroundings into the picture. Notice the photograph in this section of the small sprig of flowers held in a gloved hand—it is a lovely example of a successfully composed medium closeup.

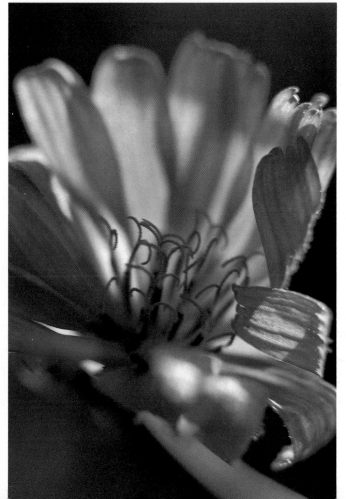

A LOOK AT THE PAST

EQUIPMENT RECOMMENDATIONS

Camera

Closeup lens

Daylight-balanced film

Exposure meter

Extra batteries

Lens cleaning kit

Reflector card

Table tripod

Tungsten film (Type A and B)

Most of us have saved at least a few mementos of joyous past occasions and of important moments in our lives: theater programs, corsages, photographs of family members. One way to share these treasures with other members of your family is to photograph them. Closeup photography offers an opportunity to create a new image and isolate special details from these fragments of time past.

You can change old photographs from stiff studio scenes with painted backdrops to full-frame portraits; or you can isolate elements of furniture or clothing that also evoke memories. In some cases, a particular physical feature of a person can be singled out; many of us have been impressed by someone's eyes or hands or mouth. Though it generally may not occur to us, these features can become powerful pictures in closeups, successful images in their own right, with the added meaning of capturing beauty in a person you have cared for.

Wedding pictures, in particular, are often a good choice for photographing in a new way, so they can be shared with others without actually giving someone a precious original. Take a look at your mementos, and think who else you know would enjoy having part of them. This is a closeup project that can bring a lot of pleasure to others as well as to you.

APPROACHING THE SUBJECT

After you collect a selection of mementos that you wish to photograph or copy, there are several techniques that may help you produce beautiful new versions of treasured photographs, theater programs, dried flowers, or whatever.

Old photographs can be easily copied once they are held flat. Tape the corners with a nondamaging type of tape to a flat white cardboard surface, illuminate the surface evenly overall, and you are ready to start isolating details.

Many photographs can be shot to good effect with light coming through the back of the picture. If you have a light box, fasten

the photographs flat on the surface. Double-check your exposure to make sure your camera is not misled due to the strong backlighting. Bracketing is always a good technique, and this is the appropriate occasion to shoot a few extra for safety's sake. If you do not have a light box, tape a photograph to a window for the same transilluminated effect.

For mementos that are not flat, set them up so that you have a maximum amount of illumination (either natural or artificial) and so that you will be able to stop down sufficiently for good overall sharpness. Reflector cards can be used either indoors or outdoors to help reflect light onto your subject.

COPYING FLAT ARTWORK OR PICTURES

Copy photography is not really different from any other type of picture-making except that the artwork or picture should be kept flat and some attention paid to lighting it. The most obvious way is to put a sheet of glass over the artwork so that the weight of the glass holds the material flat. If you decide to do this, then it is worth buying a good piece of plate glass free of imperfections and tint. Clean the glass carefully on both sides, and keep your fingers off it after you have cleaned it. Light it carefully from the side to avoid reflections, and use a polarizing filter if necessary. If you are copying a color picture with color film, remember to match the film to the light source. If you are using tungsten photofloods or spot lamps, then use tungsten-balanced film; otherwise the final result will have incorrect color balance.

If the picture or photograph you are copying will lie flat, so much the better. It can be taped on a wall and photographed, but it is advisable to use a tripod to line it up exactly at all times.

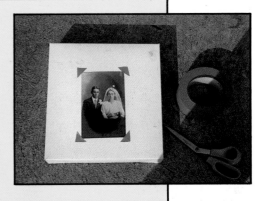

A flat image can be easily copied by taping it securely to a piece of white cardboard, as shown here. Bright, outdoor lighting provides even illumination for copying.

Make sure that the subject entirely fills the frame. If the subject is in a matte or a frame and you include the matte, meter for the subject matter and compensate a little, or bracket if you are not sure.

If you are working with old photographs and discover that they have deteriorated or are discolored from improper storage or storage materials, there is not a great deal you can do on your own that will help, other than carefully removing dust. You might consult a photographic restoration expert, however, for advice in such matters.

(Above) A detail from a treasured family picture shows the somber faces of turn-of-the-century newlyweds. The expressions are probably so severe because an exposure in those days usually took such a very long time that subjects chose expressions they could hold for seconds or even minutes.

(Left) A further closeup made from the picture above makes a new portrait from an aging photograph showing signs of deterioration. Copying old photographs can give them a new life and a different look as shown here.

(Top) An eye photographed from a black-and-white print shows one characteristic of a relative that had always impressed the photographer. The graininess of the original print is emphasized through further magnification, and the picture's tight framing gives this single eye real impact. This was photographed outdoors in late afternoon light, with the photograph placed flat on a white surface.

(Center) One young girl extracted from an old photograph of sisters, photographed in Helsinki in 1915, becomes a portrait interesting for the gentle lighting, painted backdrop, and the serenity apparent in the subject's face. This is the same girl shown in the picture on the preceding page about two years earlier. The difference in these two pictures tells us something about this girl's development into adulthood.

(Bottom) Antique shoes taken close up from an old photograph are an amusing glimpse into the history of fashion. These were quite elegant shoes in their day. Photography is a way of preserving the past through many changes in style and attitude. This leads us to think of people in the future looking at our styles and wonder what they may think. What today looks contemporary may in 20 years look odd.

PROBLEMS AND SOLUTIONS

Photographing old photographs, artwork, or almost any flat material is not simply a matter of holding the artwork flat and snapping a few frames of 35mm film. There is a little more to it than that.

Let's deal with lighting for flat copy material first. If the flat copy is translucent—that is, light will pass through it and the image still looks right—you may simply stick the artwork on a sunny window and shoot it backlit. This technique is useful for copying large transparencies or even for making reversal images (transparencies) from large black-and-white negatives. Where the material is opaque or does not respond to being backlit, it is necessary to illuminate it correctly from the side and arrange the lights so that the illumination is equal across the entire area. The ideal way is to have two light sources, on either side at a 45-degree angle. You may use almost any light source such as photofloods, reflector floods, and even electronic flash units just as long as: (a) the lighting is equal, and (b) the film is matched to the light source. For example, when working with 3400K photofloods the film should be Type A tungsten-balanced film since tungsten light sources lack sufficient blue in its spectrum to achieve proper end color balance. If you use electronic flash that is close to daylight balance, then you should use daylight film.

How do you know that your lights are correctly positioned to provide an even illumination? First, look at the copy, you can generally get a rough fix on the lighting this way. Second, pan the meter (hand-held or in the camera) across the copy and watch the readings. If the meter needle or the LED indicator remains constant, you got the lighting right first try. If not, then move the lamps until the readings stay in balance.

A lot of flat copy may well be old photographs that may have a glossy surface. The 45-degree angle lighting should eliminate any possibility of glare, but if there is a little, try using a polarizing filter. Rotate the filter and watch the image on the focusing screen.

While on the subject of filtration, you will find that many old photographs and artwork are often faded, stained, and discolored. When working with black-and-white film, a lot of this discoloration and staining can be eliminated by the judicious use of colored filters. Color filters generally lighten their

own colors and darken their opposites, and you can readily see the effect of a particular filter on the stains and discolorations by looking through the filter and noting the effect. The filter that produces the best overall cancellation of the problems to your eyes will generally work fine with the film. When you shoot with color film, about the only filter you can use is the polarizer, which is not much use at eliminating color staining, but may help by polarizing the image and saturating the overall color or tint of the original.

Remember that in all cases copying a photograph or piece of artwork will increase its contrast. It might be a good idea to choose films with a fairly low overall contrast to help minimize this effect if subsequent prints are to be made from the copy negatives or slides. If you are making slides for projection, there is really no problem. On the other hand, if the original material is faded and of low contrast, you might like to try using a high contrast film and even filters to boost the contrast in the finished negative or slide. It is even possible to recover very faded images by shooting in either color or black-and-white with an infrared-sensitive film. However, infrared color film tends to falsify the final color so it's a good idea to experiment. Remember too that infrared light comes to a different focus on your lens and at the film plane than visible light. Focus normally and then manually back off the focus to the infrared mark on the lens barrel for optimum sharpness.

If you do not have or are not inclined to set up an elaborate copy lighting situation, you can copy your material outdoors. Try to avoid direct sunlight that might cause shadows of the camera or yourself on the material. Choose a cloudy-to-bright day where the sunlight is diffused. Alternately, diffuse the sunlight with a suitable screen made of cloth gauze.

(Above) Hands and a white skirt were photographed from an old family picture just for the still quality of the image. The folds of the white skirt and the carving of the chair arm produce an interesting design that no longer is a portrait of a person, but an image with a certain appeal all its own.

(Left) Hands and a ruffled gown isolated from an old sepia-toned family picture suggests a sculptural work rather than a two-dimensional image. Closeups of this sort can give detailed information about styles and clothing of earlier times, while highlighting a favorite feature of a relative. This was shot outdoors in late afternoon so that the sepia would be rendered as warm as in the original.

(Top) The lips of a relative, always known as the prettiest in the family, became a unique image when photographed as a closeup from a black-and-white portrait. Any part of a person may be his or her best feature; often we notice one feature more than another. Photographing details from portraits can emphasize someone's best feature in an unusual image.

SUBJECTS IN MOTION

EQUIPMENT RECOMMENDATIONS

Camera

Closeup lens

Daylight-balanced film

Exposure meter

Extra batteries

Flash

Insect repellent

Lens cleaning kit

Reflector card

Small jar of honey or sugar water

Terrarium or glass-bottomed container

UV filter

Speed and motion are two qualities that attract attention to many subjects. We appreciate fast cars, fast runners, and many other subjects for their speed. Our visual representations of these things are based on the techniques of stopping motion, panning with a moving object, and blurring to suggest motion. There is a place in closeup photography for pictures whose subject is motion. It just takes a slight shift in mindset to conceive of an insect as a fast-moving object within the framework of closeup photography. But imagine the impression of a bumblebee flying by an aphid. Our sense of scale and a magnified world available through closeup photography would suggest rendering a bumblebee as a swift creature in this context.

The photographer can choose how to show motion in a picture. You can select a shutter speed that is faster than the motion of the subject and freeze a bee, for instance, in midflight. Choosing a shutter speed that is slow enough to record an insect in flight will show blurred motion.

A difficult technique to use in closeup photography, though not impossible, is panning. This is a technique used for race cars or bicycles where the camera is used to track the moving subject and renders it sharp against a blurred background. However, it is often impractical to try this given the critical focusing conditions and shallow depth of field in a closeup work.

A spider, shot head-on, was discovered exiting a tube lying on the concrete walk of a swimming pool. The photographer lay down and waited for the insect to approach the lens. The formidable effect of this insect is heightened by its sense of forward motion suggested through blur.

CONTROLLING SUBJECT MOTION

The interpretation of motion in photography depends as much on personal taste as it does on the ability of the viewer of the subsequent picture to understand the intention of the photographer. Under the conditions of normal photography, the photographer has many options available for depicting the action of movement, the most common of which is panning.

Unfortunately, in the parameters of closeup photography, your options are limited and the effective presentation of motion in a closeup photograph requires skillful employment of the speed of the film in the camera, the amount of light available, the lens aperture, and the shutter speed. Photography is a closely interwoven set of variables, some of which you can control and some of which you cannot.

High shutter speeds will certainly stop all but the fastest motion; $1/1000$ sec. will just about stop the beat of a bee's wings, for example. You get faster motion-arresting shutter speeds not from the camera, which will, on the average, have a top shutter speed of $1/2000$ sec., but by switching to the short pulse of light from your electronic flash unit.

When shooting closeup photographs, the most common examples of movement you will encounter will be the spontaneous movement of an insect or small animal, or the unexpected swaying of a flower or plant in a sudden gust of wind. You must be prepared to deal with both these problems to obtain effective images.

The wing beat of a bee or a hummingbird is several hundred cycles per second. To arrest this motion so that the subject appears to be suspended by stationary wings requires the fastest shutter speed you can muster, at least $1/1000$ sec. or faster. Fast film and wide lens apertures achieve this but whereas fast film is fine, wide apertures mean shallow depth of field and the need for very, very careful focusing. One way to avoid this is to shoot for a silhouette of your subject. The meter will read the light coming from behind the subject and automatically go for an exposure largely based on the background light. Even at shutter speeds of $1/1000$ sec. your pictures may show some movement of wing, but this will add realism to your photograph.

If you want to cheat a little, put your specimen in the refrigerator for a few

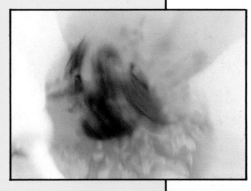

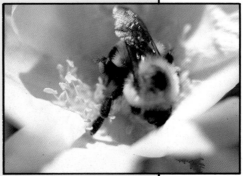

The photographs above show that simply changing your shutter speed can stop motion in the swiftest of subjects.

minutes (not in the freezer). After it has chilled it will move about quite slowly and give you a few minutes of careful composition before its metabolism returns to working temperature. The practice of blasting small creatures with insecticide is cruel and undefendable even for the sake of a photograph. However, capturing your subjects for a temporary confinement and cooling them down can help you to move them to a more appropriately lit environment.

The pictures in this section were shot within seconds of each other. The first was taken with too slow a shutter speed and shows a picture that is almost totally unsharp. The bee's motion and its activity in the flower coupled to the slow shutter speed produces massive blur and an unsatisfactory image. It's perfectly fine to have some aspect of the image blurred, but use sharp focus effectively and to state your point. The second picture was taken at a higher shutter speed and effectively annuls the bee's activity in the flower and renders the picture in sharp focus.

APPROACHING THE SUBJECT

Photographing motion in closeup or macro is really no more difficult a problem than other types of shooting. About all the photographer should remember is that the closer you get, the faster everything seems to happen. A rain drop may appear to fall at a quite leisurely pace when you watch it with your eyes, but a rain drop falling a few inches from a branch moves very swiftly down the frame under even moderate magnifications.

Sometimes it is impossible to gauge just how swiftly an insect or animal is moving. If you're not sure, bracket with a series of several shutter speeds. Try at least one above and below the one you would use given your camera's exposure calculation. The real trick in photographing motion is to anticipate movement and be ready to snap the shutter at the right moment.

If you use flash, your subjects will be sharp, as a flash can stop nearly any moving object. A famous photograph of the crown effect caused by a drop of milk splashing, which was shot in 1938 by George Edgerton, was one of the earliest spectacular stopped-motion photographs. If you do not use flash, you will have to choose your shutter speed carefully to either blur or render sharp such images as a flower blowing in a breeze or an insect flying into a flower. The closeup possibilities when photographing motion are infinite.

A butterfly with moving wings was photographed very late on a cool afternoon. With no flash available, the photographer chose to make a picture that expressed the motion of this colorful insect.

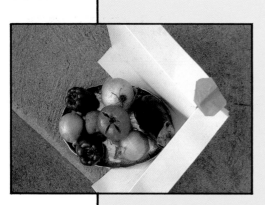

A very simple reflective set can be constructed by taping white cardboard together, as shown here.

USING REFLECTOR CARDS

Lighting for closeup and macro work is quite similar to lighting for any photographic subject. The same problems apply: how to get the light where you want it, how to achieve good modeling or shadowless lighting, how to soften harsh shadows. If you are shooting outdoors using sunlight, you certainly can't move the sun around. But you can move the subject around or modify the sunlight using white card reflectors to bounce light into the shadow areas. Bouncing light off a reflective surface onto the subject also has the advantage of softening the light and decreasing the contrast in the subject that the film has to handle.

A simple cardboard box arrangement like the one in the picture shown here works wonders at generally decreasing heavy shadows and lighting contrast. Naturally, this technique may also be used with flash or tungsten lighting to good advantage.

PROBLEMS AND SOLUTIONS

The technical problems involved in photographing motion closeup are really no different than those involved in the other situations given in this book. The difference is that in shooting motion you have to be especially quick to capture the decisive moment. When photographing motion in nature you do not have the luxury of retakes. If the shot does not work the first time, you've lost it forever.

When a subject is fleeting, preset your exposure and lens and work quickly. It takes practice and a lot of patience to learn to anticipate your subject's movement. But you can simulate spontaneous movement at your leisure to help develop the skills you will need in the field.

Set up an artificial situation in which you can observe and photograph motion. An easy example would be water dripping from a faucet. You can set this up in your own home by just turning the tap water on for minimum pressure. See if you can catch the droplets of water just before they begin to drop from the tap. Or have someone drop small stones into a pool of water and see if you can photograph the exact moment when the stone hits the surface. It's not as easy as it seems, but with time you will be able to judge the right moment to take the picture. This practice session will also allow you the time to experiment with lighting techniques, such as working with electronic flash, and you can see how your control of the lighting will affect the outcome of your photographs.

Deadly nightshade blowing in a breeze created this lovely ghost effect as the flower moved backward and forward. Low light conditions plus the breeze suggested this approach to the photographer, and the outcome is a soft picture with delicate color.

TEXTURAL VIEWS

EQUIPMENT RECOMMENDATIONS

Camera

Closeup lens

Daylight-balanced film

Exposure meter

Extra batteries

Flash

Lens cleaning kit

Polarizing filter

Reflector card

Tripod

UV filter

In this project, you will be teaching your eyes to interpret your tactile sense. Can it be done? Yes, and more successfully than you might at first realize. After you have completed one roll of film based on this adventure, texture just may become one of your favorite closeup subjects.

Our tactile sense accounts for more of our understanding of the environment than we are often aware of. Think of the nubby surface of woolens and tweeds, the bark of a tree, the pitted skin of an orange—all are details known as much for their texture as for their color or form. Exploring texture forces you to focus on the physical surfaces of what is around you. On careful examination, you will find that textures abound in an astounding variety of forms.

Some objects are highly textured under any conditions, but almost all variegated surfaces are emphasized if light strikes them from a specific angle, casting strong shadows in the crevices or variations of the surfaces. Not only will this project renew your awareness of the surfaces of things you see every day, but it will develop your understanding of how light renders a surface with characteristic texture.

These details from a set of crewel pillows were photographed outdoors on the front steps of the photographer's house. Outdoor light was selected for its convenience and for the natural shadows it produces. Many fabrics offer interesting closeup possibilities, especially when sidelit to emphasize textural qualities. Often fabrics have repeating motifs that can be effectively isolated in unique close-up pictures.

APPROACHING THE SUBJECT

You hear a lot about texture. Let's define it from a photographic standpoint. Take an ordinary sheet of paper. Looks smooth, doesn't it? It does if you look at it at a normal viewing distance and in flat, head-on light. Now tilt it so that the light illuminates it from a hard side angle. Not so smooth now.

Another example is a field covered in a blanket of snow. If the light is flat, the snow does indeed look smooth. If the light strikes from an angle, the snow suddenly develops bumps and a crystalline appearance. Go closer under the same lighting, and you begin to see more and more texture.

The face of the fairest is not smooth; that's a trick of light. Use a harsh side light, and little bumps and wrinkles begin to reveal themselves. Go in close, and the structure begins to break up into a most unflattering terrain.

Crystals, rock formations, tree bark, sand, rusty metal, and weathered wood are all prime subjects for closeup photography. Lighting each of these requires careful adjustment to draw out the surfaces. Surface variations, which may in reality only be a fraction of an inch, create fantastic "landscapes" when photographed near lifesize and enlarged.

Naturally, the rougher the surface the better textural effects you can obtain. Find a wall with peeling paint. Look at it in flat light, and there seems to be no definable texture. Wait for the light to swing around so that it shines from the side, and suddenly the paint flakes stand off in bold relief. That's texture, and although all materials have some degree of texture, it's light that reveals it.

Even the flattest of surfaces can pose problems with depth of field when working close up. The area of sharpest focus must be chosen carefully. Even the slight indentation of this knot hole in a tree caused the edges to blur.

MICRO PERSPECTIVE

You should bear in mind that the rules of perspective apply very much for closeup work just as they do in more conventional photography. Don't imagine that because you are shooting at 1:1 with a macro lens, the laws of perspective are banished. On the contrary you may find that they seem to be exaggerated.

In closeup work, perspective can be quite unflattering. Try taking a portrait of someone with a 50mm lens as close as it will normally focus and then carefully examine the results. You will find that the subject's nose is unflatteringly large in comparison with the rest of the face. Now you know why slightly longer lenses are generally considered to be more acceptable for portraiture: they have a better stand-off from the subject and thus offer a flatter perspective. Further experiments with wide-angle lenses will teach you about exaggerated perspective. The shorter the focal length the more of a caricature the portrait will be. We mention this to stress the effect of perspective on any picture.

Quite a dramatic perspective effect will occur when working with macro. If it's not noticeable, it is generally because there is so little depth of field in macro work that the picture tends to become out of focus, thus softening any perspective lines that might otherwise be inherent in the shot.

Notice how a slight shift in angle alters the perspective in these two photographs. In the first photograph, the angle of view becomes distorted, whereas in the second, the point of view remains normal.

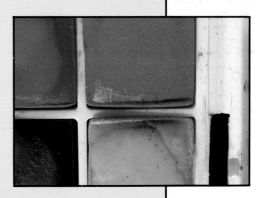

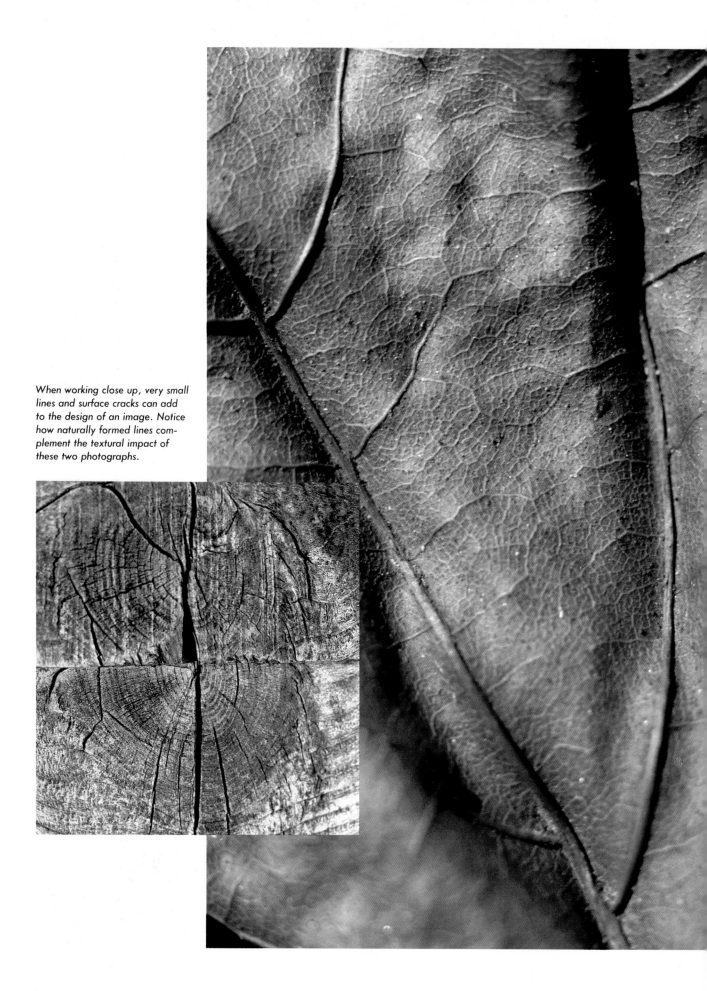

When working close up, very small lines and surface cracks can add to the design of an image. Notice how naturally formed lines complement the textural impact of these two photographs.

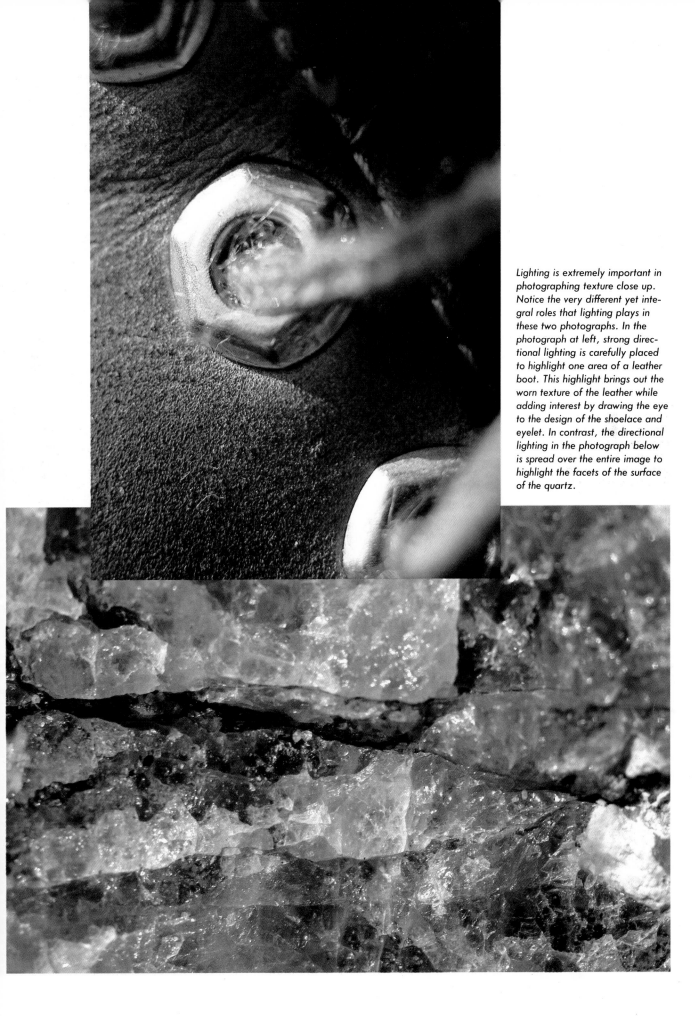

Lighting is extremely important in photographing texture close up. Notice the very different yet integral roles that lighting plays in these two photographs. In the photograph at left, strong directional lighting is carefully placed to highlight one area of a leather boot. This highlight brings out the worn texture of the leather while adding interest by drawing the eye to the design of the shoelace and eyelet. In contrast, the directional lighting in the photograph below is spread over the entire image to highlight the facets of the surface of the quartz.

Very bright directional lighting allows for ample depth of field to successfully display this dramatic study in contrasts. The photographer's eye for design is very apparent in this image. Notice how all of the elements—straight and curved lines, shadow and highlight, and smooth and rough surfaces—work together for effective composition.

PROBLEMS AND SOLUTIONS

Choose days for your photography where the light is extremely bright and not softly diffused by cloud cover. The angle of light should fall on your subject in a way that corresponds closely to the angularity of the texture. Because you will be working with very sharp light, you should be able to control your depth of field problems satisfactorily.

A portable reflector card can come in handy when the natural light of the sun is uncooperative for your purposes. You may be able to bounce extra light onto the surface at the desired angle.

One of the best tools in your camera bag when photographing texture is your polarizing filter. Because a polarizer removes even the most subtle reflections from nonmetallic surfaces, it will bring out further emphasis of the texture in your photographs.

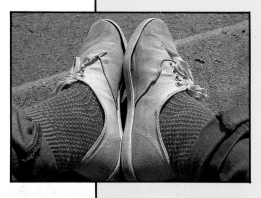

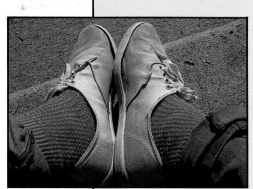

The second photograph at left shows the result of increased color saturation by pushing the film speed. The first photograph was taken at the recommended exposure, while the second was shot at a higher film speed.

COLOR SATURATION

Color film is funny stuff. It comes in a box complete with a set of instructions that almost no one reads. In fact about the only piece of information that anyone takes notice of is a statement of the speed of the film printed on the side of the box. Unfortunately, the ISO rating is often quite misleading when it actually comes to using the film and determining an appropriate exposure. As a general rule slide film will accept a little underexposure, which benefits the final reproduction of the colors. Professionals often rate film a little faster than that on the box. For example, a 64 ISO film might be rated at 80, which will cause very slight underexposure. Doing this adds a depth and richness to the color, which saturates better. To get this effect, set your exposure compensation dial to minus ½ or even 1 stop. Or you could adjust the exposure after you have metered it if your camera is manual. But the easiest way is to cheat and set the ISO a bit higher than that stipulated. It's a good idea to shoot a test roll before you start shooting in earnest. Cameras and meters vary, so it's best to find out by how much first. Just shoot a series of three exposure brackets on various subjects, record your exposures, and examine the results. The ones you like best will help you determine the speed to use.

IN A VEGETABLE GARDEN

People who grow vegetable gardens come to know the slight daily variations in the things they raise there and develop as much pleasure in the process as the outcome of their gardening efforts.

For the closeup photographer there are innumerable opportunities for pictures from the appearance of the first seedlings through to the harvest of tomatoes, squash, peas, or any other vegetable. These pictures can document a summer's effort, record the life story of a prize-winning vegetable, and even provide pictures that you might want to enlarge for a wall arrangement.

Natural light can render even the most common vegetable beautiful. Think of the strong graphic elements of their shapes and colors. The twirling spirals of vines and tendrils can also provide dramatic closeup imagery. What is often the gardener's bane can become the photographer's bounty, so be watchful for well-camouflaged caterpillars and other garden inhabitants.

While gardeners will plan their vegetable patches in a sunny location, when working close up you may need an additional light source such as electronic flash or even a reflector lamp to illuminate hidden subjects.

EQUIPMENT RECOMMENDATIONS

Camera

Closeup lens

Daylight-balanced film

Exposure meter

Extra batteries

Flash

Insect repellent

Lens cleaning kit

Reflector card

Small jar of honey or sugar water

Spray bottle of water

UV Filter

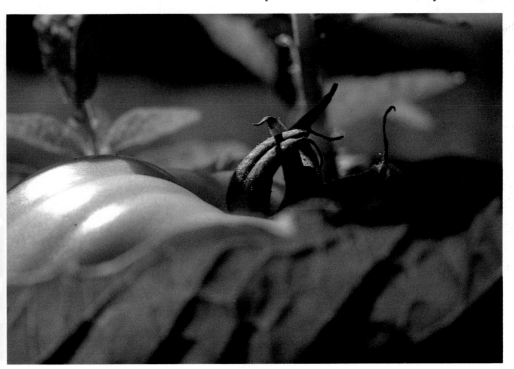

The top of an unripe tomato when backlit caused a leaf in front of the tomato to be transilluminated. The sun has caused a highlight on the rim of the tomato that emphasizes the form of this vegetable. Overall, this is a lovely study in greens that has a refreshing feeling. Natural highlights emphasize the gentle, rounded surfaces of the top of the tomato. A single subject such as this can suggest dozens of different views, each of which can be an effective picture. Try several different approaches for each of your closeup subjects.

APPROACHING THE SUBJECT

The form and color of vegetables make them inherently photogenic. Unpicked, on the plant, they can be beautiful images. Or once you pick them, you can position them with any background and in any lighting conditions you like, to produce good images.

Remember to look at the leaves and stalks as well as the vegetable itself. Many garden vegetables have beautiful parts, including blossoms, that make good subjects. Look at your subjects under varying lighting conditions. Light coming through the back of a leaf may show its colors to best advantage, while light coming sideways onto a leaf may make the most of its texture.

When you are photographing something that grows in a patch, calculate depth of field to know in advance what your background will look like. If your camera has a depth of field preview button, use it. For example, one sprig of parsley rendered sharp against a soft, undetailed background may be a more attractive image than one with semidetail in the background. However, you might want to show what will look like an indefinitely continuing row of parsley behind one sprig in sharp focus. Choose depth of field for the best impact in your picture.

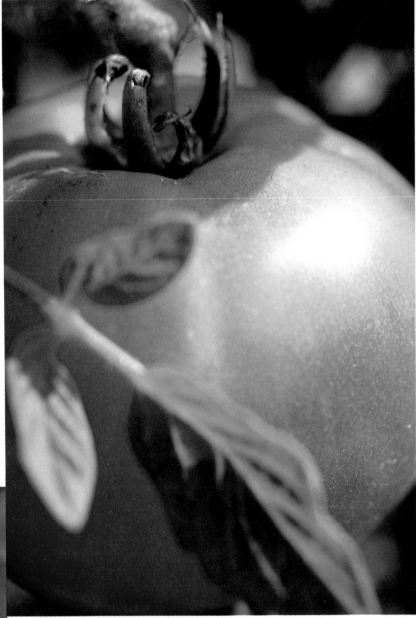

(Above) A ripe tomato is waiting to be picked by the owners of this English-style vegetable garden. Natural sidelighting flatters the color and form of this fruit. The picture is tightly framed and gains, rather than loses, meaning because the sides of the tomato are trimmed off. Experiment with the placement of your subject in the frame; often a photographer's tendency is to try to show too much, when less makes a more effective image.

(Left) Tiny predators such as this will abound in a vegetable garden. The sharp-eyed photographer spied this beetle happily munching away, much to the gardener's despair.

SELECTIVE UNDEREXPOSURE

Exposure meters, be they in a camera or hand-held, are not intelligent creatures. They tend to average out the scene to a uniform 18 percent gray reflectance. For the most part this works well, especially where the meter is through the lens and is designed to read the more central part of the scene. You can rely on your meter to give the correct exposure, but there are times when it needs a little subjective help.

Look at the two pictures used here as examples. The first one is simply metered and shows marked overexposure, which destroys the impact of the shot. Although there are a few bright highlights, the predominant area is somewhat shadowed. The meter has integrated all this information and increased the exposure. The match flare is overexposed, and the highlights are also a little washed out. In the next shot the photographer took a meter reading and then deliberately underexposed. The picture shows better contrast. The match flare is more real, and the highlights retain detail.

The reverse happens when shooting snow or beach scenes, for example. Here there is an excess of highlight so the meter tries to adjust the exposure to its 18 percent gray program. The result is a muddy beach and gray snow. The solution is to overexpose to bring everything back into balance. How do you do this? Use the exposure compensation control on the camera or the AE (automatic exposure) lock if the camera has one, and read a less bright or less dark area. Or if the camera has manual metering, set the reading a little lower or higher according to the subject.

These photographs show how selective underexposure can add impact to certain images. The first photograph was taken at the exposure given by the meter, while the second was slightly underexposed, giving it better subject definition.

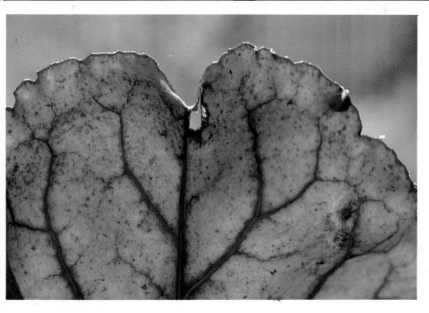

The leaves of vegetable plants offer a wide variety of unusual material for the closeup photographer. The photograph shown here was obtained by backlighting the subject. The picture emphasizes not only the vein structure but the backlighting creates a gentle rimlight to highlight the crinkled edge of the leaf.

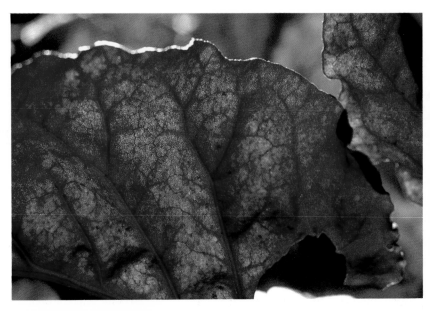

(Right) An assymetrical study of a beet leaf relies on the balanced design of the leaf as the subject. Just a bit of out-of-focus background is included at the top of the frame to give the leaf a context. The sun is low in the sky and gives a lovely halo effect to the top of the leaf.

(Below) Parsley photographed in the garden in the afternoon seems to come forward in the image. One of the main strengths of closeup photography is to look at the one, not the many. A single sprig of parsley as shown here has more impact than an entire patch of it might have had.

PROBLEMS AND SOLUTIONS

Lighting for small objects—berries, for example—can be quite tricky especially when using flash for closeup. If your camera and flash unit are not metered through the lens, make sure that the sensor eye of the flash is aimed at the subject. If it can't be aimed at the subject, use a substitute target such as a gray card or your hand held at the same plane as the subject. For a more diffuse, softer light try bouncing light off a white card held just to one side or above the subject.

To add a little realism to your pictures you may want to gently spray the subject with a mist of water from a spray bottle to produce water drops. By all means isolate your subject by placing a white (or any color you prefer) card behind it to make a neutral background.

Some fruit and vegetables are quite shiny. To achieve a better color saturation use a polarizing filter. Film should be of the daylight type when shooting outdoors in color or with a flash unit.

PRECIOUS OBJECTS

Everyone owns some small items that are precious in material or sentimental value. There are several good reasons for using these as subjects for closeup photography. One is to express your feelings of value for something and to work with beauty as a theme. Learning to express themes and concepts through photography develops visual as well as intuitive skills.

A second reason is to keep a record of them that can be useful for an insurance company in case the items are ever lost. Many photographers now document their possessions, especially those with serial numbers, in order to justify insurance claims and to facilitate recovery of lost or stolen items.

A third reason for photographing items of great value is for museum purposes or in order to sell them. It is far more reasonable to show a photograph of something to a curator or buyer in initial interviews than to transport a priceless object.

Some of the photographs accompanying this chapter are of a piece of jewelry that is not of great value except as a sentimental object. There are technical challenges inherent in photographing jewelry, as there can be problems of glare when you illuminate such an item. Other precious things can present equally difficult problems, but in the process of working them out, you will come to a far better understanding of many photographic techniques.

EQUIPMENT RECOMMENDATIONS

Camera

Closeup lens

Daylight-balanced film

Dulling spray

Exposure meter

Flash

Lens cleaning kit

Reflector card

Table tripod

Tungsten film (Type A and B)

UV Filter

Sometimes jewelry can cause objectionable highlights and glare and may need to be frosted in the freezer for a short time or, in some cases, even coated with dulling spray.

There are a few things you should know about photographing precious metals or jewels in closeup. It's easy to shoot, say, a golden statue or ikon where the lens is moved in to about 3 feet (91 cm), since you can see what's on the surface of the subject. Reflections from gold, for example, can be largely eliminated by angling the light so you don't see the reflection or by using a polarizer for nonmetallic surfaces. A polarizer by itself will only remove a percentage of the reflections so you should angle the light as well if you can. If you cannot control the light, as may be the case in a museum, use the polarizer to best effect.

Of course, if you are photographing precious objects that are your own, there is nothing to stop you from using a proprietary dulling spray to lessen recalcitrant reflections. Dulling sprays do not hurt the surface they are sprayed on, but extreme caution

should be used before you commit yourself.

For very small objects such as gem stones and small jewelry there is a neat trick that works most of the time. Put the gems or jewelry in the freezer of your refrigerator for a few minutes. Take them out, set them up, light them, and shoot. Remember what happens when you bring a cold object into a warm room? It fogs up with condensed moisture, and this effectively stops reflections on the surface of the object. Again, caution is advised. Don't chill the object too long, or beads of moisture may form on its surface, not just a mist. Under high magnifications you will be photographing the moisture beads instead of the object.

Selection of a background can complement good technique in closeup photography of small objects. Experiment with backgrounds that add color or provide effective contrast.

(Top) A silver trivet was photographed against the unusual background of a stack of folded cardboard boxes. The roughness of the cardboard with its strong shadows serves as an effectively contrasting backdrop for the gleaming silver and its delicate design.

(Above and right) Your closeup images of your favorite objects should reflect what it is that pleases you most about them. Here the photographer chose to emphasize the intricate hand-carved design of a cinnabar ginger jar. The use of strong directional lighting helps to bring out the texture of the carvings.

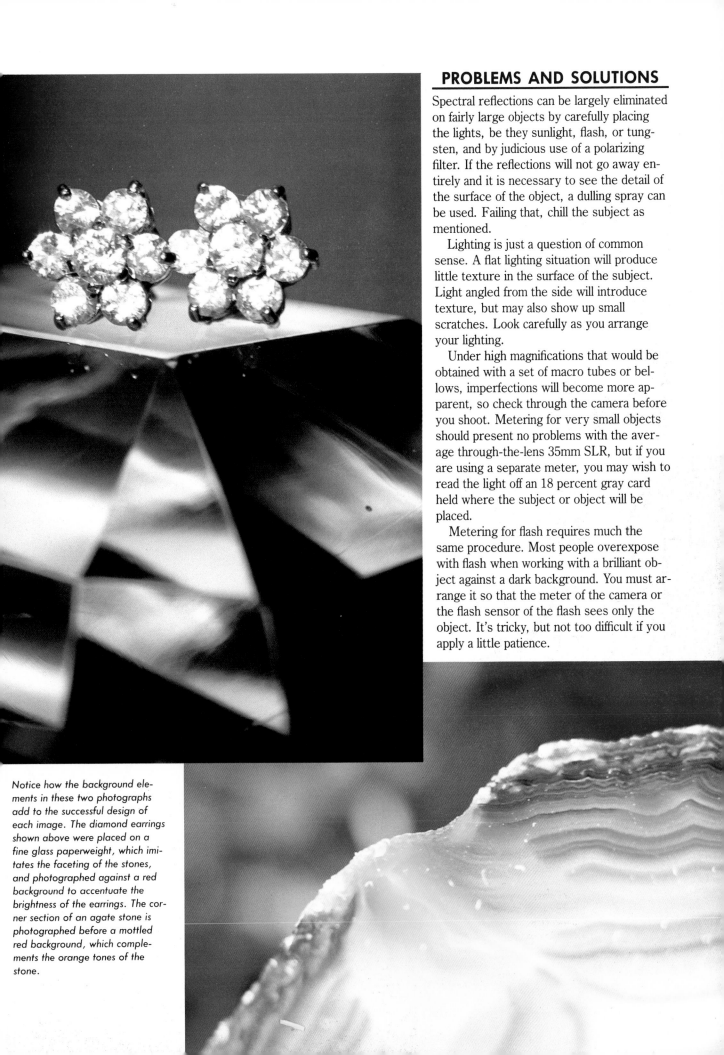

PROBLEMS AND SOLUTIONS

Spectral reflections can be largely eliminated on fairly large objects by carefully placing the lights, be they sunlight, flash, or tungsten, and by judicious use of a polarizing filter. If the reflections will not go away entirely and it is necessary to see the detail of the surface of the object, a dulling spray can be used. Failing that, chill the subject as mentioned.

Lighting is just a question of common sense. A flat lighting situation will produce little texture in the surface of the subject. Light angled from the side will introduce texture, but may also show up small scratches. Look carefully as you arrange your lighting.

Under high magnifications that would be obtained with a set of macro tubes or bellows, imperfections will become more apparent, so check through the camera before you shoot. Metering for very small objects should present no problems with the average through-the-lens 35mm SLR, but if you are using a separate meter, you may wish to read the light off an 18 percent gray card held where the subject or object will be placed.

Metering for flash requires much the same procedure. Most people overexpose with flash when working with a brilliant object against a dark background. You must arrange it so that the meter of the camera or the flash sensor of the flash sees only the object. It's tricky, but not too difficult if you apply a little patience.

Notice how the background elements in these two photographs add to the successful design of each image. The diamond earrings shown above were placed on a fine glass paperweight, which imitates the faceting of the stones, and photographed against a red background to accentuate the brightness of the earrings. The corner section of an agate stone is photographed before a mottled red background, which complements the orange tones of the stone.

You may be attracted to small details of some of your possessions. The photographer had always admired the decorative lettering on this barometer, and chose to photograph it in such a way as to depict a small detail while still retaining the essence of its purpose.

THE CONCEPT OF HORIZON AND THE RULE OF THIRDS

The first pictures shown here represent three different versions of a picture, whose importance is not the particular subject matter, but the clear horizon created by land, sky, and tree.

Which one attracts you most? Many people immediately find one more visually pleasing, without having to think about why.

If you picked the first one, you picked the most static of the three images. Because the horizon is in the middle, it does not particularly emphasize either the land or the sky. In general, any horizon set exactly in the center of the frame will be less effective than one that is offset.

If you picked the second or third, you are responding to the differentiation of the visual elements as the horizon emphasizes one over the other. A high horizon creates a certain feeling, as does a low horizon. They represent a different *feeling about space*, which we respond to in an emotional as well as a visual sense.

The important point to remember is that a horizon is not only the line separating land from sky. Any horizontal element in any image is in a sense a "horizon." Study these three photographs to understand how almost any picture has a horizon that can be used to add compositional interest to a picture by its placement in the frame. Is there a "best" place for a horizon or a vertical line in a composition? Visual convention states that images are most pleasing if they are constructed along a "rule of thirds." The image area is divided into thirds in the imagination, and important elements are placed at the lines or intersections of lines of the thirds. This is true both horizontally and vertically. The fourth photograph shows a strong vertical element in the center of the picture.

The fifth picture shows a strong vertical line placed one-third from the left of the frame. This often is the best visual solution, *though not always*. All visual rules need to be broken at times for effect. If we all followed the same visual rules all the time, we would have nothing new, different, or shocking, and there would be no visual impact in the world.

The last photograph shows the vertical line moved to the right, but not a third away from the edge of the frame. It seems odd and less pleasing than the previous image, though depending on the actual forms and color in a real picture, it could still be successful.

This series of drawings illustrates the rule of thirds in both horizontal and vertical composition. In the first illustration, the image is divided exactly in half by the horizon line, creating a static image. In the second illustration, the horizon line moves up to the top third of the frame, which presents the most interesting visual interpretation of the image. The third image has the horizon line placed very close to the bottom of the frame, which, while interesting, is not as well balanced as the second image. In the fourth drawing, we see the same principle applied to the placement of a vertical element within a frame. Notice how the same effects are obtained depending on the placement of the subject within the frame. A vertical element placed in the exact center of the frame is static. If the subject is moved off-center as shown in the fifth illustration, it is more interesting yet still balanced within the frame. The final image is acceptable, but seems more weighted toward the right side.

IN BLACK AND WHITE

EQUIPMENT RECOMMENDATIONS

Black-and-white film

Camera

Closeup lens

Dulling spray

Exposure meter

Extra batteries

Flash

Lens cleaning kit

Reflector card

Tripod

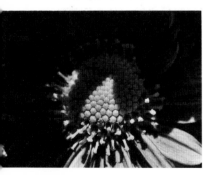

A flower in partial shade has a completely different effect when photographed without its characteristic colors. This is a good example of why almost all closeup photography is done in color— great magnifications of objects we know and enjoy looking at for their color are much weaker in black and white. However, careful attention to composition and framing make this photograph an interesting study in design.

Though color is one of the major elements in most closeup photography, there are many opportunities for black-and-white photography as well. Black-and-white closeup photography is most commonly done for industrial and scientific purposes, as well as for fine art prints. Andreas Feininger has produced a number of fine books of closeup photography, much of which is black and white. He is part of a continuing tradition of black-and-white closeup photographers who persist, despite the contemporary predilection for color.

Working in black and white requires the skill of seeing objects in gray tones. Consider a rose: with color film, the photographer aims to preserve the natural hues of the flower and its green leaves. The black-and-white photographer has to see a red rose as a deep gray and its green leaves also as a deep gray. Knowing this, a fine black-and-white photographer might choose to use filters to render certain colors in the flower a deeper or a lighter shade for the purposes of better balance in the final print.

Black-and-white closeups offer splendid darkroom experiences as well. A creative photographer can make startling prints of sharp closeups. Many darkroom techniques can be used to enhance closeup work, such as working with one or several generations of paper negatives, successively increasing contrast while simplifying detail in the image. Or through a process of rephotographing closeup prints, a photographer can create gigantic blowups with grain patterns that become abstract and more and more fascinating as they cease to represent the actual physical subject.

Black-and-white closeups can be hand-colored with brushes and thin washes of oil paint (available in any art supply store) for a range of effects from subtle to startling.

Enterprising black-and-white closeup photographers can approach local newspapers and magazines with their pictures. Not only is black-and-white photography a viable form of closeup work, but it is still in demand for publications and galleries.

APPROACHING THE SUBJECT

As you can see from the illustrations in this chapter, black-and-white film cannot be used exactly as color film, for some subjects are known for their color. Therefore, seeing photographically in gray tones, anticipating the eventual prints, becomes the major approach to successful black-and-white closeups.

Objects that exist in monochrome, such as piano keys and the clarinet shown here, translate without problem into black and white. But look at the zinnia and hornet also shown in this chapter, and note how different the effect is that these pictures lack the vivid colors of nature.

The first step, therefore, is to learn to translate color into gray tones. The second step is to compose the previsualized gray tones into an image that will be balanced and strong and effective. Composition is even more critical in black-and-white closeup photography than in color, for the latter can be so appealing that composition loses its importance in some areas.

If you do your own printing, black-and-white closeups require the best possible quality and an impeccably rendered tonal range to succeed as imagery. Soft printing, without a true white or black or definition between tonal areas, can make a black-and-white closeup appear flat and boring. This project can help refine your printing skills because of its demand for high-quality prints.

Think about it this way: if you subtract the orange color from an orange, what is left? A spherical object with a porous skin. How can you render this with beauty? Lighting becomes crucial in black-and-white.

Take one photolamp and use it to illustrate a single orange; keep working with the light until you can express the roundness of the fruit with lighting alone. Study the shadow you produce while moving the light around, and see it as part of your subject. Add a second light, and move them so that you light different sides of the fruit. Try moving the lights so that you produce an enormous, dark shadow and so that you have no shadow at all under the fruit. Take closeups of your lighting experiments. You can learn a great deal about the principles of lighting this way.

The patterns of light make excellent subject matter for black-and-white closeups. This bold graphic formation of light and gray tones shows excellent linear composition and a natural sense of balance.

139

(Left) Piano keys, which are black and white in reality, make an effective closeup image and one a pianist can really enjoy. Lighting was produced by one overhead spot that the pianist uses to simulate concert conditions and a small light at the left.

Clarinet keys, silver on black wood in life, are quite acceptable as a black-and-white closeup. The clarinet was taken outdoors and illuminated with sunlight to reduce the possibility of hot spots on the silver keys that could have happened with a photolamp.

PROBLEMS AND SOLUTIONS

Shooting closeups with black-and-white film can produce both pleasing and very dramatic results. Generally, black-and-white film offers a much higher overall resolution than color film, and subsequently very big enlargements may be made from your 35mm negatives. The choice of film is up to the photographer, but it may be apropos to remember the rule of thumb that the slower the film, that is, the lower its speed, the finer the grain and the sharper the image. Also the slower the film the higher its inherent contrast and the more care should be taken when processing such materials.

The judicious use of color filters will allow you to enhance or to decrease the impact of various areas of the subject being photographed. For example, if you shoot a red rose with a red filter, the rose will appear lighter and the leaves darker. The heavier the red filter the starker the effect will be. Generally, filters in the yellow-to-orange range are most useful for this type of effect. When you start using red and heavy red filters, the contrast gets so wide that it becomes difficult to make a satisfactory print from the negatives—unless you really want hard effects, that is. The use of a polarizing filter is as handy for black-and-white as it is for color since it will help eliminate unwanted glare and reflections from the subject.

Most amateur photographers ask the following question at some point in their experience with a camera: What do I do with all these photographs? After a year or so you are bound to have a few hundred, or even a thousand, good slides and negatives stuck in boxes and drawers doing nothing but taking up space. But take heart. There are many imaginative uses for quality photographic images that can bring you even more pleasure from your hobby and perhaps even some extra income.

CARE AND STORAGE

This is a good point to comment on the durability of photographic images. While the manufacturers of photographic film and papers are constantly improving their products in terms of quality and longevity, if you've taken photographs for a long time, you may have noticed yellowing and fading of some of your older images. It is still a fact that the dyes that create the images on your slides and prints will eventually begin to fade.

There are, however, many precautions you can take to add to the life of your photographs. Exposure to air and sunlight is the most harmful agent to photographic prints. By matting and framing the prints you display behind glass you will help to prolong their image. Take care not to place such framed photographs in direct sunlight. Photographs not on display should be stored in a cool, dry place.

Slides should also be carefully stored when not in use. Limit the length of time that each slide is projected as well, since the strong light of the projector bulb can be very harmful. Many photographers make duplicates of their original transparencies, which they use for projection. This is a good idea for the amateur as well, especially if you have a set of slides that you know will be frequently projected. In the near future, we may see images stored electronically, with the image replayed on your televison screen. This advancement will greatly prolong photographic images, but as of yet such technology is not available for home use.

If you have a darkroom and process your own transparencies, negatives, and prints, you are probably already aware of archival techniques to extend the life of your images. Allowing for proper fixative time and thorough washing of your film and prints will add years to the preservation of your work. Store your negatives and transparencies in glassine rather than plastic holders, as some

DECORATIVE AND PRACTICAL USES FOR CLOSEUP PHOTOGRAPHS

of the chemical products present in certain plastics have proven harmful to film.

DECORATING WITH CLOSEUPS

By the time you have experimented with many of the projects in this book you will no doubt have some spectacular images that you may want to display in your home. Photographs are always an expression of the photographer—his or her ability, capability, insight. They supply you with a very personal addition to your living space when displayed with thought and care.

If your photographs are in color, care should be taken in the choice of pictures displayed so that they enhance rather than detract from your environment. It is obvious that if the colors in your prints clash with the other decorations in your home, the pictures will lose their impact. Keep this visual harmony in mind when choosing matte boards and frames for your work as well.

Closeup images make for particularly high impact photographs. Your pictures will address the viewer with an otherwise unnoticed aspect of the world. Naturally, the larger the print the more dominance it gains over the environment it is hanging in, and the choice of image size in the final print is a matter of budget and personal taste. Generally, prints in the area of 8 x 10 to 11 x 14 are best for domestic use, with certain images printed smaller or larger for additional emphasis. Think carefully about the psychological effect of your subject matter on those who visit your home. A lot of people are somewhat adverse to bugs, spiders, and snakes—especially in a closeup detail!

PREPARING A SLIDE SHOW

If you shoot the majority of your images on color slide film, you will no doubt be interested in showing them to family and friends in an entertaining manner. If you have a group of slides that depict a special interest or place, you may find that local civic groups and clubs would love to have you as a guest speaker. For example, the garden club in your town would make a captive audience for your closeup views of the botanical garden in your area. You may even receive a nominal fee for your efforts or at the very least a complimentary piece of cake and a cup of coffee.

If there is one word to describe an effective slide show it is *impact*. Slides that hit the viewer between the eyes or cause him

or her to sit up and take notice while trying to figure out just what it is on the screen will get you applause when the show is over. Endless streams of slides with little expertise or image value will soon have your audience wandering off to the kitchen to raid the refrigerator.

No slide should be up on the screen for more than a few seconds, so plot your commentary with this in mind. Sitting and staring at a shot of an insect while the photographer enthusiastically describes its type, habit, and how it was photographed is guaranteed to put all but the most devoted photographer or bug-lover to sleep.

The same applies to close up photographs of your spouse, girl or boy friend, or your cute kids. Keep your patter short and snappy and don't show too many slides at one sitting. A good multimedia show is a fast one that leaves the audience satisfied, but still asking for more. Ideally, it is nice if the show is slickly presented, with no bright light flashed on the screen between slides. If you can fade one slide through another so that the show moves through smooth transitions, so much the better. There are slide projectors available that do just that, and you can set the change and dissolve rate according to your taste.

Adding music and commentary tracks is by no means as difficult as it sounds. There are quite a few inexpensive dissolve units available that will work well with the average slide projector and a tape recorder (either cassette or reel to reel). The music should be selected to suit the slides, and the voice-over commentary kept to a minimum.

PRODUCING YOUR OWN GREETING CARDS WITH CLOSEUPS

There is no doubt that a personal greeting card beats a store-bought one for originality, creativity, and thoughtfulness. It's easy to produce your own greeting cards using your close-up negatives or slides. In fact, if you shoot slides and have access to a slide printer, it can be executed in about 60 seconds flat. Just place the slide in the printmaker and press the button. Color photocopies work very well too.

Once you have your print, simply slip it into a blank greeting card. There are many commercial types available for this purpose. Check with your local photo dealer.

Closeups provide some very lovely im-

ages for such purposes. Winter scenes can add a lovely personal touch to your holiday greetings. You can even produce your own stationary note cards for general use. This is a very satisfying way to share your photographs with friends and relatives.

SELLING YOUR CLOSEUP PHOTOGRAPHS

Many amateur photographers are aware that there is a large source of revenue to be tapped in the field of stock photography. Indeed, entire books have been devoted to this lucrative field.

Essentially, the term stock photography applies to images sold for a fee by stock agencies for general purposes such as advertising or editorial illustration, decoration for business offices, publicity brochures, and the like. A photographer contracts with a specific stock house to act as his or her agent in the rental of photographs that are kept on file with the stock house. The agency collects all fees for the photographer and issues payment minus their commission for the sale.

If you have a large number of top-quality photographs that you feel might be of value for this kind of income, you may want to invest in some of the books that cover this topic more extensively. The following discussion will tell you a few basics you may want to consider.

Pick out a few magazines you have around your home and take a good look at the photographs that illustrate the articles and advertisements. Chances are that many of these photographs were leased from stock photo agencies. Now take out what you consider to be your best photographs. Compare them to the published work. Are your photographs as good? Many of them probably are. But having a collection of high-quality photographs is only the first step to earning income through stock.

A lot of honest self-criticism is necessary at this point. If you go to a stock agency, they may show interest in your work, but they usually tend to look for a photographer with a professional track record, no matter how excellent your slides may be. The demand for good images is continuous, and the agency will expect a steady flow of work if they accept you for representation. If your work is good and you can supply them with more, then by all means begin to contact the agencies. But be prepared to be without

your slides for a long time or have duplicates made for your personal (not commercial) use. A stock house does not care for photographers who put their slides into the agency and then expect immediate results or who snatch them back after a few months. A year is usually the minimum amount of time that an agency expects to hold onto a batch of slides.

These words of caution are not meant to discourage the amateur photographer from entering the lucrative world of stock photography. Many photographers with no more experience than yourself have earned thousands of dollars from this field with very little effort. However, it is a venture that should be approached with the same healthy trepidation that you would exercise with any other business venture.

You can of course act as your own agent in submitting slides to magazine or book publishers. This method of selling your photographs provides a lower pay scale than that of stock photography, but it can offer almost immediate results for your efforts.

This area requires a bit of research on your part before you submit any work. Look carefully through back issues of any magazine that you wish to contact and make sure your photographs are compatible with its content. There is nothing so annoying to an editor as to have to wade through a batch of slides that obviously have no bearing on what his or her magazine is about.

If you know of a book publishing company that regularly publishes books on specific topics, you may want to contact an editor with a list of subjects of which you have photographs. Keep in mind that when submitting unsolicited work to any business, be it stock agency or publishing firm, you should always label your work carefully and provide a stamped, self-addressed envelope for its safe return.

Finally, it has been previously mentioned that closeup photographs are excellent subjects for personal greeting cards. If they are good enough for your own use, it stands to reason that commercial greeting card companies will also be interested in seeing your work. Again, research your market carefully and look for companies to whose product your work is best suited. Go into stores that sell cards and look at the type of picture each company uses. The name and address of the company will be on the back of the card. If a company accepts your work, they will keep coming back to you for more.

INDEX

Designed by Jay Anning
Graphic Production by Ellen Greene